Symbols and Allegories in Art

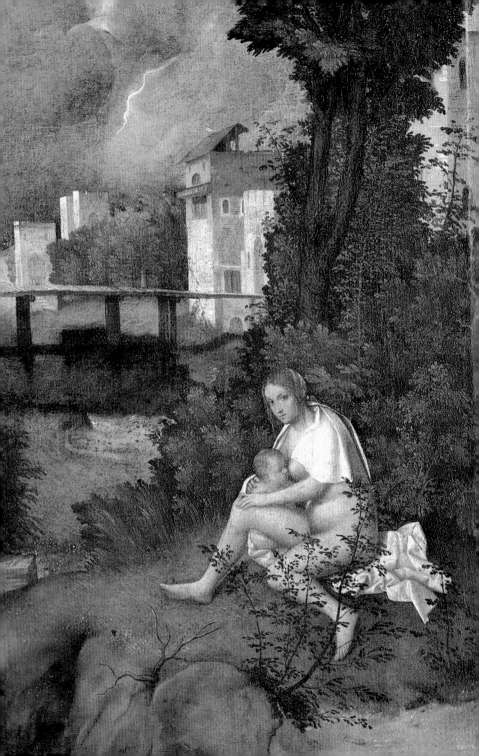

Matilde Battistini

Symbols and Allegories in Art

Translated by Stephen Sartarelli

The J. Paul Getty Museum
Los Angeles

A Guide to Imagery

Italian edition © 2002 Mondadori Electa S.p.A., Milan
All rights reserved. www.electaweb.it

Original Art Director: Giorgio Seppi
Original Editorial Coordinator: Tatjana Pauli
Original Graphic Design: Dario Tagliabue
Original Editing: Lidia Maurizi
Original Layout: Chiara Forte
Original Cover: Anna Piccarreta
Original Image Research: Elisa Dal Canto

English translation © 2005 J. Paul Getty Trust

First published in the United States of America in 2005 by
Getty Publications
1200 Getty Center Drive, Suite 500
Los Angeles, California 90049-1682
www.getty.edu

10 9 8 7 6 5 4 3 2

Mark Greenberg, *Editor in Chief*

Ann Lucke, *Managing Editor*
Mollie Holtman, *Editor*
Robin H. Ray, *Copy Editor*
Pamela Heath, *Production Coordinator*
Hespenheide Design, *Designer and Typesetter*

Page 2: Giorgione, *The Tempest* (detail), ca. 1506. Venice, Gallerie dell'Accademia.

Pages 8–9: Limbourg Brothers, *July* (detail), illumination from *Les Très Riches Heures du duc de Berry*, ca. 1416. Chantilly, Musée Condé.

Pages 98–99: Caravaggio, *Narcissus* (detail), ca. 1599–1600. Rome, Galleria Nazionale di Arte Antica, Palazzo Corsini.

Pages 174–75: Hieronymus Bosch, *The Garden of Earthly Delights*, detail from the *Garden of Earthly Delights Triptych*, 1503–4. Madrid, Prado.

Pages 276–77: Sandro Botticelli, *Spring* (detail), ca. 1482–83. Florence, Uffizi.

Page 366: Wooden ceiling of the Labyrinth Room, sixteenth century. Mantua, Palazzo Ducale.

Contents

Introduction

What do artworks say? What do they represent? Does the artist sometimes hide a deeper message within the superficial image? In the past, painters drew images and codes from a vast repertoire of symbols that their predecessors had used. These symbols were understood by their contemporaries, but we modern viewers no longer know how to interpret them. They are an integral part of the artwork's structure; if we cannot decode them, we cannot comprehend the story that the images tell and the message they want to convey.

Medieval thought reorganized the major symbolic codes of antiquity into a new religious and teleological conception of the world, imposing a clear dichotomy between the principles of good and evil, according to which the principal figures of the Christian pantheon were assigned their proper place: Christ, the Virgin, the angels, and the saints on the one hand, the devil and his emissaries on the other. Romanesque art is rich in symbols drawn from the past, some immediately accessible to our contemporary world, others categorized as demonic and monstrous because they have become inscrutable with the passing of time.

The Renaissance saw a revival of classical culture, brought about by the reading and translation of ancient manuscripts by the humanists and their dissemination via the newly invented printing press. These texts restored to the West some very ancient cultural traditions, dating as far back as the Mesopotamian, Indo-Iranian, and Egyptian civilizations.

The "symbolic images" of the fifteenth and sixteenth centuries were profoundly influenced not only by the myths of Graeco-Roman antiquity but also by Platonic philosophy and the Hermetic and esoteric traditions derived from the Jewish Kabbalah. In this intellectual environment, the work of art was seen as a "second nature" and a new cosmogenesis, akin to the alchemical transmutation of matter. Renaissance artists therefore used alchemical symbols in their works to reformulate the fundamental stages of the world's creation and harmony, or to communicate, to a limited circle of "initiates" (patrons, humanists, painters, and literati), a shared body of important moral and intellectual values.

During the seventeenth century, much of the iconographic repertory was collected in

a series of treatises and dictionaries, which the artists used to help them give clear and efficient expression to the most commonly used symbols and their corresponding meanings. Over the course of the seventeenth and eighteenth centuries, however, artists began to apply these codes in an almost mechanical fashion; the images were gradually emptied of their deeper meanings and turned into simple didactic icons.

The visionary painting of the late eighteenth century, the culture of Romanticism, and nineteenth-century Symbolism reasserted an antinaturalist conception of art that brought together figures and meanings drawn from the imagination and the unconscious. Not until the twentieth century, however, did certain artistic trends such as Surrealism link their aesthetic and creative principles back to the esoteric tradition of the past.

The purpose of this volume is to provide today's readers and museum-goers with a tool for orienting themselves in the world of images and learning to read the hidden meanings of certain famous paintings. Given the nature of the subjects under discussion, for which there is never any single, definitive interpretation, we merely present a number of different keys to reading the various works of art. The brief iconographic explanations make no claim to exhausting the complexity of the references and subjects treated in the individual works.

The book is thematically divided into sections: the first, symbols of Time, looks at how artists in various periods of European history represented the concept of temporality through the presentation of its chief symbolic personifications; the second section, symbols of Man, explains a number of cultural and anthropological archetypes drawn from Western religious and philosophical traditions; the third, symbols of Space, seeks to lead the reader into the "magical" places in the world that surrounds us; the fourth, Allegories, looks at the principal iconographic themes of art history.

In the appendixes, the literary and iconographic sources that inspired the artists—and the intellectuals who guided them in the construction of their images—offer the reader the opportunity to deepen his or her knowledge of this fascinating world, so rich in exciting surprises.

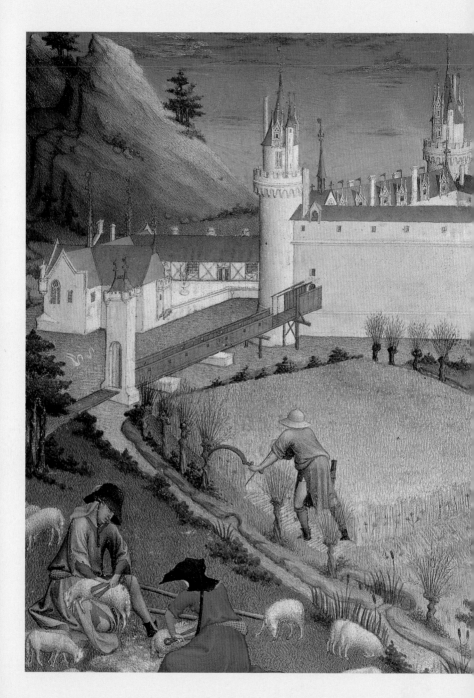

TIME

Ouroboros
Oceanus
Opportunity
Eon
Time
Christ Chronocrator
The Zodiac
The Seasons
Spring
Summer
Autumn
Winter
The Months
Dawn (Aurora)
Noon
Twilight
Night
The Hours
Life
Death
The Ages of the World
The Ages of Man

Depicted as a snake biting its own tail, it represents eternity, the continuity of life, and the totality of the universe. It is the primordial symbol of creation.

Ouroboros

Symbol of the eternal return and of life's continual regeneration, the "King Snake," or Ouroboros, is the image that best defines the concept of time as a cycle: the "Great Year" of the ancients. According to this tradition, the cosmic cycle is completed every time the stars return to their starting point. At that moment (every 15,000 years by medieval calculations; 25,800 years by modern calculations), time reverses its order and begins to move in the opposite direction. With the advent of Christianity, this concept was supplanted by the doctrine of linear time, endowed with a beginning (the creation of the world) and an end (the Last Judgment). The King Snake plays an important role in the alchemical/Hermetic tradition as well, where it represents the process of refining substances.

As an iconographic motif, the snake biting its tail was used to represent eternity and is often associated with gods and emblems that personify Time. The symbol gained particular importance in the Italian Renaissance, due to the rebirth of paganism as promoted by the Neoplatonist philosophers Pico della Mirandola and Marsilio Ficino.

Princes and noblemen put this symbol on the reverse side of medals to symbolize their intellectual, political, or moral disposition.

Derivation of the name
From the Coptic *ouro*, "king," and the Hebrew *ob*, "snake"

Origin of the symbol
For the Egyptians, it is the ring that joins together the four cosmic deities: Isis, Osiris, Horus, and Set

Characteristics
The act of biting one's tail represents the principle of self-fertilization. It is accompanied by the inscription *en to pan* (In One, the Whole)

Religious and philosophical traditions
Gnosticism, Hermeticism, alchemy, theosophy

Related gods and symbols
Hermes (Mercury), Eon, cosmic time; the winged serpent, the alchemical or Mercurial dragon, quicksilver; ring of fire; circle

▶ *Ouroboros*, eighteenth-century Arab miniature.

In the Renaissance, Demogorgon was considered the founding father of the gods and the supreme warder of the occult powers.

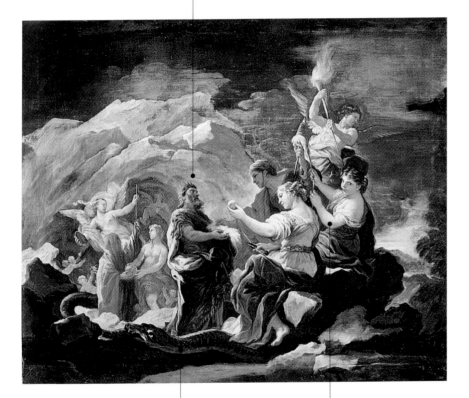

The body of Ouroboros, half white, half black, alludes to the union of opposites (earth and sky) within the primordial whole.

▲ Luca Giordano, *Cave of Eternity*, ca. 1685. London, National Gallery.

The three Parcae (Fates) weave a man's destiny from birth.

The phoenix, which rises up from its own ashes, represents both resurrection in the Christian sense and the synthesis of the four cosmic elements: earth, water, air, and fire.

The armillary sphere symbolizes the universe.

The chains allude to the inexorable yoke of Ananke (Necessity), which weighs upon human existence.

The painting's literary sources probably include Pietro Pomponazzi's Tractatus de immortalitate animae, Claudianus's Gigantomachia, *and Ovid's* Metamorphoses.

▶ Giulio Romano, *Allegory of Immortality*, ca. 1520. The Detroit Institute of Arts.

Ouroboros symbolizes the eternal return and the cyclical nature of time.

The sphinx represents man's inescapable destiny.

The world, dominated by death and transience, is shown caught between a monster's claws.

He is represented as a bearded old man, often as a bust, with crabs' claws in his hair. He can also assume the form of a cosmic serpent.

Oceanus

Oceanus is the cosmic river that girds the universe, presiding over the birth and death of all things. As guardian of the flow of time and eternal change, he has a dual nature: In his aspect as primordial water, he is the original, inexhaustible source of life; as the boundary of the world, he symbolizes the inescapable destiny of existence (Gr. *heimarmene*). His opposite counterpart is Styx, the divine river that flows around the Realm of the Dead.

In ancient Greece, every situation had its corresponding temporal divinity, such as Kairos (Opportunity), Nike (Victory), and Hermes. The latter, for example, was identified with the silence that sometimes falls over public events, while Kairos personified the moment to take action. Nike presided over wars and sporting competitions, transforming the time of battle into the moment of victory. Oceanus was later associated with the Persian god Zervan, who embodies two distinct temporal principles: eternity (infinite time) and necessity (the time of long dominion).

In the *Orphic Hymns*, this function is fulfilled by Ananke (Necessity), who takes the form of a snake and wraps the universe in his coils. In Christian representations, Oceanus is stripped of all temporal significance, becoming simply the father of the world's waterways. He appears at the feet of Christ, the "new Sun" and Lord of Time.

Derivation of the name
Latin *Oceanus*, from the Greek *Okeanos*

Origin of the symbol
In Greek mythology, he is son of Uranus and Gaea

Characteristics
He girds the universe with his coils and represents the concept of time as flux and endless change

Religious and philosophical traditions
Pre-Socratic philosophy, Judaism, Orphism

Related gods and symbols
Thetys, Eros-Phanes, Ananke (Necessity), Nemesis (Revenge), Chronos, Hermes (Mercury), Kairos (Opportunity), Nike (Victory), Zervan; Ouroboros, cosmic snake (Ophion), water, sea, egg, lotus, reed, island, the hereafter, the river Styx

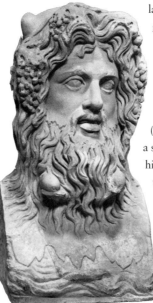

▶ *Bust of Oceanus,*
Roman. Vatican City,
Vatican Museums.

The winged fish is a symbol of Christ fleeing the world.

The pendulum represents man's destiny. In many paintings it is associated with images of the Crucifixion.

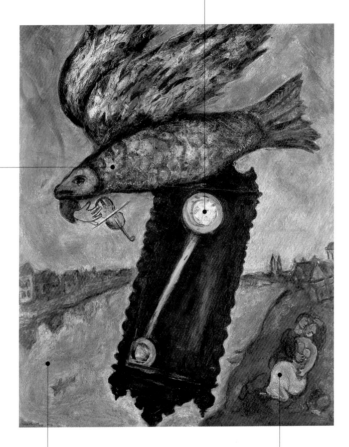

On the banks of the river of life, a loving couple symbolizes the life-giving power of the waters.

The Dvina River expresses the concept of time as flux and the source of life animating all nature. The painting's title is drawn from a line of Ovid's Metamorphoses.

▲ Marc Chagall, *Time Is a River without Banks*, 1930–39. New York, Museum of Modern Art.

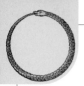

It is usually portrayed as a girl poised atop a rolling sphere, with her face covered by a shock of hair and the back of her head bald.

Opportunity

Opportunity is the favorable moment for taking action and bringing one's wishes to fruition. In classical antiquity, it was personified by Kairos, son of Oceanus and brother of Nike. He is a winged young man holding a scale on the razor's edge, an allegorical image of the fickleness of his favors, which one must know how to seize "on the fly."

Opportunity later came to be represented as a maiden with her face covered by a thick shock of hair and the back of her head completely bald. Man must show his skill by grabbing the lock of hair before the girl turns and vanishes forever. To seize the fleeting moment is no easy task, however. During the Middle Ages, opportunity was condemned and juxtaposed with the stability of Virtue.

Starting around this time, the image of Opportunity gradually becomes merged with that of Fortune, with whom it shares certain attributes, such as the wheel and the sphere. During the Renaissance, this symbol reclaimed its ancient, positive connotation and was included in moral and allegorical scenes, where it represents the virtue of knowing the proper moment for taking action and intervening effectively in the course of events.

▶ School of Andrea Mantegna, *Occasio et paenitentia* (Opportunity and Penitence), ca. 1500. Mantua, Palazzo Ducale.

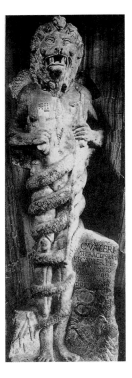

It takes the form of a man with a lion's head and a snake coiled around his body, holding a scepter, a key, and a lightning bolt.

Eon

Eon personifies the vital essence and divine fluid that lives on after the body dies. The snake, symbol of the immortal soul and of continually renewed life (its six coils symbolize the course of the sun over the span of a year), is the visible manifestation of this quality. Worshiped as the "lord of light" and emanation of divine being, Eon symbolizes the eternity that governs the sphere of the fixed stars. Endowed with a twofold nature—represented by the lion's head (the solar and summer principle, related to the element of fire) and the snake (the subterranean, wintry, and humid aspect corresponding to earth)—Eon contains all the cosmic opposites within himself: life and death, good and evil.

In artistic representations, Eon's body is often surrounded by the signs of the zodiac, which are also sometimes inscribed in the serpent's skin.

An eon, or "great century," consists of one thousand earth years. Christian doctrine, which divides cosmic time into seven eons corresponding to the seven days of creation, has the end of the world occurring at the completion of the final eon. One calculation from late antiquity predicted the end for the year 1492, the same year Europeans first visited America. More generically speaking, the passage from one eon to another coincides with the end of one age and the start of a new spiritual order.

Derivation of the name
From the Greek *aion*, and the Late Latin *aeone*, meaning "age" or "period"

Origin of the symbol
It is a personification of the term *aion*, which means "being in existence since the beginning of time"

Characteristics
Eon can stand for either a cosmic era or the god who presides over the cult of Mithras. As guardian of the doors (or gates) of the Beyond, he holds a key, a scepter, and a thunderbolt

Religious and philosophical traditions
Zervanism, the Mithraic mysteries, Orphism, Zoroastrianism, Manichaeanism, Gnosticism

Related gods and symbols
Ra, Oceanus, Chronos, Mithras, Zervan-Ahriman; cosmic serpent, good, light, darkness, spirit, matter

Statue of Lion-Headed Aion, ◄ from the Mithraeum at Ostia. Vatican City, Vatican Museums.

Time

Time is represented either as a bearded, winged old man holding a sickle, an hourglass, and a billhook or as an old man leaning on a crutch.

Derivation of the name
From the Old Norse *timi*, "time" or "prosperity." The root of the medieval Latin *tempus*, however, means "to cut," pointing to Time's role in mowing down the hours of earthly existence

Origins of the symbol
It derives from the medieval merging of Kronos (father of Zeus) and Chronos (time)

Characteristics
As the destructive principle, Time symbolizes the transience of all things. As a beneficent god, he contributes to the triumph of truth and innocence against the snares of calumny and vice

Religious and philosophical traditions
Alchemy, Hermeticism, astrology, Neoplatonism

Related gods and symbols
Chronos, Kronos (Saturn), Janus; truth, virtue, life, death, melancholy

The iconography of time has its origins in the medieval superimposition of two distinct divinities from antiquity: Kronos, father of Zeus, and Chronos, the Greek god of time. Kronos (the Roman Saturn) represents the immutability and irreversibility of events; he is the cosmic principle opposed to the changeability of the universe and is often portrayed devouring his own children. His castration and exile to the northern reaches of the world express the inevitable construction of a new cosmic order.

In the Middle Ages, through the images of Rabanus Maurus's *De universo*, Saint Augustine's *City of God*, the *Ovide moralisé*, and the *Fulgentius metaforalis*, Time gradually came to be identified with Wisdom. This transposition would become extraordinarily widespread during the Renaissance: Florentine Neoplatonism and the alchemist tradition made Saturn the highest manifestation of thought.

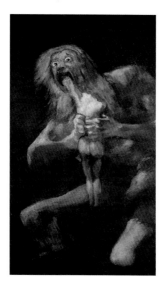

As minister of Death, to which he consigns the predestined victims, Time is also sometimes represented as a demon with iron teeth, standing tall amid ruins or arid, desolate landscapes. As the father of Truth, and in the positive role of "revealer," he is often portrayed in the backgrounds of moralizing allegories, cutting Cupid's wings. As the god of the melancholic temperament, he is represented as Saint Jerome in meditation.

▶ Francisco Goya, *Saturn Devouring One of His Children*, 1821–23. Madrid, Prado.

The girl is offering
the young man a
carnation, symbol
of fidelity in love.

The young man has been inter-
preted as Time, with one hand
turned to the happy past and the
other to the bitter future.

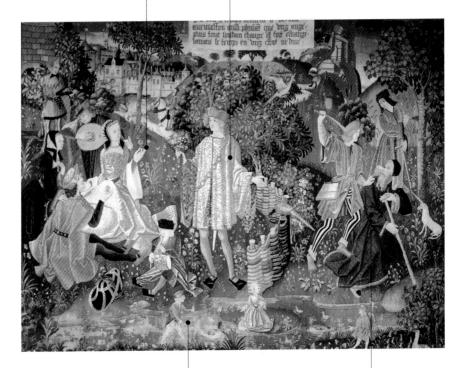

Saturn is portrayed as a lame
old man leaning on a cane.

The carefree children
at play represent the
age of innocence and
obliviousness.

▲ French tapestry, *Allegory of Time*,
early sixteenth century. Cleveland,
Museum of Art.

The fruit-filled cornu-
copia symbolizes the har-
mony and plenty that
accompany the return of
the reign of Saturn
(which here stands for the
Medici government).

Capricorn is the astrological
emblem of the Medici family.
Cosimo I, who commissioned
the fresco, was under the pro-
tection of this sign (his rising
sign), which symbolizes
strength and victory in battle.

▲ Giorgio Vasari, *The First Fruits of the
Earth Offered to Saturn*, 1555–57.
Florence, Palazzo Vecchio.

In accordance with classical iconography, Saturn is portrayed as a venerable, mature man with a veil covering his head.

The snake biting its own tail became an attribute of Saturn in the fifth and fourth centuries B.C.

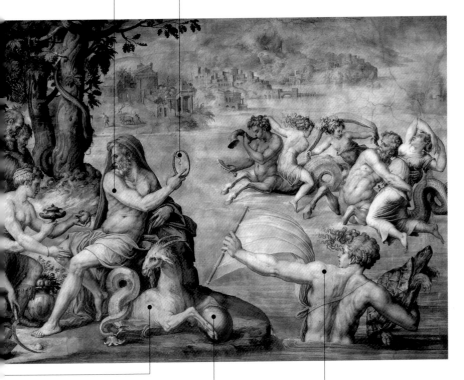

The nymph holding a sail and a tortoise (the heraldic devices of Cosimo I) personifies the fortune of the duke.

The ball, heraldic symbol of the Medici family, represents the globe of the world, "governed by those seven stars" (Vasari) that make up the constellation of Capricorn.

The scythe is one of the original attributes of Saturn, an agricultural deity who presided over the crop harvests. It symbolizes the inexorable passing of time.

Renaissance images of winged Saturn are based on Petrarch's Triumph of Time. *The god is sometimes portrayed with two pairs of wings: the folded wings allude to time past, and the spread wings to time yet to come.*

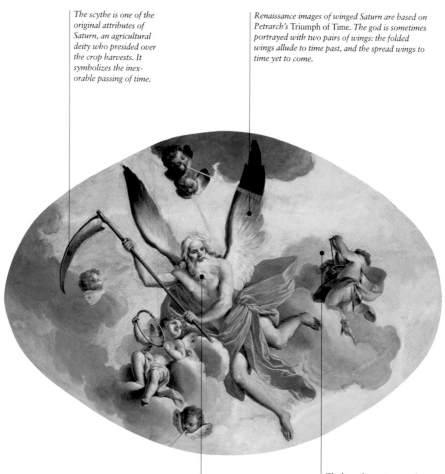

The hourglass represents the irreversible passage of time.

In Renaissance and Baroque art, Time is portrayed as a winged, naked old man.

▲ Giacomo Zampa, *Allegory of Time,*
eighteenth century. Forlì, Palazzo
Lombardini Monsignani.

The sickle and the snake biting its own tail are attributes of Time.

Truth, which never has anything to hide, is portrayed as a defenseless, naked maiden.

The apple and the snake-haired head identify this figure as Discord.

Envy is recognizable by his dagger and firebrand.

▲ Nicolas Poussin, *Time Revealing Truth with Envy and Discord*, 1641. Paris, Louvre.

He is portrayed as the master of the zodiac and placed inside a mandorla or enveloped in a luminous halo. He is sometimes assigned the attributes of the ancient solar divinities, such as a shining crown.

Christ Chronocrator

The birth of Jesus upset the temporal and cosmic order of antiquity. He became the "Sun" of salvation and divine justice, illuminating all past and future events in the history of mankind with new meaning.

Within this new perspective, the cyclical conception of time, based on nature's perpetual self-regeneration, was replaced by time as a linear, irreversible process that culminates in eternal salvation (*oikonomìa*). In the teleological Christian conception, the circular character of time becomes synonymous with imperfection: the unending process comes to represent waste and inefficiency, incapable of completion and self-realization.

This radical change is reflected in the dating system, which is made to begin with the birth of Christ: the Anno Domini. As Lord of the Zodiac, Christ takes the place reserved in antiquity for the gods of the sun (Helios, Apollo, Zeus) and presides over the influence that the spiritual entities (the angels and saints) have on the destiny of men.

His ordering function is also felt in the rhythms of the daily hours, the change of the seasons, and the dates of the liturgical year. As an ordering principle of time, the figure of Christ sometimes overlaps with that of God the Father or is represented by the tetramorphic symbol of the four Evangelists.

Derivation of the name
From the Greek *Christos*, "the anointed one"; *chronos*, "time"; and *kratos*, "strength," "power"

Origin of the symbol
Created by the Fathers of the Church, it is the synthesis of the principal cosmic symbols of antiquity

Characteristics
As the ordering principle of time, he is presented as the "new Sun" of the Christian zodiac

Religious and philosophical traditions
Mesopotamian and Indo-Iranian sun-cults; Christianity

Related gods and symbols
Helios (Sun), Phoebus (Apollo), Zeus (Jupiter), Father Time, Oceanus, Eon; zodiac, solar wheel, tree of life, cross, ladder, sword, light, tetramorph

▶ Christ-Apollo at the center of the zodiac, detail from a North Italian manuscript, eleventh century.

Christ is portrayed in the act of setting the universe in motion.

The angels represent the spiritual energies governing the celestial spheres.

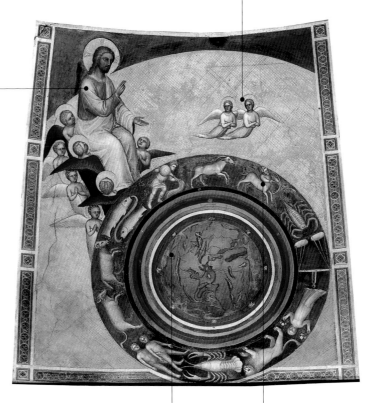

The wheel of the zodiac expresses Christ's role as chronocrator.

The earth is placed at the center of the universe, in accordance with Aristotelian and Ptolemaic doctrine.

▲ Giusto de' Menabuoi, *The Creation of the World*, from *Stories of the Old and New Testaments*, 1370–78. Padua, baptistry.

Oceanus and Demeter are presented in a subordinate position with respect to Christ. They have lost all cosmological value and are reduced to simple personifications of natural elements (sea and earth, respectively).

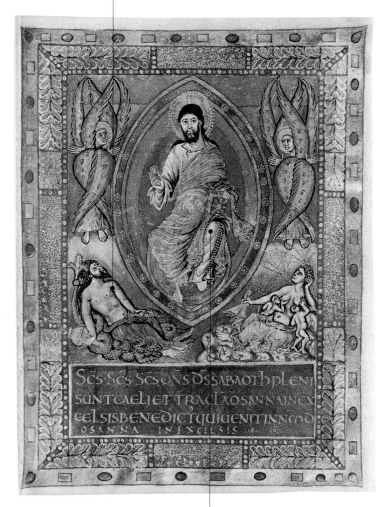

As the New Sun, Christ is enveloped in a mandorla of light and occupies the center of the composition.

▲ *Christ in Majesty,* illumination from the *Sacramentary of Saint-Denis,* ca. 870. Paris, Bibliothèque Nationale.

The sun and the moon represent the two eras of the world: the age of the Gospels (sun) and that of the Old Testament (moon).

The cross is the vehicle of the Resurrection and transfiguration of Christ.

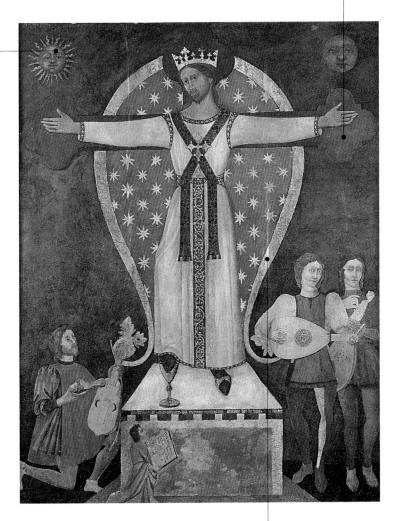

▲ The Holy Face of Lucca and the Legend of the Minstrel, mid-fifteenth century. Lanciano (Italy), Museo Diocesano.

The omega-shaped mandorla underscores Christ's role as chronocrator, the beginning and end (alpha and omega) of all things.

Christ Chronocrator

The archangel Gabriel has the task of carrying the cross, symbol of the sacrifice that God made to save mankind.

Christ is represented as a judge, separating the elect from the damned.

The Virgin Mary represents Christian humility, grace, faith, and hope.

The elect ascend into Heaven, summoned by God to be the voice of salvation and truth.

The saints and martyrs accompany the apparition of Jesus Christ.

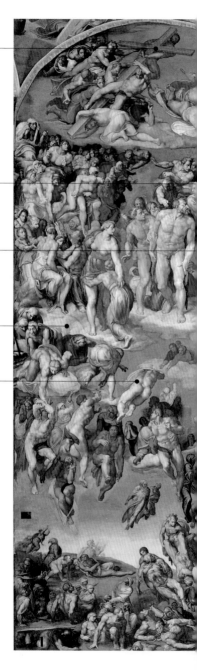

▶ Michelangelo, *The Last Judgment* (detail), 1537–41. Vatican City, Sistine Chapel.

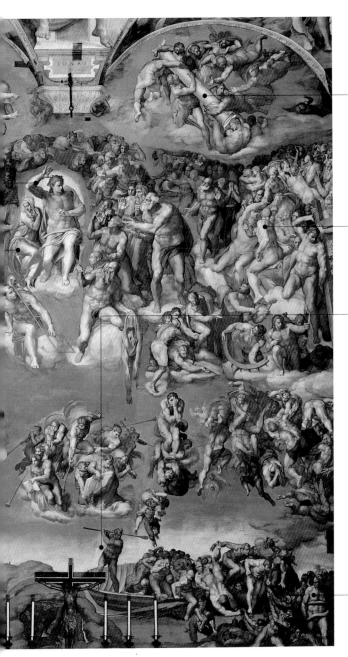

The column, associated with the flagellation, is an element of the Passion of Christ.

The group of the damned includes a number of famous sinners from Dante's Divine Comedy.

Charon ferries the souls of the dead to the gates of Hell.

Minos, the king of Crete, is represented as the judge of the dead. The snake wrapped around him determines, by the number of its coils, to which ring of Hell each damned soul is condemned.

It is represented by the symbol of the wheel, with the signs of the zodiac arranged in a circle.

The Zodiac

The zodiac, or "wheel of life," expresses a "qualitative" conception of time, in which the celestial orbs influence human existence. It is divided into twelve equal parts corresponding to the months of the year and the principal constellations that appear along the ecliptic. Early Christians tried to reconcile the astrological tradition of the past with the new religious orthodoxy, giving moralistic interpretations to many of the figures of the zodiac. Representations of the apostles or the prophets were placed alongside the mythological personifications of the constellations, and the figure of the Year, at the center of the celestial wheel, was replaced by Christ Chronocrator, who imposed a teleological, linear interpretation on the different symbols of time.

The zodiac appears as an iconographical motif most often in the Renaissance, in philosophical and moralizing representations of the horoscopes of great men. Among the most famous such renditions are the sphere of the *Farnese Atlas*; the Chapel of the Planets in the Tempio Malatestiano of Rimini; the fresco decorations of the Vatican apartments, by Pinturicchio (Hall of the Sybils), Raphael (Stanza della Segnatura), and Giovanni da Udine and Pierin del Vaga (Hall of the Pontiffs); Peruzzi's painting of the horoscope of Agostini Chigi in the Villa Farnesina in Rome; the Hall of the Winds in the Palazzo del Te at Mantua, frescoed by Giulio Romano; and Dürer's map of the heavens.

Derivation of the name
From the Greek *zoe*, meaning "life," and *diakos*, "wheel"

Origins of the symbol
It spread through the Mediterranean civilizations from the Chaldaeans to the Graeco-Roman world and represented the circular movement of the stars over the course of the year

Characteristics
Astrologers see a masculine (spiritual) element and a feminine (material) element in the zodiac, expressing the union of the vital principles and the affinity between the various parts of the cosmos. As a symbol of the year, it shows a man sitting at its center, holding the sun and moon

Related gods and symbols
Signs of the zodiac, wheel of fortune, seasons, months, hours, wind roses, cardinal points, the elements, the temperaments

▶ *Northern Hemisphere of the Zodiac*, miniature from the *Miscellanea Astronomica*, fifteenth century. Vatican City, Vatican Libraries.

The woman dressed in blue, holding the
celestial vault, is a personification of
Astronomy.

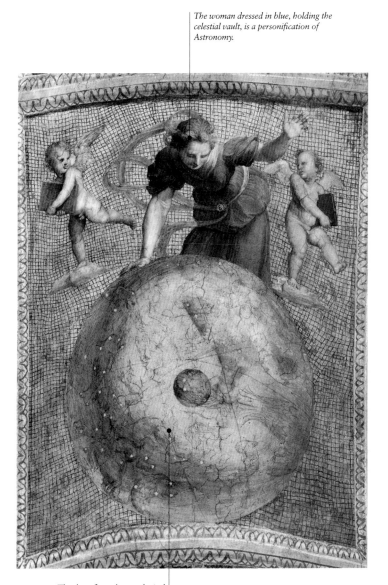

The sky reflects the astrological
configuration on October 31,
1503, the day Julius II
(Giuliano della Rovere) was
elected to the papal throne.

▲ Raphael, *Astronomy*, 1508.
Vatican City, Vatican Palaces,
Stanza della Segnatura.

They are represented as men and women of varying age, in the guise of Olympian gods or as the four sacred animals corresponding to the solstices and equinoxes.

The Seasons

The seasons cadence the fundamental moments of human life: birth (spring), maturity (summer), decline (autumn), and death (winter). They relate to the astrological tradition, in which the heavens directly influence the sublunar world. In the Orphic myths, the four animal heads of Eros-Phanes—ram, lion, bull, and snake—correspond to the four seasons. The Olympian myth of creation separated the four attributes of Phanes into individual deities, with Zeus corresponding to the ram, the sacred animal of spring; Helios to the lion (summer); Dionysus to the bull (autumn); and Hades to the snake, symbol of winter and of the life that is renewed through death. In the classical era the Greeks represented the seasons as four women, often featured on funerary monuments as symbols of the transience of human life. In medieval and Renaissance iconography they are represented by the agricultural labors associated with each season: sowing, mowing, harvesting, and hunting.

Derivation of the name
Old English *sesoun* from Old French *seson*, related to the Latin *satio*, "act of sowing"

Origins of the symbol
It derives from the division of the year at the spring and autumn equinoxes and the summer and winter solstices

Characteristics
The alternation of the seasons marks the rhythms of nature and life. The circle and the dance are symbols of eternal rebirth

Related gods and symbols
Spring: Eros-Phanes, Zeus (Jupiter), Hera (Juno), Kore, Persephone (Proserpina), Flora. Summer: Helios (Sun), Phoebus (Apollo), Demeter (Ceres), Pomona. Autumn: Dionysus (Bacchus), Vertumnus. Winter: Hades (Pluto), Hephaestus (Vulcan), Kronos (Saturn), Janus

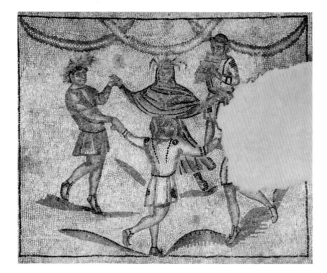

▶ *The Dance of the Seasons*, sixth century A.D. Ravenna, Museo Nazionale.

The kiss represents the union of day and night at the equinox.

Autumn, his head crowned with vine tendrils and ivy, is made to look like Bacchus.

Winter is personified by an old man, wrapped against the cold.

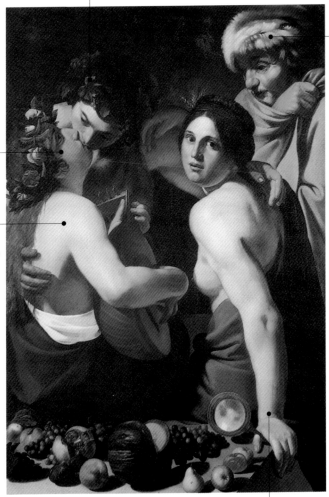

The figure of Spring is crowned with a garland of flowers.

▲ Bartolomeo Manfredi, *Allegory of the Seasons*, early seventeenth century. Dayton Art Institute.

Summer is represented as a radiant woman with bared breasts. Her attribute is a crown of wheat stalks.

Spring is represented as a young woman crowned with a garland of flowers, holding a budding twig in her hand.

Spring

Derivation of the name
The Old English word *spring* means "source" or "beginning" and as the "spring of the year" acquired its meaning as springtime

Characteristics
It is the first season of the year and represents the periodic rebirth of nature after "death" in winter. The ram is its symbol and Hermes its god

Related gods and symbols
Hera (Juno), Kore, Persephone (Proserpina), Flora, Hermes (Mercury), Aphrodite (Venus), Eros, Eos (Aurora); dawn, air, the sanguine temperament, childhood

Feasts and devotions
The Floralia, the Roman festivals celebrating the rebirth of nature, took place between April 28 and May 3; the *ver sacrum*, or "spring offering," a public vow pronounced by a magistrate on behalf of the people of Rome; Christian Easter

Spring is one of the most beloved of subjects in the Western mythological, literary, and iconographical repertory. It is the first season of the year and represents youth and gaiety. In the Christian interpretation, springtime rebirth becomes a symbol of human redemption. Easter, whose celebration dates back to ancient pagan rites, honors the resurrection of Christ as the victory of life over death. In Cesare Ripa's *Iconology*, the famous compendium of symbols for seventeenth-century painters, Spring is a young woman "of just stature, dressed on her right side in white, on her other side in black" (the two colors symbolize the dual nature of the season: goddess of self-renewing nature and of the dead); she is "girt in the middle with a rather broad sash, dark blue in color and with a number of stars in a circle" (symbol of the zodiac); "under her right arm she gracefully holds a ram, in her left hand, a bunch of diverse flowers, and has at her feet two little wings the color of her dress" (attributes likely inherited from the Greek god Hermes, who presides over the season).

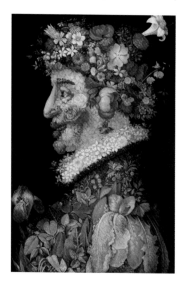

In ancient Greece, Spring was identified with Kore-Persephone (Proserpina); in Rome, with the Italic goddess Flora, symbol of nature's fertility and protectress of pregnant women. She is also represented by the seasonal agricultural labors, such as the June mowing of wheat.

▶ Giuseppe Arcimboldo, *Spring*, 1563. Madrid, Real Academia de Bellas Artes de San Fernando.

As the season of love, Spring is often accompanied by a swarm of cupids and images of embracing couples.

Flora is the goddess of springtime rebirth.

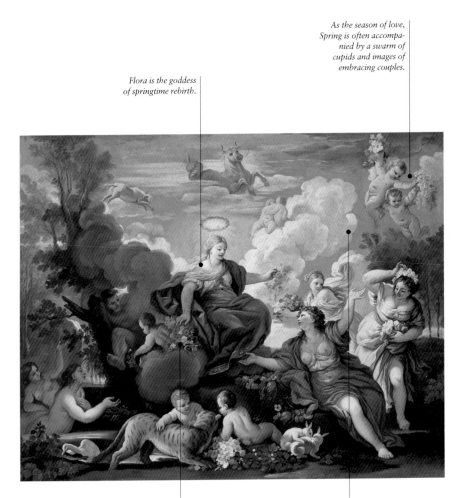

Spring is associated with the sanguine temperament, the airy element (usually represented by Zephyr, god of the winds), and the age of youth.

Flora is surrounded by flowers and shoots, symbols of the regeneration of nature after the repose of winter.

▲ Copy of Luca Giordano, *Triumph of Spring (Flora)*, seventeenth century. Milan, Civiche Raccolte del Castello Sforzesco.

Summer is represented as the goddess Ceres wearing a crown of wheat stalks and holding a torch.

Summer

The summer season, when the fruits of the earth ripen, is often represented as a bare-breasted woman accompanied by a number of distinguishing attributes: a stalk of grain, a burning torch, and a fruit-filled cornucopia. Her colors are yellow and gold.

In Greek mythology, the summer was identified with Demeter, goddess of the earth and agriculture. The goddess journeyed to the Underworld in search of her daughter Persephone, who had been abducted by Hades, god of the dead; this motif reflects Ceres' dual nature as bestower of abundance but also of drought.

During the Renaissance, in the complex system of correspondences between macrocosm and microcosm, the summer season was associated with fire, the choleric temperament, and the iconographic motif of the five senses. In Giuseppe Arcimboldo's famous cycles of the Seasons and the Elements, painted for Maximilian II von Habsburg between 1563 and 1566, the former are represented as anthropomorphic still lifes. Summer

Derivation of the name
From the Old English *sumor* and Old Frisian *sumur*, which share an ancient root with the Sanskrit *sama*, "half-year"

Characteristics
It is the second season of the year and represents the full manifestation of the sun's energy. Its symbols include the crown of wheat stalks, the scythe, and the dragon. It is sacred to Apollo, god of the sun

Related gods and symbols
Helios (Sun), Phoebus (Apollo), Demeter (Ceres); noon, fire, choleric temperament, maturity

Feasts and devotions
The Eleusinian mysteries, the Thesmophoriae in honor of Demeter, propitiatory rites for a fertile earth; St. John's day (June 24), which falls around the summer solstice

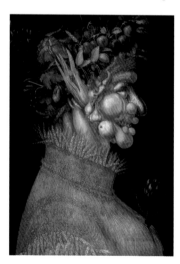

appears as a man in the flower of youth, laden with symbolic motifs related to sun worship and the cult of empire: the stalks of grain that make up his clothing, the artichoke, and ripe corn.

In Western iconography, this season can also be represented by its corresponding farm labors.

▶ Giuseppe Arcimboldo, *Summer*, 1563. Vienna, Kunsthistorisches Museum.

The warm tones, ranging from yellow to ochre, are typical of the summer season.

The cutting of the wheat normally occurs in late June, around the time of the summer solstice.

The theme of working in the fields is here combined with a celebration of rest. In his cycle of the Seasons, Bruegel presents a splendid slice of the peasant life of his time.

▲ Pieter Bruegel the Elder, *The Wheat Harvest*, 1565. New York, Metropolitan Museum.

The mirror, which represents sight, is half obscured, an allusion to the transience of beauty.

Peaches, a typical summer fruit, represent taste.

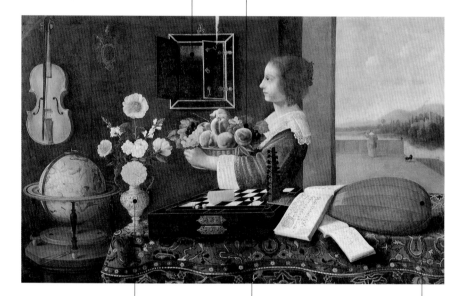

The chessboard and dice allude to touch.

The flowers refer to the sense of smell.

▲ Sebastian Stoskopff, *Summer* or *Allegory of the Five Senses*, 1633. Strasbourg, Musée de l'Oeuvre Notre-Dame.

The musical instruments and score refer to the sense of hearing.

It is represented as a virile, elderly man with winged feet, holding a cluster of grapes in his left hand. In his right hand is a balance (symbol of the autumn equinox), which weighs a white globe against a black one.

Autumn

Autumn is the time of the harvest, the reward for toiling in the fields and the fruit of human knowledge applied to the governance of nature.

It is the season of Dionysus, the god who presides over the cult of the vine in Europe, Asia, and North Africa. The vine was celebrated in the month of September, during the festive rites of the grape harvest. In antiquity another autumnal plant, also connected to Dionysus, was venerated: ivy, food of the Maenads. For the ancients, the myth of the god's death and rebirth expressed the correspondence between the equinoctial seasons of spring and autumn. In the Roman era, ivy stems were a source of dye, which was used to paint triumphant generals red: a symbol of victory over one's enemies and over death.

Artists have often used the image of the grape harvest to represent the fall season, associating the image of Dionysus with detailed portrayals of the harvest's various phases and the pressing of grapes. In Western iconography, the autumn landscape is sometimes used as an allegorical image of old age and the imminence of death (winter).

The personification of Autumn in Cesare Ripa's *Iconology* has several distinctive attributes, such as old age, a cluster of grapes, and a scale.

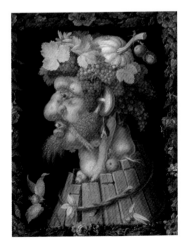

Derivation of the name
From the Latin *autumnus*, a term of Etruscan origin

Characteristics
It is the third season of the year. Its symbols are the cluster of grapes, the wine vat, the fruit basket, and the hare (an animal hunted during the month of November). It is a season sacred to Dionysus

Related gods and symbols
Dionysus (Bacchus), Vertumnus; twilight, earth, melancholic temperament, beginning of old age

Feasts and devotions
Dionysiac mysteries; the Roman Vertumnalia, which took place in late October to celebrate the transition from summer to fall

Giuseppe Arcimboldo, ◄ *Autumn*, 1573. Paris, Louvre.

The vats are used
to store must. It
will be used to
make the new
wine, symbol of
joy and springtime
rebirth.

In autumn the herds are brought
in from their summer pastures.

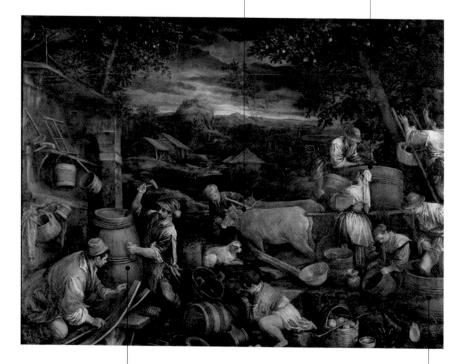

Peasants water-
proof the barrel
staves and use
hoops to prevent
the wood from
warping.

Autumn is represented by the
activities and labors related
to the wine harvest and the
pressing of grapes.

▲ Jacopo Bassano, *Autumn*, 1576.
Rome, Galleria Borghese.

The kiss exchanged
between Night and Day
symbolizes the equinox.

The dim light and
the image of the
astronomer observ-
ing the equinox are
an allegory of the
autumn season.

The sunset alludes
to old age and
decline, tradition-
ally associated with
autumn.

▲ Dominicus van Wijnen, *An
Astrologer Observing the Autumn
Equinox*, 1680. Warsaw, Muzeum
Narodowe.

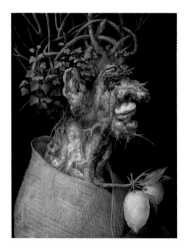

Winter is represented as an old man, either in a landscape of bare trees or shivering beneath a warm cloak.

Winter

Winter is the season of death and nature's annual rest. It is closely associated with subterranean principles of darkness and damp, represented iconographically by reptiles and amphibians such as snakes and salamanders.

The gods of winter are Saturn, the lord of time (who reigns over the signs of Capricorn and Aquarius), and two-faced Janus, the deity who consecrated the start of the Roman year (*caput anni*). As protector of the handicrafts practiced mostly during this part of the year, the god of fire, Hephaestus (Vulcan), was also associated with the winter season.

In Renaissance and Baroque iconography, winter is often represented by the myth of Proserpina's abduction by Pluto, or by images of manual labor and peasant life: hunting scenes, wood gathering, the slaughter of the pig. Giuseppe Arcimboldo associates his anthropomorphic rendition of winter (an allegorical portrayal of Maximilian II of Austria) with the watery element, the subterranean principle associated with the Realm of the Dead (the river Styx), and the primordial source of cosmic and earthly life (Oceanus and Neptune).

In the works of the German painter Caspar David Friedrich, which are imbued with a deep religious spirit, winter becomes a symbol of Christian faith and hope, represented by bare, snow-covered landscapes.

Derivation of the name
The English "winter" derives from the Old Norse *vetr*, from the Indo-European *wed-* or *wod-*, "to be wet"

Characteristics
It is the fourth season of the year. Its symbols are the snake and the salamander, and it is sacred to Hephaestus

Related gods and symbols
Kronos (Saturn), Hephaestus (Vulcan), Janus; night, water, phlegmatic temperament, old age, death, hours

Feasts and devotions
The Saturnalia, celebrations in honor of Saturn, were held December 17–19; the Roman New Year, devoted to Janus; Carnival, which celebrates the end of winter and the imminent return of spring

▶ Giuseppe Arcimboldo, *Winter*, 1563. Vienna, Kunsthistorisches Museum.

The fire and the vat allude to the slaughter of the pig.

This part of the canvas shows winter pastimes such as ice skating and ice bowling.

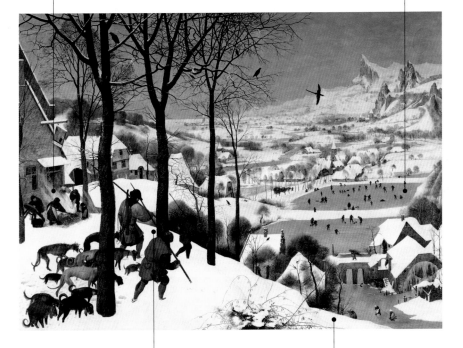

The color white, with its variations in the tones of ice, the gray-greens and brownish blacks, presents a vivid image of the harsh winter climate.

The return from the hunt represents the much-awaited rest of winter and corresponds to the sixth season of the Flemish calendar. In Flanders the solar year was divided into six distinct parts: the four traditional seasons, early spring, and late fall.

▲ Pieter Bruegel the Elder, *Hunters in the Snow*, 1565. Vienna, Kunsthistorisches Museum.

Saturn is approaching the temple of Janus, who will open the doors to the new year. To the god's traditional attribute, the cane, the artist has added a double face, turned at once to the past and the future.

▲ Antoine Caron, *The Triumph of Winter*, 1568–70. Paris, private collection.

At the head of the procession one recognizes Apollo, playing a kithara remodeled to sixteenth-century tastes; Mercury, with the caduceus, helmet, and winged sandals; and Minerva, with the Medusa's head mounted on her breastplate.

Winter is carried in triumph on a coach drawn by white birds.

Vulcan, god of fire, is traditionally associated with winter. Blacksmiths would practice their craft during this time of year, when the farms did not need their labor in the fields.

As a celestial transposition of the snake, the lightning bolt sheds light on Poussin's unusual decision to represent winter by means of the biblical story of the Great Flood.

The dim, veiled sun is a symbol of death.

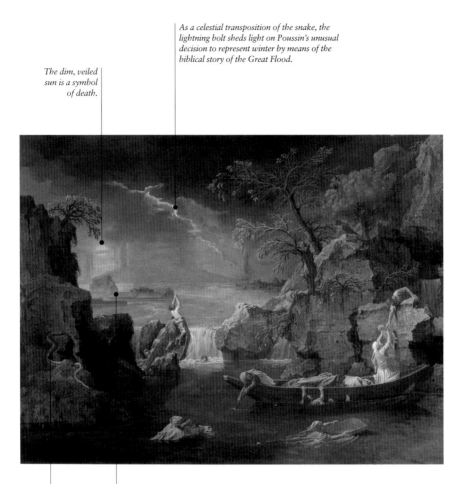

The ark alludes to the continuation of life beyond death.

The snake represents both the dark world of Hell and the regenerating power of nature.

▲ Nicolas Poussin, *Winter*, 1660–64. Paris, Louvre.

They are represented by allegorical personifications or images of agricultural labor and courtly amusements.

The Months

The iconography of the Months is related to that of the calendar and the zodiac. Each month has its corresponding planet and celestial deity, whose influence is manifested in nature and the different human temperaments. In their representations of the Months, medieval miniaturists have given us an extraordinary slice of feudal life, with detailed illustrations of period clothing, the amusements of the nobility, and the different types of farm labor, all of it cadenced by the cycles of nature and the succession of the seasons. The tasks of plowing, sowing, preparing the butter, mowing and harvesting grain, harvesting grapes, and gathering wood in winter—all reconstructed in realistic illustrations of the peasant world— alternate with an allegorical vision of court society and its favorite pastimes: banquets, jousts, courtship, wedding processions, and falconry.

During the Renaissance, representations of the Months became a starting point for the great revival of secular themes and symbols, drawn for the most part from classical culture. In Christian iconography, each month has its corresponding apostle or prophet. Among the most famous are the *Months* in the Palazzo della Ragione in Padua.

Derivation of the name
From the Old English–Old Frisian *monath* and Old Teutonic *maenoth*, which are related to the Teutonic *maenon*, which means "moon"

Origin of the symbol
The months derive from the subdivision of the solar year into twelve parts, first introduced by Julius Caesar in 46 B.C.

Characteristics
They measure the time the sun takes to pass through a given constellation. They are used in Romanesque art for didactic purposes, as symbols of man's redemption from original sin through labor

Related gods and symbols
Sun, moon; zodiac, the seasons, the crafts, the temperaments, the virtues

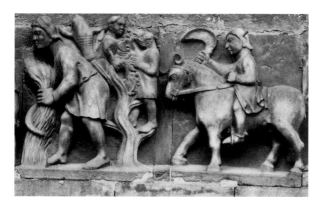

◀ School of Benedetto Antelami, *The Months* (detail), 1220–30. Cremona (Italy), cathedral.

The month of January is identified by the astrological symbols in the lunette: Capricorn and Aquarius. At the center of the semicircle is the chariot of the sun.

Written in Gothic script, the words "approche + approche" invite bystanders to come pay homage to the duke.

The figures in the foreground are servants of the court: the cupbearer, baker, and steward.

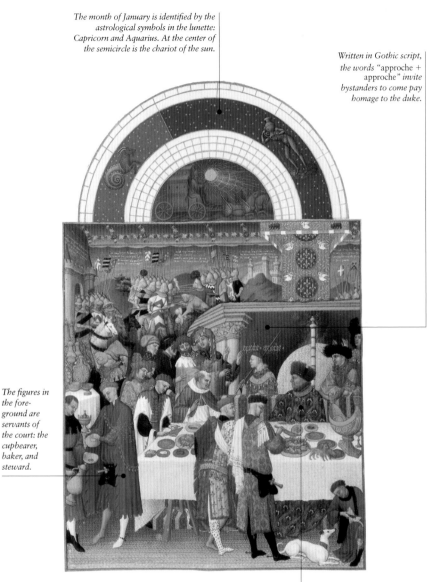

▲ Limbourg Brothers, *January*, illumination from *Les Très Riches Heures du duc de Berry*, ca. 1416. Chantilly, Musée Condé.

One usually paid homage to the feudal lord in the month of January.

In wintertime peasants would go
into town to sell wood and buy
provisions.

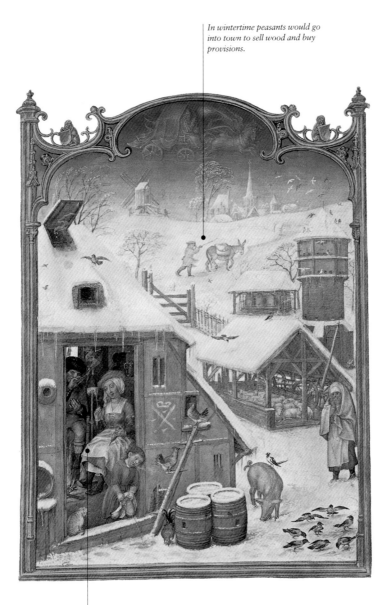

February is portrayed through the
depiction of a typical workday:
spinning, weaving, repairing tools,
and feeding the animals.

▲ *February*, illumination from the
Grimani Breviary, late fifteenth century.
Venice, Biblioteca Marciana.

Every month in this cycle indicates the sun's position on the left-hand side of the tapestry. The angle of the man's arm is based on the orb's position in the ecliptic and determines how the images are to be interpreted.

▲ Bramantino and Benedetto da Milano, *March*, from the *Trivulzio Tapestries of the Months*, 1504–9. Milan, Civiche Raccolte del Castello Sforzesco.

The central theme of the composition is the celebration of peace through the glorification of farm labor.

The sign of Aries, *drawn from the first printed edition of Hyginus's* Poetica astronomica, *presides astrologically over the latter part of March.*

The presence of soldiers alludes to Mars, the god of war, after whom the month is named.

The little bird is a very ancient symbol of spring, drawn from Ovid's Fasti.

March is personified by an allegorical figure celebrating the rebirth of nature in spring.

The inscription on the pedestal pays homage to the new year, which begins astrologically in March.

According to Marcus Manilius's Astronomica, *the treatise from late antiquity that served as the inspiration for this fresco cycle, each month has its corresponding patron god, who exerts a powerful influence over the inclinations and temperaments of those born under that sign.*

The god of war, Mars, kneels before Venus, symbolizing the retreat of the bellicose instincts in the face of love's power. The chain binding him to the goddess stands for the bonds of love.

The season of love is celebrated in April and May under the influence of Venus, the goddess of grace and beauty.

▶ Francesco del Cossa, *April*, 1469–70.
Ferrara (Italy), Palazzo Schifanoia.

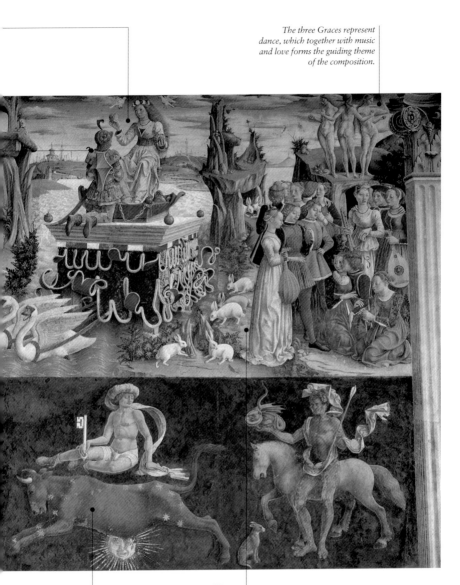

The three Graces represent dance, which together with music and love forms the guiding theme of the composition.

The sign of Taurus is accompanied by its "decani," each representing a period of ten days in the month.

The rabbits symbolize fertility, like the pomegranate bushes on the left side of the painting.

The sun is accompanied by the name of an astrological sign, in this case, Gemini.

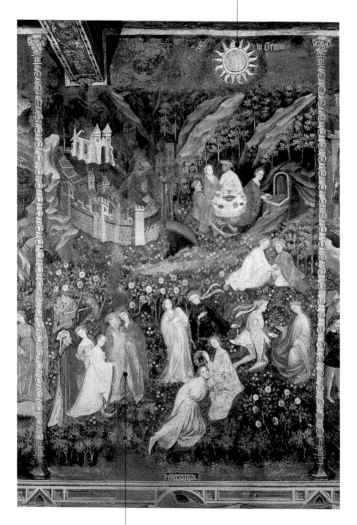

This depiction of the month of May features the theme of courtship, which takes place in a magnificent Garden of Love, lush with flowers and fragrant herbs.

▲ Master Wenceslaus, *May*, ca. 1400. Trento (Italy), Castello del Buonconsiglio.

The representations of Gemini and Virgo carry a hidden alchemical connotation: The former represent the union of opposites, the latter the process of albedo that yields a white, transforming elixir.

The god Hermes is patron of the month of June and the sign of Gemini. We recognize him by the caduceus, the sack, and his winged feet.

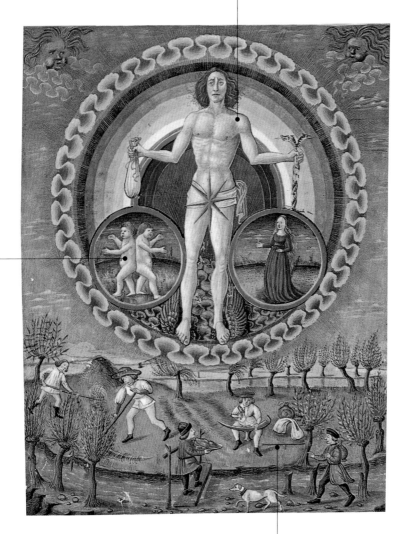

Wheat is typically harvested in June.

▲ *June*, miniature from *De sphaera*, second half of the fifteenth century. Modena (Italy), Biblioteca Estense.

A peasant is threshing his wheat, a task traditionally performed during this month.

The lion corresponds to the astrological sign of the latter part of July, Leo.

The sun is in Virgo during the month of August.

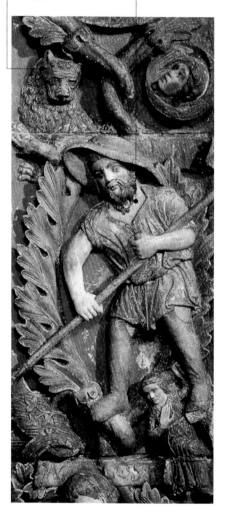

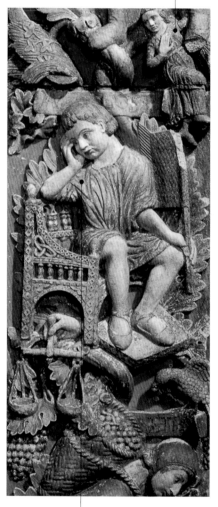

▲ *July* and *August*, thirteenth century. Venice, San Marco.

The boy resting his weary head evokes the lassitude of summer's dog days. The iconography closely follows the motif of melancholic lethargy.

September marks the grape harvest and the preparation of wine.

The sign of Scorpio identifies this figure as the month of October.

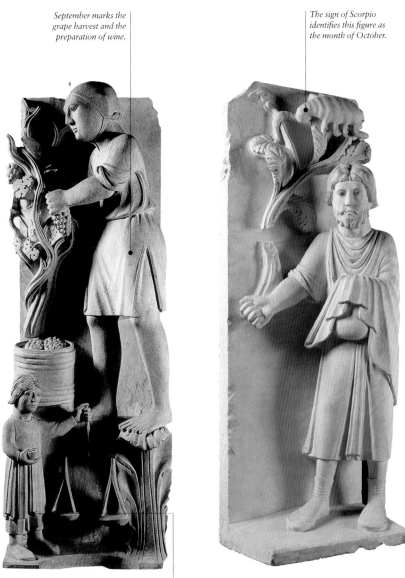

▲ Benedetto Antelami, *September* and *October*, early thirteenth century. Parma, baptistry.

The scale connotes the astrological sign of Libra, which corresponds to the month of September.

The painter represents November by means of the hare hunt, which took place at this time of the year.

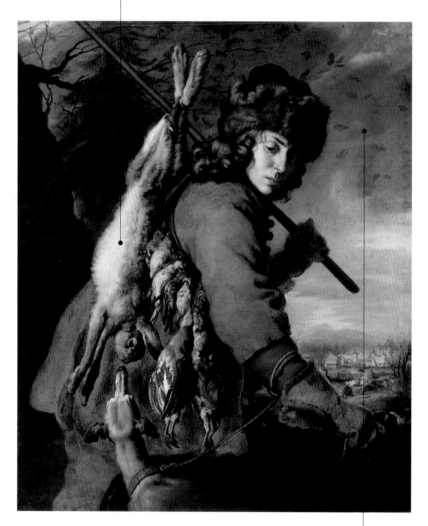

The leaden sky and falling leaves convey the gloomy weather of this time of the year.

▲ Joachim von Sandrart, *November*, 1643. Schlessheim, Staatsgalerie.

The sun in Sagittarius characterizes
the temperament of those born in the
last month of the year.

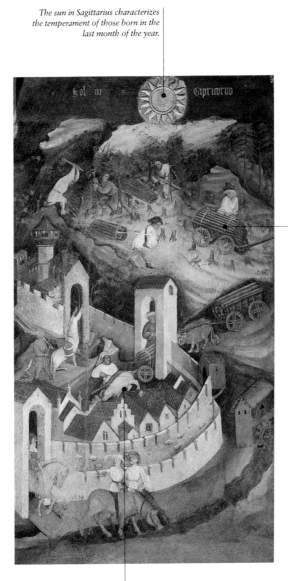

In depictions of
this month, figures
typically collect
wood in the forest
and transport it
into the city.

Pigs were usually slaughtered in December,
to provide abundant food for the winter.

▲ Master Wenceslaus, *December*,
ca. 1400. Trento (Italy), Castello del
Buonconsiglio.

She appears as an eternally young girl, dressed in light veils and holding a torch.

Dawn (Aurora)

Aurora, or the Dawn, precedes daylight, personified by her brother the Sun. She symbolizes hope and potential. The names Hemera (Day) and Hespera (Evening) express her different functions in the solar chariot's retinue. In the Christian religion, she stands for rebirth and spiritual enlightenment (the realm of the Holy Spirit) and is represented in the guise of the Christ child and the Virgin, symbols of the soul in its nascent state.

Aurora is one of the most important figures in the Hermetic tradition and corresponds to Wisdom (Sophia). The great alchemist Jakob Böhme, in his *Aurora*, likened it to the *rubedo*, the final, red stage of the alchemical Work: "The Aurora, at the summit of the *rubedo*, is the end of all darkness and the expulsion of night and that wintry time that sweeps up those who caress it without due caution." It is thus the cognitive ordering principle that brings an end to the ignorance of initiates and the putrefaction of matter. Also associated with Aurora are the river Acheron, the airy element, and the sanguine temperament. Like the aurora borealis, she is a personification of the Beyond.

Derivation of the name
From the Latin *aurora*, "dawn"

Origin of the symbol
In Greek mythology, Aurora (Eos) is the daughter of Hyperion and Theia

Characteristics
She is the light that spreads just before daybreak. She precedes the solar chariot and is accompanied by the morning star (Venus). Her tears are the source of dew

Religious and philosophical traditions
Gnosticism, Kabbalah, Hermeticism, alchemy

Related gods and symbols
Eos, Helios (Sun), Phoebus (Apollo), Hemera, Hespera, Christ child, the Virgin Mary; the Beyond, the river Acheron, air, spring, the sanguine temperament, childhood

▶ Louis Dorigny, *Allegory of the Dawn (Aurora)*, ca. 1685. Venice, Ca' Zenobio.

Aurora represents the victory of sunlight over the shadows of night and is portrayed as an eternally young girl dressed in diaphanous veils.

The lily is a symbol of pure, divine light.

The black sun (in total eclipse) alludes to the darkness of night and death.

▲ Philipp Otto Runge, *Morning* (first version), 1808. Hamburg, Kunsthalle.

The groups of children are an allegory of the Trinity.

Helios is portrayed driv-
ing the solar chariot.

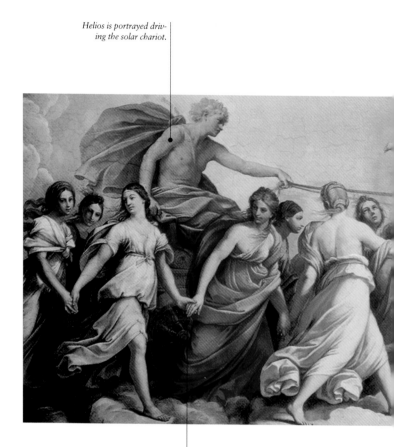

The girls holding hands are
the Hours, goddesses who
set the rhythm of human
activity and personify the
humidity of the sky.

▲ Guido Reni, *Dawn (Aurora)*,
1612–14. Rome, Palazzo Rospigliosi
Pallavicini.

The burning torch is a symbol of Eosphorus, the morning star, also known by the name of Lucifer ("he who brings light").

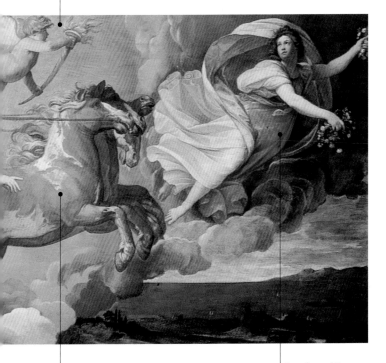

Rosy-fingered Dawn (Aurora) precedes the chariot of the Sun. This iconography is derived from the Iliad.

The team of four horses represents the four seasons.

Noon

It is the symbol of light at its physical and spiritual peak and is represented as the instant when all nature halts and falls silent.

Derivation of the name
From the Old English and Old Norse *nón*, "noon"

Origin of the symbol
It derives from the position of the sun at its zenith

Characteristics
It is the fleeting moment when nature stops, giving way to a magical, ecstatic dimension of time

Religious and philosophical traditions
Kabbalah, Hermeticism, alchemy

Related gods and symbols
Helios (Sun), Phoebus (Apollo), Zeus (Jupiter), Pan, Christ-Sun, Satan; the river Phlegethon, fire, summer, the choleric temperament, youth, sloth

Noon has a two-fold aspect: It is the hour of divine inspiration and mystical union in which the full symbolic power of the Christ-Sun becomes manifest, and it is also the moment of epiphany of the midday demon, the fantastical personification of the deadly sin of sloth. In the Middle Ages, the demon was identified with the Greek god Pan, the expression of demonic forces and panic. Noontime, when the sun is at its zenith (its highest point over the earth), is also a symbol of eternity, represented by the total absence of change and imperfection (shadow).

In Renaissance art, Day is represented as a strong, virile man, symbol of the full manifestation of the sun's energy, which dispenses strength and vitality. A famous example of this iconographical motif appears in the Medici Tombs designed by Michelangelo in San Lorenzo in Florence.

The day is associated with the fiery element, the choleric temperament, and the Phlegethon (one of the four rivers in the Underworld).

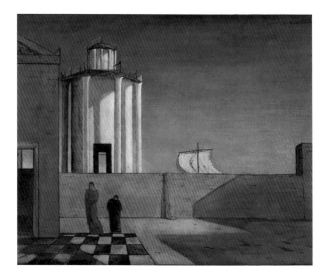

▶ Giorgio de Chirico, *Enigma of the Arrival and the Afternoon*, 1911–12. Private collection.

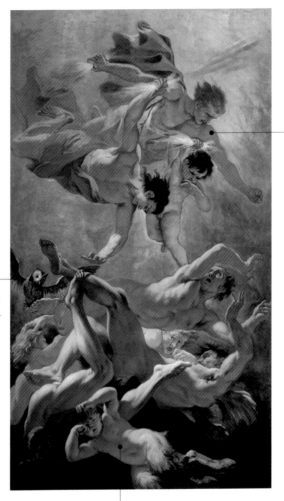

The Olympian solar gods are banishing the demons with beams of bright light.

The owl, an attribute of Night, accompanies the personifications of nightmares.

The god Pan is represented as a young satyr waking from sleep.

▲ Sebastiano Ricci, *Allegory of the Day: Noon*, ca. 1696–1704. Venice, Fondazione Querini-Stampalia.

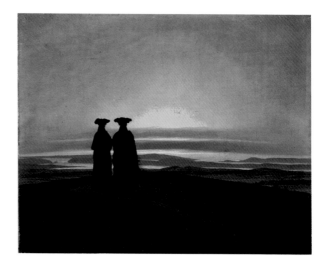

The passage from daylight to nighttime darkness has often been represented as a symbol of inner reflection or as an allegory of old age.

Twilight

Derivation of the name
From Middle English *twye lyghte*, the "between light"

Origin of the symbol
It derives from the position of the sun after sunset

Characteristics
The sunset, like the moonrise, marks the passage from the diurnal energies (which are solar and life-giving) to the lunar, death-dealing forces that inhabit the realm of the night

Related gods and symbols
Helios (Sun), Hespera, Christ; the river Styx, earth, autumn, the melancholic temperament, old age, flame

It is the best moment of the day for reflection and is often used as a metaphor for the passage of time and the exhaustion of creativity. Like many symbolic moments, Twilight has a dual aspect: It can be likened to old age and the imminence of death and oblivion, or it can represent very intense emotions and sentiments, such as nostalgia.

In Renaissance art, Twilight is portrayed as a hoary old man and juxtaposed with the virgin Aurora. This representation derives from the classical myth of Eos and Tithonus, to whom the gods granted immortality but not eternal youth. As an iconographical motif, the sunset is charged with symbolic meanings, especially from the Romantic period onward, when it becomes a veritable "passage of the soul." Romantic painters used flaming skies to accentuate the emotional force of the scene depicted, sometimes as an image of the power of God (in Friedrich) or as a symbol of the tragic nature of human destiny (in Turner).

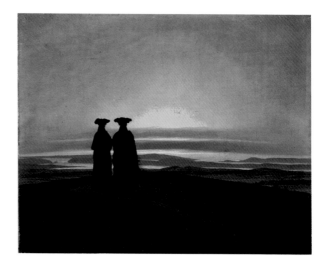

▶ Caspar David Friedrich, *Landscape at Sunset with Two Figures*, 1830–35. St. Petersburg, Hermitage.

*Evening is shown riding
the chariot of the sun, get-
ting ready to streak
through the sky.*

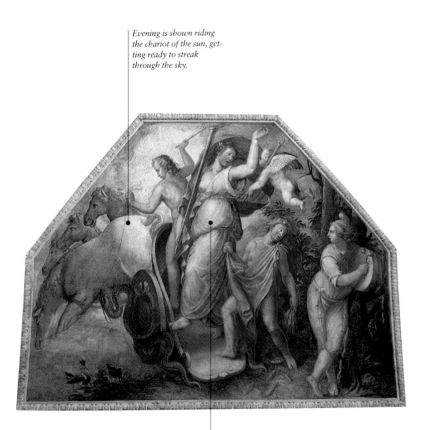

*In Greek mythology, the onset of
evening was personified by the
goddess Hespera, the nocturnal
face of Eos (Aurora).*

▲ Camillo, Cesare, and Sebastiano
Filippi, *Sunset*, detail of the Sala
dell'Aurora, second half of the sixteenth
century. Ferrara, Castello Estense.

Night

Night is sometimes portrayed riding in the celestial chariot, drawn by four black horses, in a dress embroidered with stars, or immersed in sleep and accompanied by her attributes, the owl and the moon.

Derivation of the name
From the Old English *niht (nyht)* and Old Saxon *naht*, with older roots in the Latin *nox (noct-)*, the Greek *nykt-*, and the Sanskrit *nákta (nákti)*

Origin of the symbol
According to the *Orphic Hymns*, Night is the primordial mother of the cosmic principles

Characteristics
Night precedes Day, whose future manifestations she prepares. In her course across the sky, she is accompanied by her daughters, the Furies and the Fates

Religious and philosophical traditions
Orphism, Neoplatonism, occultism

Related gods and symbols
Chaos, Eros-Phanes, Uranus, Gaea, Luna, Leda, Hecate Trivia; Cocytus, water, winter, the phlegmatic and melancholic temperaments, life, death

Night is the primordial Mother, source of all cosmic beginnings. According to the *Orphic Hymns*, she joined with the wind and laid a silvery egg (the moon), out of which was born Eros-Phanes, the desire that propels the universe. Sky, Earth, Sleep, and Death are considered her children. As the universal womb, Night is linked to the watery element and the world underground, where seeds germinate. Because of these qualities, it is the wellspring of possibilities, which are only fully realized in the light of day. In ancient art, Night is portrayed as a woman wrapped in a black veil and surrounded by sleep-inducing poppies. Night also represents the dimension of dream and Eros and is the portal to the realm of fantasy and the occult. For this reason, it is associated with the goddess Hecate and the "Bog of Tears," the Cocytus of Virgil and Dante.

The Christian motif of "Holy Night" is another iconographic and symbolic interpretation of the same subject.

▶ Gaetano Previati, *Day Awakens Night*, 1898–1905. Trieste (Italy), Museo Revoltella.

In the Renaissance, especially
in the intellectual milieu of
Florentine Neoplatonism,
Night recovers her attributes
as primordial Mother and is
associated with the mytho-
logical figure of Leda.

The goddess's position, with her
head resting on her hand, expresses
Night's kinship to the melancholic
temperament.

According to the Orphic and
Pythagorean doctrines, Leda and
Night are the personification of a
dualistic theory of death, in which
joy and pain coincide.

The owl and poppies are
symbols of Death and Sleep,
twin children of Night.

▲ Michelangelo, *Night*, 1520–34.
Florence, San Lorenzo, Sacrestia
Nuova.

The cities ablaze in the background, and the painting's overall atmosphere, are drawn from a famous print by Marcantonio Raimondi.

The monstrous creatures, personifications of Nightmare, are drawn from Lucian's True History.

▲ Battista Dossi, *Night* (or *Dream*), 1544. Dresden, Gemäldegalerie.

The twig held by Sleep is
imbued with water from
Lethe, one of the four rivers
of the Underworld, which has
mythical sedative properties.

Sleep, child of Night and guardian of her repose, is
shown putting his mother to sleep. His image is based
on a passage in the Thebaid of Statius.

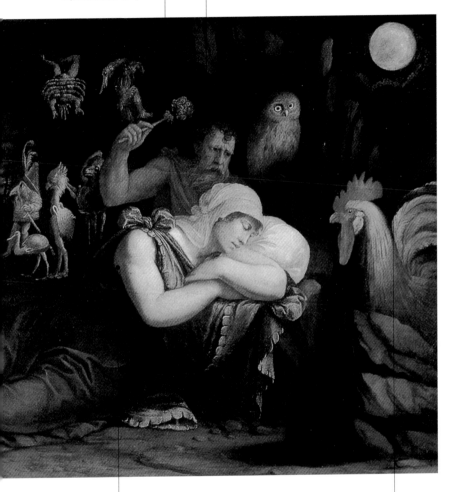

The scene is based on the
theme of the "House of
Sleep," as evoked by Ovid
in the Metamorphoses.

During the day, Night rests in a cave in the
far west, watched over by the animals and
deities that make up her retinue: the
rooster, the owl, the moon, and Sleep.

Night

Poppies, with their pro-
nounced sedative effect, are
an attribute of the goddess.

The Moon is one of
the daughters of
Night.

The bat and the
owl are animals
sacred to Night.

The woman with
breasts bared is
Night, covering
the sleeping Dawn
with her cape.

The Dawn (Aurora) is
identified by the bunch of
roses in her hand.

▲ Giovanni Mannozzi, *Night with
Dawn and Cupid*, 1635. Florence,
Museo Bardini.

Night is represented as a protective power, and her cloak of darkness serves to emphasize the salutary light emanating from the Christ child and the heavenly realm.

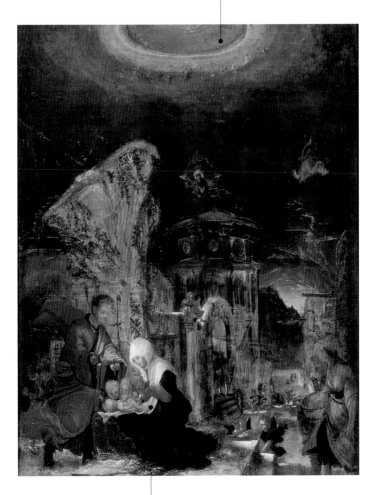

The artist presents the darkness of night as propitious to meditation and the celebration of the glory of the Lord.

▲ Albrecht Altdorfer, *Holy Night*, 1520. Vienna, Kunsthistorisches Museum.

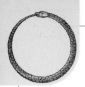

They are represented as twelve girls dancing around the chariot of the Sun or in Aurora's retinue.

The Hours

In the ancient division of the year into three parts, the Hours represent spring, summer, and winter. In classical Greece, they were identified as Thallo (blossoming), Auxo (growth), and Carpus (the ripe fruit), and they were assigned, together with the three Graces, to the retinues of Aphrodite and Hera. The dance of the Hours, like that of Life, reflects the cyclical concept of life widespread among the ancients and symbolizes the periodic rebirth of nature.

The Hours are traditionally portrayed as twelve girls in the retinue of Helios and Apollo, and their task is to harness the horses to the solar chariot. In Christian iconography their place around the divine mandorla is taken by the angels (the red seraphim and blue cherubim). For the Gnostics, the twelve hours of the day, which rotate around the Christ-Sun, correspond to the twelve apostles. To the Renaissance mind, the four main subdivisions of the day become an allegory of the natural realm and, as such, occupy a middle zone between the subterranean world and the celestial spheres. This middle position is reflected in the primary function assigned them by Michelangelo: designating the destructive power of time in the world.

Derivation of the name
From the Greek *horai* (*horae* in Latin)

Origin of the symbol
The Hours date back to the cult of the seasons in the ancient triadic subdivision of the solar year

Characteristics
They mark the divisions of the day and set the rhythm of human activities. They personify the humidity of the sky and the cosmic forces. Because of their ordering quality, Hesiod identified them with Good Order (Eunomia), Justice (Dike), and Peace (Eirene)

Related gods and symbols
Zeus (Jupiter), Themis, Helios (Sun), Phoebus (Apollo), Eos (Dawn), Aphrodite (Venus), Hera (Juno), Persephone (Proserpina); the seasons

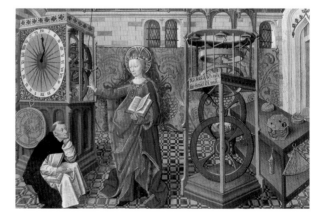

▶ *The Virgin Mary and a Clockmaker Monk*, illumination from a fifteenth-century book of hours. Brussels, Bibliothèque Royale Albert 1er.

*The six girls personify
the various activities of
the day, from waking to
sleeping.*

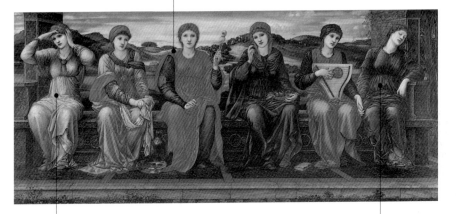

*The last girl, shown sleep-
ing, holds hands with her
sister, who is devoted to
such evening activities as
music and entertainment.*

*The first hour of the
morning is shown
waking up, setting the
tone for the activities
that will mark the day.*

▲ Edward Burne-Jones, *The Hours*,
1870–82. Sheffield, Sheffield City Art
Galleries.

The mechanical watch and industrious ants symbolize an active and perfectly functioning memory.

The elongated head represents Sleep, which confuses and falsifies the mechanisms of memory.

The flaccid watches allude to the dross and imprecision of the mnemonic system, especially as they are manifest in sleep.

▲ Salvador Dalí, *The Persistence of Memory*, 1931. New York, Museum of Modern Art.

It is represented by circular forms such as the dance, by branching forms such as the tree, or by the theme of human destiny personified by the three Fates.

Life

Every symbol related to the periodic renewal of nature and the creation of the elements (both material and spiritual) is connected to the image of life. Water, the source, the egg, the tree, the dance, and the wheel are among its most important representations. Christianity replaces the cyclical notion of existence with a teleological notion of life's processes (both human and cosmic), in which all these processes result in either salvation or eternal damnation.

In the classical tradition, the destiny and length of human life were personified by the three Fates, or Parcae, who were portrayed as three women weaving. The theme of the "dance of life"—closely related to cosmogonic rituals that re-enact the stages of the world's creation—recurs frequently in Western iconography from antiquity to the present day. We see examples in the dance of the maidens on the ancient *Ara Pacis* in Rome, in Pieter Bruegel the Elder's *Dance of the Peasants*, in Canova's *The Three Graces, Venus, and Mars*, and in Matisse's *The Dance*. In the medieval image of the *danse macabre*, the ceaseless rhythm that characterizes the circle of life in ancient and classical symbolism is turned on its head.

Derivation of the name
From Old English *lif*, corresponding to the Old Frisian *lif*, meaning "life," "person," or "body"

Origin of the symbol
It derives from nature's cyclical renewal through the alternating phases of birth, death, and rebirth

Characteristics
It represents the cosmic principle of perpetual generation and evolution, and indicates the period of time between birth and death

Related gods and symbols
Mother Earth, Night, Eros-Phanes, the Moirai or Fates (Parcae), Christ; the seasons, wheel, dance, tree, source, egg, death

◀ Frantisek Kupka, *The Beginning of Life*, 1900–1903. Paris, Musée National d'Art Moderne, Centre Georges Pompidou.

Two-headed Janus represents the two great divisions of time: the past and youth, and the future and old age.

Escorted by the Hours and preceded by Aurora, Apollo rides in triumph on the chariot of the Sun.

The young man and three girls have been interpreted as the four seasons.

The soap bubbles symbolize the fleeting nature of earthly existence.

The dance expresses the circular conception of cosmic time, marked by the perpetual cycle of the seasons.

Time sets the rhythms of life to the sound of a zither.

The hourglass is a classic attribute of Time and alludes to its inexorable passing.

◀ Nicolas Poussin, *The Dance of Human Life*, 1638–40. London, Wallace Collection.

In classical tradition, the course of a human life was personified by the Moirai or Fates (also called Parcae), who spun (Clotho), measured (Lachesis), and cut (Atropos) the thread of existence.

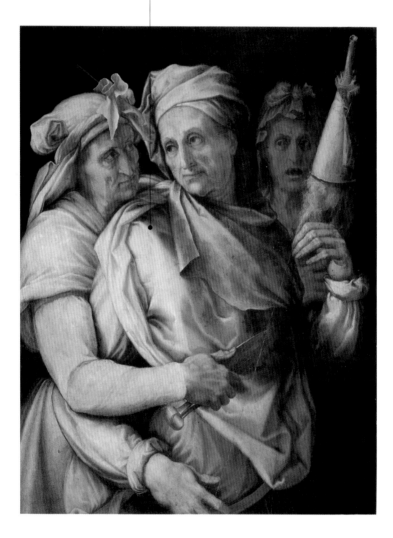

▲ Francesco Salviati, *The Three Fates*, ca. 1545. Florence, Galleria Palatina, Palazzo Pitti.

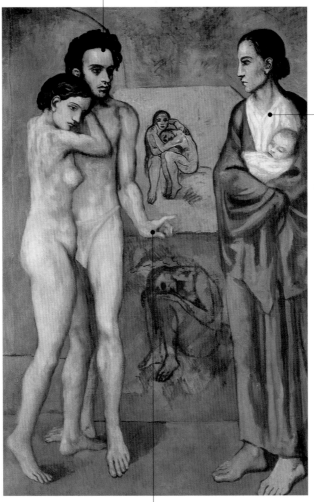

▲ Pablo Picasso, *La Vie*, ca. 1903.
Cleveland, Museum of Art.

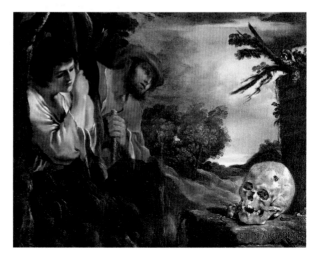

Death

It appears as a skeleton holding a scythe and an hourglass or kissing a girl. It can also assume the form of a solitary horseman or a shadow.

Derivation of the name
From Old English *déath* and Old Frisian *dâth* or *dâd*

Origin of the symbol
In Greek mythology, Death is the daughter of primordial Night

Characteristics
It represents a fundamental stage in spiritual evolution

Religious and philosophical traditions
Dionysian mysteries, Orphism, Kabbalah, Christianity, alchemy

Related gods and symbols
Mother Earth, Night, Thanatos, Eros-Phanes, Time, Kronos (Saturn), Dionysus (Bacchus), Hades (Pluto), Persephone (Proserpina), Phoebus (Apollo), Artemis (Diana), Athena (Minerva), Aphrodite (Venus), Ares (Mars), Orpheus; winter, life

Death represents the end of the life force, as well as the inescapability of human fate. Like all the other major archetypes, it is an ambivalent symbol that lends itself to a wide variety of representations. As the daughter of Night and sister of Sleep, Death also has the power of regeneration.

In the tradition of the Dionysian mysteries, its dual function is associated with rites of initiation and passage: "Dying meant being loved by a god and participating through him in eternal beatitude" (Edgar Wind). For Christians, it is a fundamental dynamic principle, without which eternal life and resurrection would not be possible.

One of the most celebrated images of death is that of the "kiss of death," or *mors osculi*, caused by the breath of God. This ecstatic death, which mystics and biblical exegetes compared to the joys of love, has been represented in mythological form by the motif of amorous encounters with gods, such as Diana with Endymion, Jupiter with Ganymede, and Mars with Rhea.

▶ Guercino, *"Et in Arcadia Ego,"* 1618. Rome, Galleria Nazionale d'Arte Antica, Palazzo Barberini.

Death with his hourglass
shows the knight that his
last hour is approaching.

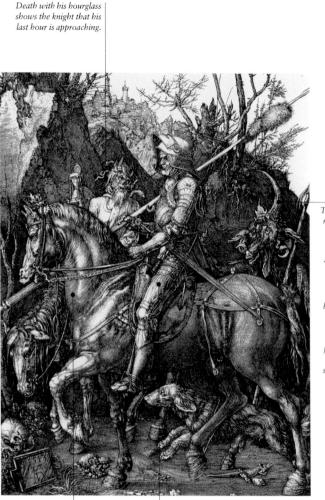

The horselike
monster per-
sonifies the
nightmare.
The word
"nightmare"
and the
French
cauchemar
both contain
the suffix
mar, *which
suggests a
female horse
and has the
same ancient
roots as the
Latin word
for death,
mors.*

The theme of the solitary
horseman alludes to the jour-
ney to the Underworld.

The symbolism of the
horse is two-fold: It has a
solar, celestial aspect asso-
ciated with vital energy
and the heavens, as well
as a subterranean, deathly
aspect, related to the
moon and to water.

▲ Albrecht Dürer, *The Knight, Death,
and the Devil*, engraving, 1513.

Death

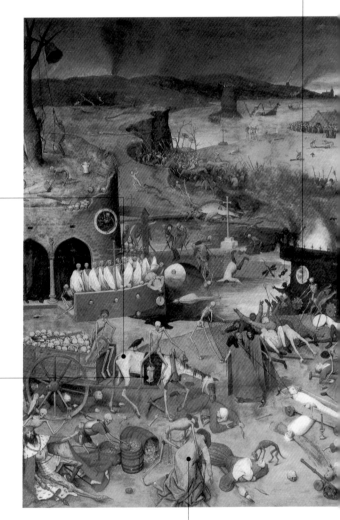

The scythe is a principal attribute of Death, here represented as a leering skeleton who mocks human frailty.

In Anglo-Saxon and Germanic folklore, the pale horse is the steed of Death.

The hourglass is associated with the passage of time, the seasons, and the transience of life.

The figures of the cardinal, the peasant, and the emperor derive from the iconography of the danse macabre.

Many kinds of death are represented here: death by violence; public executions; and accidental death, including drowning.

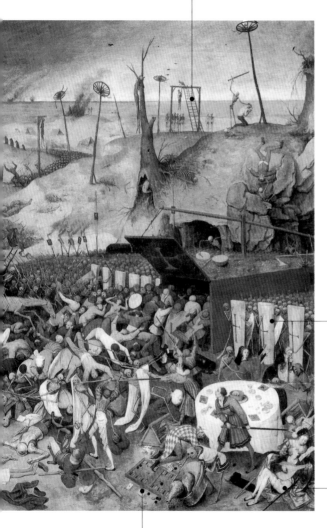

The battalions of skeletons in close ranks advance against the living.

The loving couple absorbed in song seems oblivious to the destiny gathering behind them.

The overturned backgammon board, symbolizing games of chance, is a recurrent motif in allegories of human destiny.

▲ Pieter Bruegel the Elder, *The Triumph of Death*, ca. 1562. Madrid, Prado.

Dancing skeletons surge
through forests and villages,
sowing terror among the people.

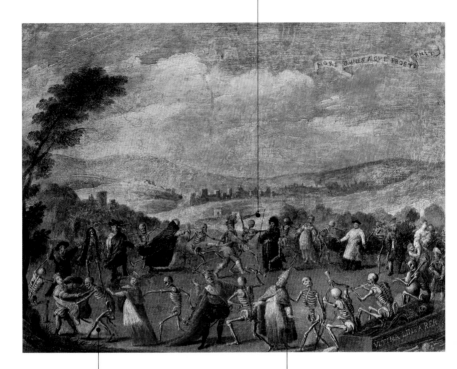

The circular dance, recalling
ancient symbols of life, is
here inverted and parodied
in the terrifying image of the
danse macabre.

Death represents the principle of equality.
It makes no distinctions among the social
classes, indiscriminately striking down
every rank and age: popes, emperors, the
bourgeoisie, peasants, nobles, and clerics.

▲ Anonymous, *Danse Macabre*,
seventeenth century. Milan,
Pinacoteca dell'Arcivescovato.

The motif of the skeleton kissing a young woman is used to represent Death.

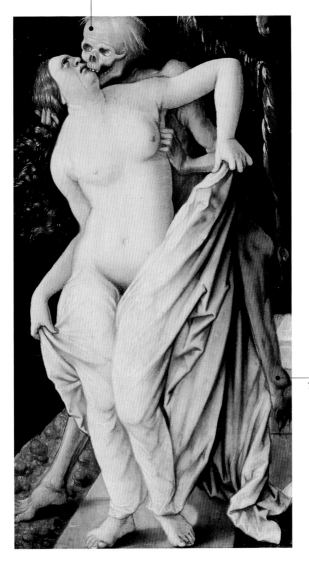

The cloven hoof is a traditional attribute of Death.

▲ Hans Baldung Grien, *Death and the Maiden*, 1517. Basel, Kunstmuseum.

The idealized portrait of Simonetta Vespucci as
Proserpina, queen of the Underworld, faithfully
follows the iconography of the pagan mysteries
linked to the cult of the Afterlife.

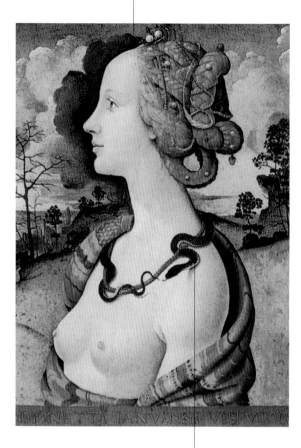

The snake alludes to the girl's hopes for
resurrection. She died prematurely of
consumption at the age of twenty-three.

▲ Piero di Cosimo, *Portrait of
Simonetta Vespucci*, ca. 1520.
Chantilly, Musée Condé.

The moon, personified by the goddess Diana, is one of Death's many faces. Its ghostly surface was considered the entrance to the Realm of the Dead.

Endymion's eternal sleep invokes the theme of ecstatic death, which mystics likened to the joys of love.

▲ Pier Francesco Mola, *The Sleep of Endymion*, ca. 1660. Rome, Pinacoteca Capitolina.

They represent the different phases of human civilization, as they evolved and were understood in mythology and religion.

The Ages of the World

Origin of the symbols
They derive from the myth of Saturn and the image of a happy age when decay and death did not exist. With the advent of Christianity, this myth becomes merged with the image of the Garden of Eden (Paradise Lost), symbol of the human condition before Original Sin

Related gods and symbols
Hephaestus (Vulcan), Diony-sus (Bacchus), Prometheus, God the Father, Christ, the Holy Spirit; time, the seasons, life, death, Atlantis, Garden of Eden, the ages of man

In the classical tradition, as codified in Hesiod's *Theogony*, human history consists of four great ages, each corresponding to a metal. The different eras are ordered chronologically from the original state of perfection (the golden age) to the state of decadence and unhappiness (the iron age). This hierarchy closely follows the division of the cosmos into other four-part systems: the four cardinal points, the seasons, and the ages of man.

Alongside this religiously oriented doctrine, the natural philosophers from Epicurus to Lucretius developed an alternative conception of the growth of civilization, in which progress was guided not by a divine presence but by the natural evolution of the race after the discovery of fire. The painting cycles of Piero di Cosimo and the Renaissance illustrations of the treatises of Vitruvius and Philaretes are based on this concept.

According to the Christian mystics, historical time divides into six ages: Lucifer reigns over the first five, which run from Adam to the birth of Christ, while the sixth, illuminated by the grace of God, is the reign of eternal salvation. Both readings of human history associate the conquest of progress with the theme of sacrifice, represented by the punishment of Prometheus and the crucifixion of Jesus Christ.

▶ *Cosmic Time Surrounded by the Six Ages of the World*, from the *Liber floridus* of Lambert of Saint Omer, ca. 1120. Wolfenbüttel, Herzog August Bibliothek.

Saturn, lord of the golden age, is portrayed with his head covered and the inevitable scythe or crutch.

Figures endowed with flowers and earthly delights allude to the plentiful harvests and the fertility of nature during the reign of Saturn.

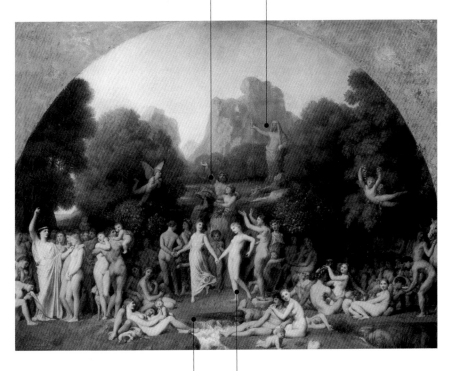

The stream represents the source of life. Its miraculous waters bestow eternal youth on mankind.

The circle of girls dancing to the panpipes symbolizes the change of the seasons and the circle of life.

▲ Jean-Auguste-Dominique Ingres,
The Golden Age, 1862. Cambridge,
Mass., Fogg Art Museum.

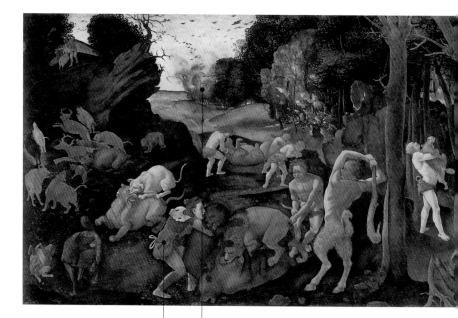

There is no psychological or behavioral distinction between the wild beasts, the mythological satyrs and centaurs, and primitive man.

Fire, not yet harnessed by man, spreads destruction across the fields and through the woods.

The sow with a woman's face and the goat with a man's features are the legacy of mankind's coupling with beasts in the stone age.

▲ Piero di Cosimo, *A Hunting Scene* (Caccia Primitiva), ca. 1500. New York, Metropolitan Museum.

▶ Piero di Cosimo, *The Forest Fire*, ca. 1500. Oxford, Ashmolean Museum.

This image represents the stone age, a time when the metal-forging power and energy of fire had not yet been discovered.

The presence of the shepherd and the wooden cottage indicate the passage from the stone age to the iron age, marked by the introduction of agriculture and the ability to control spontaneous fires.

They are represented by three-faced heads or by men and women at different stages of life, often shown in amorous poses.

The Ages of Man

Renaissance painting witnessed the emergence of a theme that would become very popular in intellectual circles of the period: the ages of human life represented in allegorical scenes or triple portraits. This iconographic motif, closely tied to the theme of the seasons and the elements, served a pedagogical and moral purpose within the complex spiritual education reserved for the courtiers and princes of the age. The subject is often represented by loving couples set in a landscape. The use of couples to illustrate the seasons of human life derives from a very ancient tripartite schema: the riddle of the sphinx, deciphered by Oedipus, concerning the three ages of man—childhood, youth, and old age.

Medieval Christian mystics associated the ages of man with the ages of the world: the age of the Father, characterized by the fear of God, corresponds to the Old Testament; the age of the Son coincides with the era of wisdom and the foundation of the Church; and the age of the Holy Spirit is the reign of joy and freedom.

Origin of the symbols
They are related to the cycle of the seasons, to the death and rebirth of nature, and the inescapability of human fate

Characteristics
They symbolize the attainment of spiritual equilibrium through the passage of time

Related gods and symbols
Time, the seasons, the elements, life, death, *Vanitas*, the ages of the world

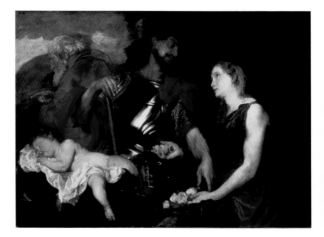

► Anthony van Dyck, *The Ages of Man*, 1625–27. Vicenza (Italy), Musei Civici, Palazzo Chiericati.

*The solitary old man is
holding two skulls, one for
time past, the other for the
fate that awaits him.*

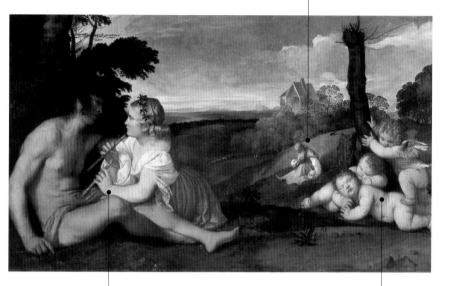

*Youth is represented by a
happy young couple. This
painting has been interpreted
as both an allegory of the
three ages of man and a rep-
resentation of the myth of
Daphnis and Chloe.*

*The pair of toddlers
sleeping under Cupid's
protective wings alludes
to childhood and the age
of innocence.*

▲ Titian, *The Three Ages of Man*,
ca. 1512. Edinburgh, National Gallery
of Scotland.

The man seen from behind represents old age.

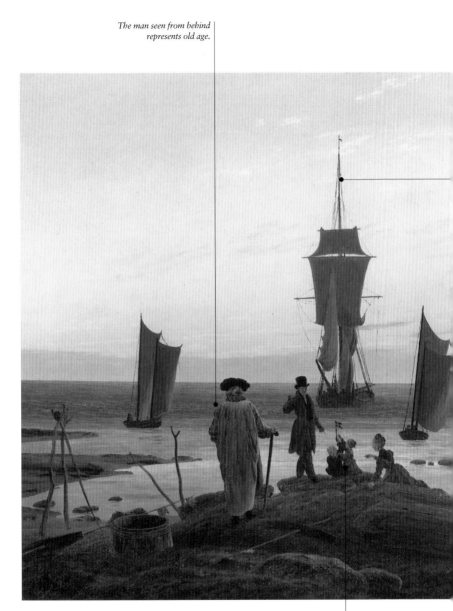

The age of childhood is placed at the center of the composition as a symbol of joy, happiness, and hope.

The boat spreads its sails protectively over the children playing on the beach. It represents hope, the infinite potential for realization that life has to offer.

The ships on the horizon symbolize the journey to the next world.

The profile of the overturned boat is reminiscent of a coffin. The fact that it is pointing toward the old gentleman is probably an allusion to the imminence of death.

◄ Caspar David Friedrich, *The Ages of Man*, ca. 1835. Leipzig, Museum der Bildenden Künste.

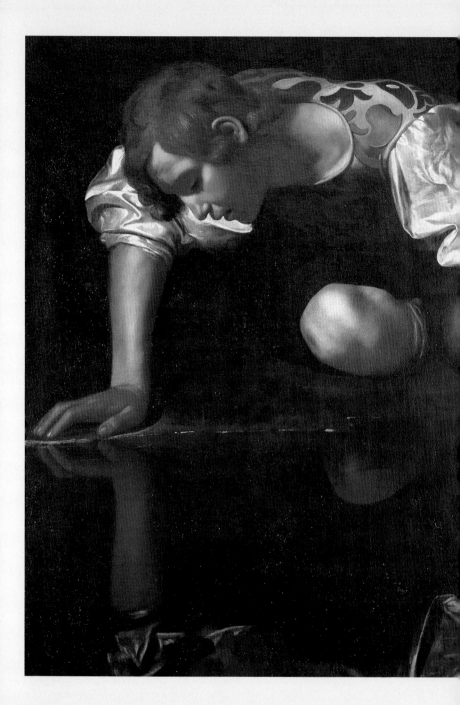

MAN

Androgyne
Microcosm
Christ
The Virgin Mary
The Trinity
Eve
Mother
Egg
Mirror
Cross
Halo
Angel
Satan
Monster
Polycephalos
Tetramorph
Zoomorph

A human figure endowed with two heads (one feminine, one masculine), four legs, and both types of sexual organs.

Androgyne

The androgyne or hermaphrodite represents the primordial union of the male and female principles and the human condition before the Fall. All the many manifestations of reality can be found in this state of perfection, which coincides with the very nature of God himself (Yahweh, Zeus, Eros, Shiva, and many other cosmogonic deities are conceived as androgynous). The myth of the androgyne is found both in Greek philosophy (Plato, *Symposium*) and in certain versions of Genesis, in the primordial Adam before Eve was made from his rib. In classical mythology, the androgyne takes the form of Hermaphrodite, the divine hybrid born of the love between Hermes and Aphrodite. Because it is attributed power and universal knowledge (in every esoteric tradition, the highest form of knowledge is the rejoining of opposites in their original union), in the Renaissance the androgyne becomes the emblem of princes and emperors. Noteworthy artistic representations of the phenomenon include the

Derivation of the name
From the Greek *andros*, "man," and *gyné*, "woman"

Origin of the symbol
It represents the harmonious union of the male and female principles, in keeping with the esoteric conception of divinity as a synthesis of all phenomenal contradictions (Oneness, Being, the All)

Characteristics
It is always accompanied by complementary attributes such as the sun and the moon, water and fire, gold and silver; it is the bearer of knowledge entrusted to initiates, and universal love

Religious and philosophical traditions
Orphism, Gnosticism, Hermeticism, Kabbalah, alchemy, Jungian analytic psychology

Related gods and symbols
Sun, moon; egg, the philosopher's stone, Adam, Eve

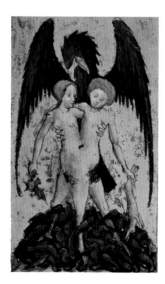

portrait of François I of France, now in the Bibliothèque Nationale in Paris. The symbol of the androgyne also appears, in a more ambiguous fashion, in the works of Leonardo da Vinci (*Study of Bacchus, Mona Lisa*). Marcel Duchamp's *Mona Lisa with Moustache* (1919) renders this esoteric theme explicit. The androgyne is a recurrent image in Surrealist art and the works of Marc Chagall.

▶ *The Androgyne*, illumination from the *Aurora consurgens*, late fourteenth–early fifteenth century. Zurich, Zentralbibliothek.

The androgyne is an allegory of the totality of the human psyche, made up of an anima *(the feminine principle, the Moon) and an* animus *(the masculine element, the Sun).*

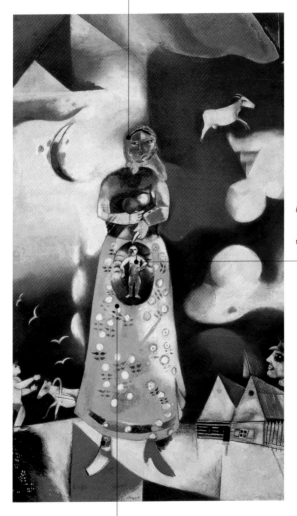

The child in the womb may be considered a symbol of cosmic love, arising from the concordia oppositorium *(reconciliation of opposites).*

This image of maternity is derived from representations of the Mother of God in Russian icons.

▲ Marc Chagall, *Pregnant Woman (Maternity)*, 1913. Amsterdam, Stedeljik Museum.

It is represented as a man standing with arms spread, inscribed in a circle or square. At times he is surrounded by the wheel of the zodiac.

Microcosm

Derivation of the name
From the Greek *mikro* (small) and *kosmos* (world)

Characteristics
It symbolizes the correspondence between the different degrees of the cosmos and represents the cognitive powers of man and the immortality of the intellectual mind

Religious and philosophical traditions
Pythagorism, Platonism, Gnosticism, Kabbalah, Hermeticism, alchemy, natural magic

Related gods and symbols
Macrocosm, the seasons, elements, temperaments, and virtues; pentagram

The image of the microcosm derives from mystical and esoteric doctrines concerning the correspondence between the parts of the human body and the universe. These doctrines form the basis of ancient medical knowledge, which assigned an astrological sign to each part of the body and treated illness by consulting the stars and studying their influence on the earthly world (the animals, plants, cosmic elements, and human temperaments). The Bible contains the same notion, defining man as "in the image and likeness of God," and as the "crown" or "measure" of creation. This symbol has a very important cognitive function, since one may, through the analysis of the body and the study of the soul, gain an understanding of everything that exists in nature, including God. Natural magic and Renaissance alchemy are also based on this complex system of correspondences.

In the field of art, the doctrine of man as microcosm—revived in the Renaissance through the translation of Hermetic texts by Marsilio Ficino and the spread of Vitruvius's theory of proportions—had a profound influence on the structures of Romanesque churches, on the architectural theories of Leon Battista Alberti and Francesco di Giorgio Martini, and the paintings of Leonardo, Albrecht Dürer, and William Blake.

► Leonardo da Vinci, *The Proportions of Man according to Vitruvius* (detail), ca. 1500. Venice, Gallerie dell'Accademia.

The wheel of the
zodiac sets the
rhythms of human
existence.

The man and
woman represent
the two funda-
mental psychic
principles.

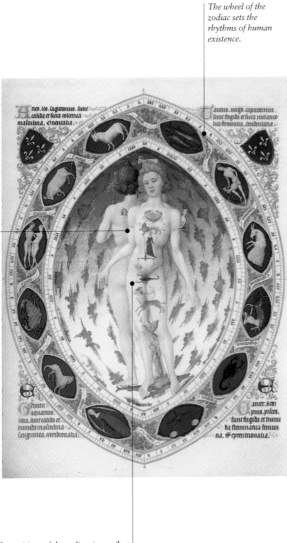

The positions of the zodiac signs reflect
the principles of astrological medicine,
which saw correspondences between
celestial bodies and human moods, ill-
nesses, and medications.

▲ Limbourg Brothers, *Anatomical
Man*, illumination from the *Très
Riches Heures du duc de Berry*, ca.
1416. Chantilly, Musée Condé.

God the Father is the Highest Good, the principle of love that gave rise to the cosmos.

The image of the Son is based on the figure of the cosmic Adam embracing the universe.

The circle of fire represents divine love, while the blue circle stands for the dark fire of judgment.

Man stands at the center of the cosmos, as the "measure" of all creation.

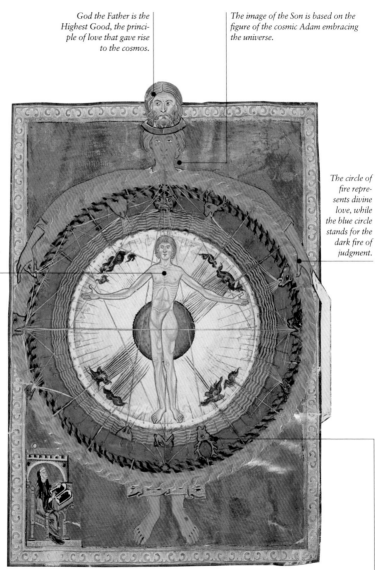

▲ Man in the Plan of Divine Creation, manuscript illumination from the *Liber divinorum operum* of Hildegard von Bingen, ca. 1230. Lucca (Italy), Biblioteca Governativa.

The twelve animal heads symbolize the virtues, which are introduced into the human soul by the breath of God.

Christ resurrected symbolizes the synthesis of the four elements, represented by the aura of light surrounding his face and the shroud wrapped around his body.

The light expresses the reunion of the elements in their primordial wholeness, and the passage into a dimension transcending sensory reality.

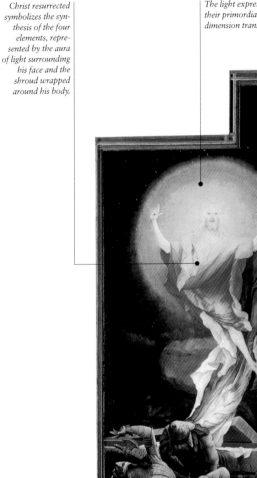

The energetic force of the resurrection blinds and knocks down the soldiers guarding the sepulcher.

▲ Matthias Grünewald, *Resurrection*, side panel of the *Isenheim Polyptych*, 1515–16. Colmar, Musée d'Unterlinden.

The animals' horns are arranged to form a crown, an imperial attribute.

The wolf, endowed with very keen vision, forms the figure's eye.

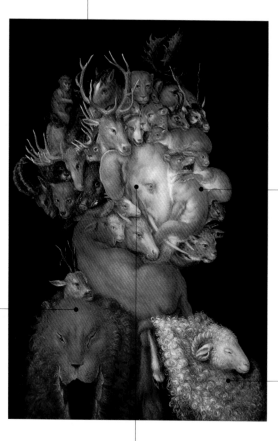

The lion symbolizes strength and virtue attained through effort.

The ram is an emblem of the Order of the Golden Fleece and represents glory.

The elephant is situated to form the cheek, the seat of shame according to the tradition recorded by Pliny the Elder in his Natural History.

▲ Giuseppe Arcimboldo, *Earth*, 1570.
Private collection.

Emperor Rudolph II von Hapsburg is portrayed as
Vertumnus, the god of seasonal change. The painting
symbolizes the sovereign's role as a synthesis of the
cosmos and an emblem of man as microcosm.

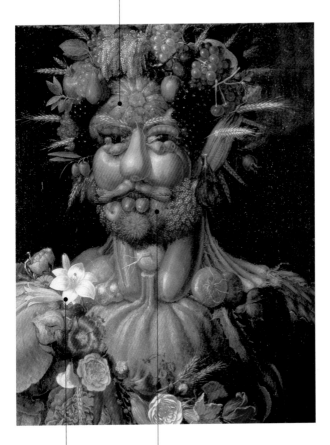

The emperor's features are rendered through
an anthropomorphic arrangement of the
fruits of the four seasons.

The identification of the
human body with a garden
in bloom or with the earth
derives from the Latin
word for man, homo,
which is related etymologi-
cally to the word humus,
earth or soil.

▲ Giuseppe Arcimboldo, *Emperor
Rudolph II von Hapsburg as
Vertumnus*, 1590–91. Bålsta
(Sweden), Skoklosters Slott.

He can be represented in the garb of a Roman emperor, as the Good Shepherd, as the judge on his throne, or in the guise of a warrior struggling with the demon.

Christ

Derivation of the name
From the Greek *christos*, "the anointed one"

Characteristics
He is the ordering principle of all the cosmic symbols and the synthesis of all the moral virtues

Religious and philosophical traditions
Christianity, alchemy

Related gods and symbols
Sun, Time, the Trinity, God the Father, the alchemical Christ-Lapis, the Antichrist, Satan; sky, earth, fire, air, man as microcosm, crown, scepter, throne, globe of the world, mandorla, halo, book, horn, mountain, cross, ladder, fish, lamb, pelican, phoenix, lily, tetramorph, the Evangelists, angel

Feasts and devotions
December 25, Christmas; January 6, the Epiphany; Good Friday, the Passion; Easter Sunday, the Resurrection

Many very ancient esoteric traditions and cosmogonic symbols from prior eras come together in the image of Christ. His appearance on Earth coincides with the beginning of a new spiritual order, represented in the homage of the three Magi and his baptism. As Chronocrator, he is master of time and humankind and comes to take the place traditionally assigned to the sun. As a teleological principle, he represents the summation of all future and past events and is identified with the Platonic Highest Good. As Pantocrator, he is the ordering principle of reality, the synthesis of the cosmic elements and the spatial coordinates, the primordial unity of all living creatures. As Redeemer, he symbolizes the triumph of life over death, eternal salvation, and the liberation from Original Sin. In art, early nonrepresentational symbols of Christ (the monogram, fish, lamb, and tetramorph) give way to realistic or visionary representations.

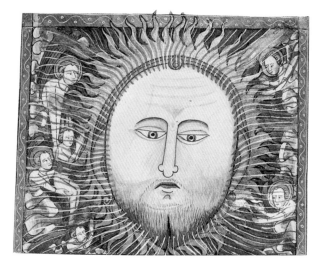

► James le Palmer, *Omne Bonum* (detail), ca. 1360–75. London, British Library.

The circle of angels represents the dance of life, symbol of fertility and spiritual regeneration.

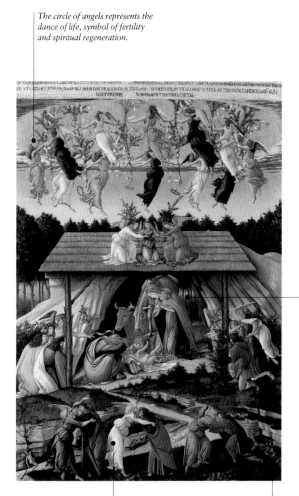

The motif of the cave is closely related to the mission of Christ on earth as the Savior of the souls of the just.

At the sight of the Redeemer, the demons flee the earth's surface to take refuge in the darkness of Hell.

The olive branch and the embracing angels symbolize universal peace, which will spread across the earth after the coming of the Savior.

▲ Sandro Botticelli, *Mystical Nativity*, 1501. London, National Gallery.

The baldachin, shaped like a cornucopia, alludes to Mary's role as childbearer.

Saint Paul, armed with a sword, banishes the heretics.

The figure in Oriental dress walking away symbolizes the refusal of divine grace through baptism.

The woman without feet has been interpreted as a symbol of Justice and Truth. Together with the kneeling figure, she represents an allegory of the theological virtues.

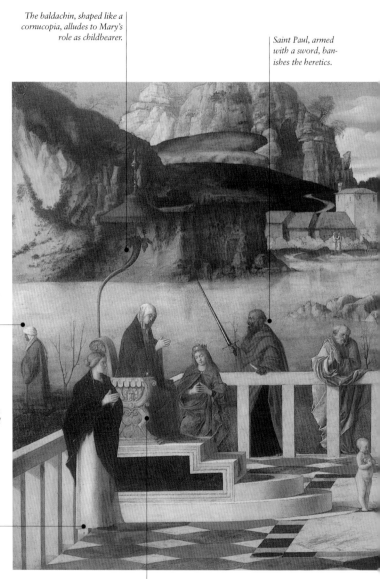

▲ Giovanni Bellini, *Sacred Allegory*, ca. 1500–1505. Florence, Uffizi.

The frieze apparently shows scenes of the myth of Marsyas, interpreted as a parallel to the Passion of Christ.

The tree of knowledge is a source of life and wisdom.

The man with hands folded in prayer may represent the hope of bodily resurrection after death. The painting has been interpreted as an allegory of the Word Made Flesh.

The young man pierced with arrows is Saint Sebastian.

The child seated on the cushion is supposed to represent Christ, who receives the fruits of the tree of knowledge from the angels.

The flourishing tree represents the regeneration of life in the Savior.

The dove is the symbol of the Holy Spirit.

Christ, standing along the central axis of the composition, embodies the center of the world.

The dry tree alludes to the fate of those who refuse baptism.

The angels symbolize the Holy Trinity.

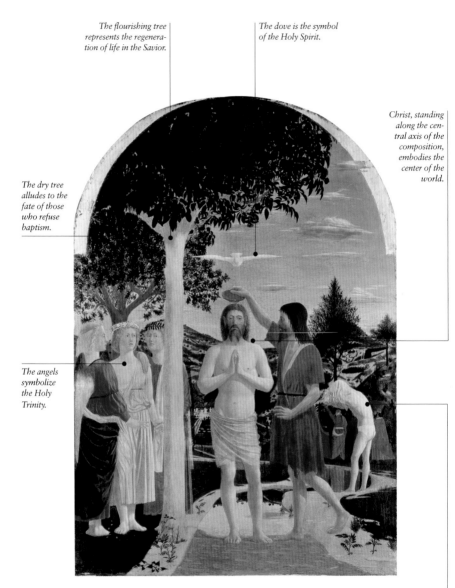

▲ Piero della Francesca, *Baptism of Christ*, ca. 1440–50. London, National Gallery.

In casting aside his clothes, the baptismal candidate shows that he has chosen to leave behind his prior life in order to enter a new dimension of existence.

The lily is a symbol of mercy.

The heavenly throne embodies Christ's role as universal judge. The rainbow symbolizes the alliance between God and man.

The incandescent sword represents divine justice.

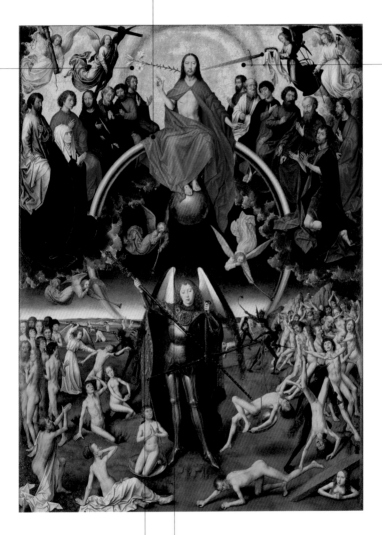

The archangel Michael leads the angelic forces in their struggle against the demons. Some biblical exegeses identify him with Christ.

The globe of the world is dominated by the will of Christ.

▲ Hans Memling, *Last Judgment*, central panel of the *Last Judgment Triptych*, 1466–73. Gdańsk, Muzeum Narodowe.

The hand is in the act of slapping Christ.

The pelican is a symbol of Christ's sacrificing himself to redeem humanity. The bird was believed, erroneously, to injure itself to allow its chicks to drink its blood.

The whips and rods allude to the flagellation.

The Virgin is portrayed in the blue garments typical of the Pietà.

▲ Master of the Strauss Madonna, *Imago Pietatis with the Virgin Mary and Mary Magdalen*, ca. 1400. Florence, Galleria dell'Accademia.

Christ's face, an "image" of his divine nature, is registered on Veronica's veil.

The shock of hair was torn from Christ's head as he ascended Mount Calvary.

Hanging from the column of the flagellation is the rope with which Christ was tied. The painting contains the instruments of the Passion, the so-called *arma Christi*.

The ladder used in the Deposition from the cross is the means of ascending into Heaven.

Mary Magdalen, the healer, is shown with her medicinal unguents at her feet.

She is represented as a young woman "clothed in sunlight," with her feet on the moon and a crown of stars around her head.

The Virgin Mary

The iconography of the Virgin Mary retains a number of features from the "white goddesses" of antiquity: the Egyptian Isis and the Greek Artemis, expressions of the feminine, lunar principle that governs the universe together with the Sun. This correspondence is found above all in the Eastern cult of the Black Madonna, whose votive images were superimposed on the figures of Diana of Ephesus and Hecate Trivia, the terrible queen of the Underworld.

In the Middle Ages, Mary's divine image as the "light of God" was accompanied by the epithet "morning star," traditionally given to the goddess Venus.

In Western iconography, the Virgin is usually represented as the "new Eve," illuminated by God's grace and able to resist the temptations of the devil, represented as a snake. This conception was used by Caravaggio in his famous *Madonna with the Serpent* (*Madonna dei Palafrenieri*).

During the Counter-Reformation, the iconography of the Virgin underwent a profound revision in an attempt to counter the Lutheran and Calvinist "heresies" that denied Mary her function as mediator for divine grace. As part of this effort, the Immaculate Conception would assume a central role in art.

Characteristics
She is the highest expression of universal love and harmony (*Tota Pulchra es*, Thou art beautiful); the mother and mystical bride of the Lord; the incarnation of divine grace; the Queen of the Apocalypse. She is the quaternary principle that completes the Trinity and a symbol of the realization of the divine will

Religious and philosophical traditions
Catholicism, Orthodoxy, alchemy, fidelity in love

Related gods and symbols
Ishtar, Isis, Artemis (Diana), Selene, Moon, Christ; Church, grace, light of God, alchemical milk of the Virgin, well, source, tower, garden, rose garden, month of May

Feasts and devotions
August 15, the feast of the Assumption; December 8, the Immaculate Conception

▶ Geertgen tot Sint Jans, *Madonna in Glory*, ca. 1480. Rotterdam, Museum Boymans-Van Beuningen.

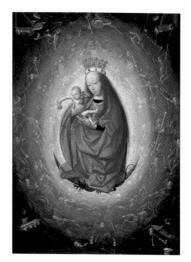

The rosebush is a symbol of divine grace and love and is directly linked to the liturgical function of the rosary.

The gate of Heaven, the tower, the hortus conclusus, and the City of God represent the Virgin's role as redeemer of man's sins.

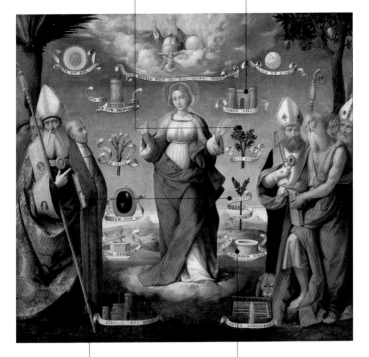

The water of life and the font of Heaven allude to Mary's generative, life-giving function.

The olive branch symbolizes peace and hope. The image represents the arma Virginis *(weapons of the Virgin) by which Mary is invoked in the litany.*

▲ Benvenuto Tisi, known as Il Garofalo, *Immaculate Conception with the Doctors of the Church*, first half of the fifteenth century. Milan, Pinacoteca di Brera.

The cave represents the maternal womb, place of rebirth, and passage to the hereafter. The rock is closely linked to Christ's mission on earth as one who purifies and replenishes the soul.

The Virgin is portrayed in her protective role as mother and nurturer.

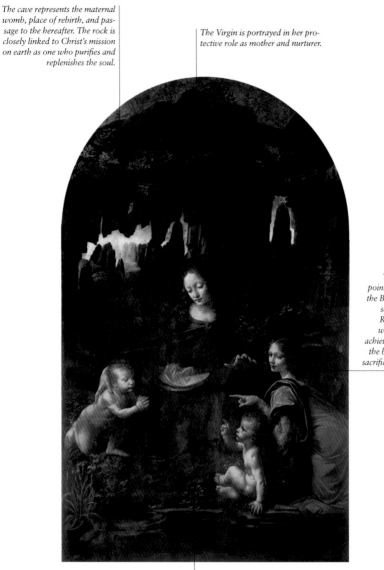

The angel is pointing at John the Baptist, messenger of the Redemption, which will be achieved through the baptism and sacrifice of Christ.

The finger pointing upward refers to the higher, heavenly dimension to which Christ is predestined.

▲ Leonardo da Vinci, *The Virgin of the Rocks*, 1483–86. Paris, Louvre.

The dove is a symbol of divine grace, dispensed on earth through the Virgin's love.

Mary is represented as the "new Eve" triumphing over the tempting devil.

The lily is a symbol of purity and the Immaculate Conception.

The moon, an ancient attribute of Isis and chaste Diana, was incorporated into the iconography of the Virgin. In Christian cosmology, the Virgin-Moon complements Christ-Sun in governing the universe.

The snake symbolizes evil.

▲ Giambattista Tiepolo, *Immaculate Conception*, 1767–69. Madrid, Prado.

It is represented as a triangle with the vertex pointing upward. At its center one may find the eye of God or the individual figures of the Father, the Son, and the Holy Spirit.

The Trinity

It is the Christian dogma of the simultaneous presence of God (the One and Triune) in the persons of the Father (power), the Son (intelligence), and the Holy Spirit (love). In the Neoplatonic exegesis, Orpheus, Plato, and Zoroaster are considered the pagan prophets of the Trinity, while the Egyptian god Serapis (associated with the Greek god Hades) is considered a vestige of it. His animal heads (the wolf, the lion, and the dog, which symbolize the three parts of Time) are interpreted as an imperfect presentation of the Trinitarian mystery. The Italian Renaissance revived this polymorphic conception of divinity from Proclus, who said it was a "preliminary" stage of the manifestation of divine unity.

In the Middle Ages the Trinity is represented variously as three seated figures, a three-headed figure sitting on a throne, three interwoven circles, a trefoil, three angels of equal stature, and a T-shaped cross. Starting in the tenth century, when the anthropomorphic representation of the Holy Spirit was banned, the dove became part of the divine triad. In 1628, at the height of the Counter-Reformation, the three-headed representation of the Trinity was also prohibited. The Holy Family and the Three Marys are also considered images of the Trinity.

Derivation of the name
From the Latin *trinitas*, derived from the adjective *trinus*, meaning "three in one"

Origin of the symbol
The Trinitarian dogma was formulated in 325, during the Council of Nicea

Characteristics
It represents the fulfillment of divine Unity in the three persons of the Father, the Son, and the Holy Spirit

Religious and philosophical traditions
Artemis (Diana), Hecate Trivia, Hades (Pluto), Cerberus, Orpheus, Serapis; God the Father, Christ, the Holy Spirit, the Virgin Mary; dove, three, triangle with vertex on top, three interwoven circles, T-shaped cross, trefoil

Feasts and devotions
Feast of the Trinity, which falls on the first Sunday after Pentecost

▶ Niccolò di Pietro Gerini, *Trinity*, late fourteenth–early fifteenth century. Rome, Capitoline Museums.

God the Father is the first person in the Trinity and represents the power of the Supreme Being.

The dove is the emblem of the Holy Spirit.

The Son of God, or the Word Made Flesh, represents the divine intelligence and love that redeem humanity.

▲ Albrecht Dürer, *Adoration of the Trinity (All-Saints Altarpiece),* 1511. Vienna, Kunsthistorisches Museum.

The T-shaped, or Tau, cross is a symbol of the Trinity and divine grace.

The mirrored representation of Christ as both the Father and Son is based on the dogma of the Word Made Flesh.

The division of the painting's space into the three bands of Heaven, earth, and Hell is directly related to the symbolism of the Trinity.

▶ Enguerrand Quarton, *Coronation of the Virgin*, 1453–54. Villeneuve-lès-Avignon, Musée Municipal.

The Virgin Mary represents the quaternary principle that completes the dogma of the Trinity.

Cherubim and seraphim enfold the body of Mary, which is borne up to Heaven on a cloud.

Eve

Derivation of the name
From the Hebrew *hawwà*, "mother of all the living"

Origin of the symbol
It derives from the myth of the creation of woman from Adam's rib, as narrated in the Book of Genesis

Characteristics
She is a symbol of sin and transgression of divine rule, but she can also represent (in esoteric and Kabbalistic traditions) the desire for knowledge and man's free will

Religious and philosophical traditions
Judaism, Gnosticism, Christianity, Kabbalah

Related gods and symbols
Ishtar, Isis, Artemis (Diana), Cybele, Adam, God the Father, Satan; moon, androgyne, snake, dragon, tree of knowledge, tree of good and evil, flesh, matter, affect, love

She is commonly portrayed in the act of offering Adam the forbidden fruit, accompanied by the tempting serpent.

The mother of the human race represents the female aspect of the pre-Adamite androgyne. With the myth of Eve's birth from Adam's rib, biblical tradition confirms the spiritual, physical, and psychic separation of the two most important cosmogonic principles.

In the Book of Genesis, she appears as the active and superior element of the primordial couple. Her thirst for knowledge expresses an all-inclusive love of life and its manifestations. Eating the forbidden fruit means embracing existence in all its aspects, participating in good as well as evil. This positive characterization of Eve can be found in Renaissance alchemical treatises and in biblical and Kabbalistic literature, where she is seen as the first embodiment of knowledge.

As a symbol of the life-giving energy of the universe, she is similar to Eastern (Indian) images of the snake-goddess (*kundalini*) who dwells at the base of the spine. In late-medieval iconography, the motif of "Eve as snake," now freighted with entirely negative connotations, is frequently found in paintings and manuscript illuminations. In the visionary works of Bosch and Van der Goes, the woman's face is often transposed onto the reptile, her psychic alter-ego.

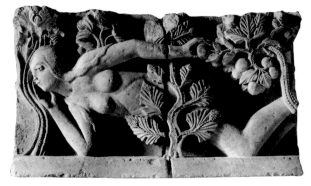

► Gislebertus, *Eve in the Garden of Eden*, ca. 1130. Autun, Musée Rolin.

The horns are inherited from the ancient cult of Isis. In the Christian reading they acquire a negative connotation and become an attribute of the devil.

A symbol of Original Sin, Eve lends her features to the tempting serpent.

The tree of good and evil is here shown in its typically bifurcated form. The Y shape, symbol of the choice between goodness and sin, represents the paths the soul may travel after death.

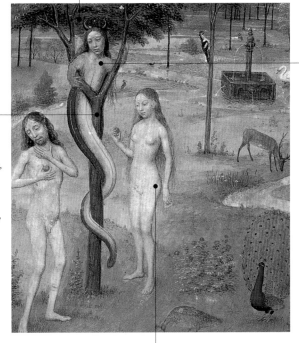

Adam and Eve are portrayed in the act of eating the forbidden fruit.

▲ French school, fifteenth century, *Original Sin*, illumination from the *Horae Beatae Mariae Virginis*. Naples, Biblioteca Nazionale.

The enchantress embodies the cognitive role of Eve, who abandons her unconscious state in Eden to embrace life in all its complex manifestations.

Immersed in nature, Eve is portrayed as the mother of all the living.

▲ Henri Rousseau, *The Dream*, 1910.
New York, Museum of Modern Art.

Here the snake represents not so much the tempting devil as the regenerative powers of nature connected to the aquatic and subterranean worlds.

She is represented either nursing an infant, immersed in nature, or surrounded by attributes that allude to fertility.

Mother

Life's receptacle and womb, the figure of the Mother is related symbolically to water and the earth, the principles of universal germination. As with all the principal archetypes, her symbolism is dualistic, expressing the cyclical process of nature (birth, death, rebirth).

In prehistoric cultures, the *regressus ad uterum*, the return to the maternal womb, symbolized both death and the first step toward resurrection. Many funerary and initiation rites made use of this image to guarantee that the deceased's soul was launched on the path to rebirth.

In a general sense, all the symbols that express a receptive or protective function can be traced back to the Mother, such as rites connected with the fertility of the land and the cosmic deities that personify it.

The inverted triangle symbolizes the woman's generative power; it is a visual and conceptual synthesis of her role as womb of life. In art the Great Mother is presented as a headless goddess lying on her back, with her sexual attributes in plain view.

Derivation of the name
From the Latin *mater*, "mother," "womb"

Characteristics
She is the symbol of universal fecundity and reception. The woman's uterus is considered the source of all life, and amniotic fluid its lymph

Religious and philosophical traditions
Judaism, Christianity, Kabbalah, Hermeticism, alchemy

Related gods and symbols
Mother Earth, Ishtar, Isis, Gaea, Rhea, Demeter (Ceres), Hera (Juno), Artemis (Diana), Selene, Eros, Eve, Luna; the Virgin Mary, the Church, Saint Anne; vase, egg, athanor, seashell, cave, life, water, night, death, knowledge, inverted triangle, heifer, garden

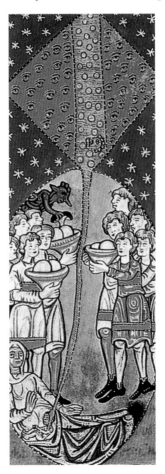

▶ Illumination from the *Liber scivias* of Hildegard von Bingen, ca. 1165. Formerly in Wiesbaden, Hessisches Landesbibliothek.

The lightning here symbolizes both fire and water (rainstorms).

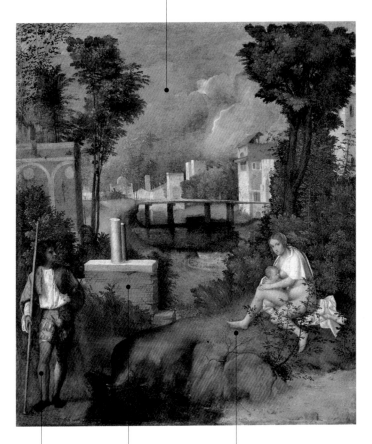

The man represents the male, celestial principle that fertilizes the earth. From this union, life (the baby in the painting) is born.

The broken columns of the temple of Solomon allude to Adam and Eve's expulsion from Eden and the inevitability of death.

The Mother symbolizes the nutritive role of nature and woman's bond with the earth. In Hermetic terms, the Mother-Sophia is a symbol of man's redemption from impurity and death.

▲ Giorgione, *The Tempest*, ca. 1506. Venice, Gallerie dell'Accademia.

The column echoes the motif of the
Madonna's long neck, suggesting that the
painting may be interpreted as an allegory
of the Immaculate Conception.

The egg-shaped
vase represents
the crucible,
inside which
base matter is
transformed
into "gold."

The Virgin's body
recalls the form of
the athanor, the
crucible of the
alchemical Work.

The sleeping Child is the
Christ-Lapis, the central
figure in Christian alchemy.

▲ Parmigianino, *Madonna of the Long
Neck*, 1535–40. Florence, Uffizi.

The crown of myrtle and the rose petals are symbols of love, the driving principle of the universe and of alchemical transmutation.

The conch is a very ancient attribute of Venus, who is represented here as a receptacle of Mercurial water (Cupid's irreverent spurt), which triggers the alchemical transformation of matter.

The goddess's belly, symbol of feminine eroticism and the Mother's reproductive function, is a Hermetic allusion to the athanor, inside which the gestation of the philosopher's stone occurs.

▲ Lorenzo Lotto, *Venus and Cupid*, 1530. New York, Metropolitan Museum.

Leda, whose name means "woman," is the Great Mother who gives birth to the cosmic egg, here represented by the two sets of twins.

The swan, the form Zeus took to disguise himself, stands for the fertility principle.

Leda's quadruplet children—Castor and Pollux (symbols of concord), and Helen and Clytemnestra (symbols of discord)—represent the Neoplatonic principle of discordia concors.

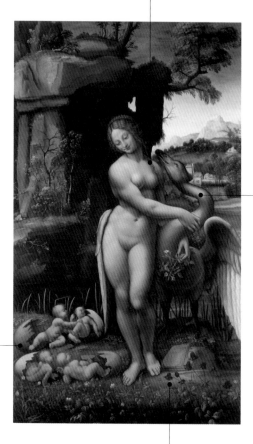

The painting has been interpreted as an allegory of musical creation based on the Orphic-Pythagorean doctrine of the harmony of opposites.

▲ Leonardo da Vinci (copy), *Leda*, 1505–7. Florence, Uffizi.

It is represented in many different forms: as cosmic egg, as uterus and womb, as alchemical vessel, or as a symbol of divine perfection.

Egg

The archetype of the oval appears throughout human history from the earliest times, weaving a web of correspondences between civilizations and cultures that otherwise seem very distant from one another. Most cosmogonic myths conceive of the universe as egg shaped or having originated from an egg. The egg is the primordial cell that contains the multiplicity of beings in embryonic form, the image of the original whole that preceded all differentiation. A symbol of life in forma-tion, fertility, and perfection, the egg contains within itself a plurality of meanings. It is related to the principal archetypes that derive from myths of the generative split.

Art, philosophy, and religion use the egg to symbolize the ineffable mystery of life and its diverse manifestations. "Ovoid" idols appear throughout Western and Eastern iconog-raphy. They range from the Tibetan mandala to the Chinese *yin* and *yang*, to the mandorla of Christian mysticism, an expression of Christ's divine nature and a symbol of resurrec-tion. In medieval churches the egg, representing the vehicle of inner enlightenment, was often hung high up, where the faith-ful could see it. The term "alchemical" or "philosophical egg" refers to the form of the receptacle in which the "incubation" of the Work takes place. As the womb of creation, the alchemical athanor fulfills the functions of the female uterus: germina-tion and nourishment. The gestation of the philosopher's stone is supposed to mimic the biological process of maturation in utero.

Derivation of the name
From the Old English *áeg* and Old Saxon *ei*. There may be a connection (as seen in the Latin *ovum*) with the Indo-European root *awi*, meaning "bird"

Characteristics
It is the symbol of life in ges-tation and of perfect con-sciousness. It represents the cosmos and the life-giving principle that engendered it (Eros-Phanes)

Religious and philosophical traditions
Orphism, Pythagorism, Neo-platonism, Judaism, Chris-tianity, Kabbalah, Hermeticism, alchemy

Related gods and symbols
Mother Earth, Eros-Phanes, Leda; God the Father; cos-mos, vase, athanor, uterus, life, night, water, death, moon, androgyne, philoso-pher's stone (*rebis*), eagle, phoenix, divine light, man-dorla, halo

◄ Fra Angelico, *Transfiguration of Christ*, ca. 1441. Florence, San Marco.

Egg

The flaming circle combines the symbolism of the egg with the epiphany of the divine light that gives order to the cosmos and dispenses consciousness. Inside it we see the star of the sun.

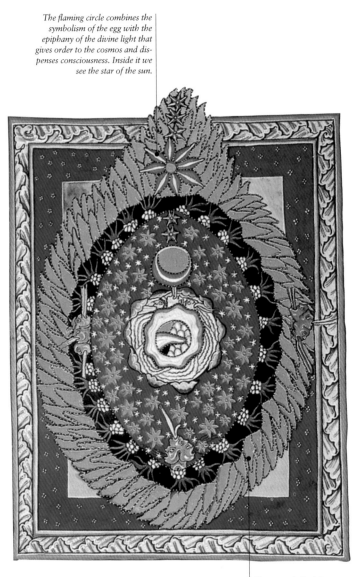

▲ *The Cosmic Egg*, illumination from the *Liber scivias* of Hildegard von Bingen, ca. 1165. Formerly in Wiesbaden, Hessisches Landesbibliothek.

The outer shell of the egg stands for the air; the albumen, or inner skin, for the watery element; and the yolk, for the earth.

The seashell motif represents the generative nature of the Virgin and her link to water and the sea.

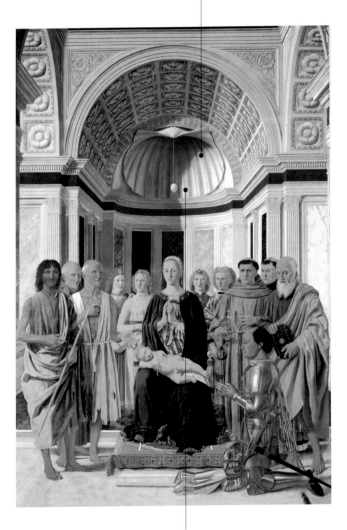

The ostrich egg, symbol of divine perfection, is situated slightly off the central axis of the composition, to indicate the superiority of faith over reason.

▲ Piero della Francesca, *Madonna and Child with Saints, Angels, and Duke Federico da Montefeltro*, ca. 1475. Milan, Pinacoteca di Brera.

Egg

The globe of the world contains the three realms of nature: the animal (orange), the vegetable (blue), and the mineral (gray).

The two-headed hermaphrodite is the rebis, who symbolizes the alchemist's simultaneous dominion over the beginning (egg) and end (universe) of creation.

The black clothing alludes to the first phase of the alchemical Work: the nigredo, or putrefaction of matter. The golden braid and red belt represent the rubedo, or red phase.

The golden egg is a symbol of the primordial whole that preceded the differentiation of phenomena. From it will be born the lapis, the new alchemical life-form, symbol of the philosopher's stone and the origin of the world.

▲ The Philosopher's Egg, illumination from the Splendor solis of Salomon Trismosin, sixteenth century. London, British Library.

The X represents the unknown and the enigmatic nature of existence.

The egg is a symbol of life.

The feet refer to Zarathustra, who "makes the world turn in dance-steps."

The scroll may contain secrets about human destiny.

▲ Giorgio de Chirico, *Metaphysical Composition*, 1914. New York, Metropolitan Museum.

Mirror

Derivation of the name
From the Middle English *mirour* and Old French *mireor*, derived from the Latin *mirare*, "to look at," and *mirari*, "to wonder, admire" (root of "miracle")

Origin of the symbol
It derives from the Greek myth of Narcissus. In the Renaissance, it becomes an allegorical image of painting

Characteristics
Its surface displays an image of the soul, man's hidden, inner self

Related gods and symbols
Narcissus, Aphrodite (Venus), Mary Magdalen, Satan; beauty, death, pride, vanity, lust, prudence, learning, reflexive knowledge, the unconscious

It is a symbol with multiple meanings. It may represent inner or reflective knowledge, beauty, the virtue of prudence, or the vice of vanity.

Among all the objects endowed with symbolic significance, the mirror holds a position of privilege. Its ambiguity and multiplicity of meanings are reflected in the extraordinarily rich iconography that has been attempting to represent it from the Middle Ages to the present day.

The mirror's significance is two-fold, on both the moral and cognitive levels. Its first level of meaning, generally negative in character, is conveyed in the myth of Narcissus and in allegories of the sins of lust, vanity, and pride. It has a positive connotation as a symbol of inner knowledge (the repentant Magdalen) or esoteric knowledge (the magic mirror), or as a symbol of prudence. The various names given to the object reflect this dual character. The Latin term *speculum* brings out the cognitive side, as it "speculates" on the image of reality; the French term *miroir* (origin of the English "mirror") dwells on the contemplative role, deriving from the Latin *mirare*, "to look at," implying as well the inevitable self-contemplation.

In the early sixteenth century, this investigative tool gained strategic importance in the painters' guilds, which wanted to assert the superiority of their art over sculpture. Thanks to the

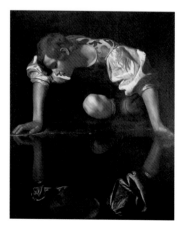

reflecting surface of mirrors, they were able to paint objects "in full relief," allowing the observer to glimpse even the most hidden recesses of the bodies portrayed.

▶ Caravaggio, *Narcissus*, ca. 1599–1600. Rome, Galleria Nazionale d'Arte Antica, Palazzo Corsini.

When held up to the goddess
of love, the mirror becomes a
powerful tool of seduction.

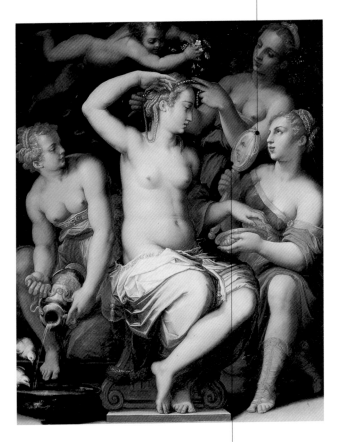

The mirror is the means by
which man can contemplate
the divine, since mortals are
not allowed to glimpse gods
directly, upon pain of blind-
ness or death.

▲ Giorgio Vasari, *Venus at Her Toilet*,
ca. 1588. Stuttgart, Staatsgalerie.

The hourglass symbolizes the inexorable passing of time.

The mirror reflects the image of Death, who pitilessly exposes the transience of beauty.

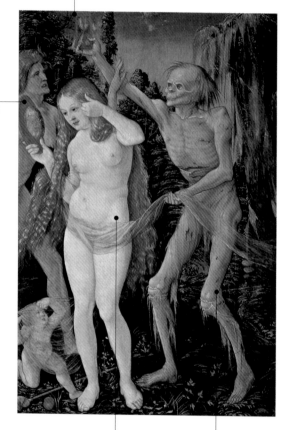

The girl gazes at her own youthful beauty, not seeing that it is a fleeting, ephemeral asset.

The figure of Death is integral to the theme of Vanitas and the transitory nature of earthly pleasures.

▲ Hans Baldung Grien, *The Three Ages and Death*, ca. 1509–10. Vienna, Kunsthistorisches Museum.

The candle's flickering
light and smoke allude
to the theme of Vanitas.

Mary Magdalen rep-
resents the perfect
subject for the theme
of the mirror. Able to
pierce its depths, the
young woman dis-
covers the vanity of
carnal enticements.

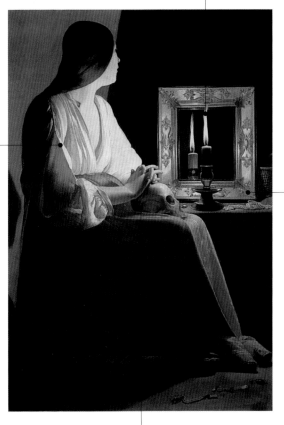

The "mirror of
the soul" is a
vehicle for inner
knowledge. The
first step along
the path of
virtue is, in fact,
to "look inside
oneself."

The skull is a
symbol of life's
transience.

▲ Georges de la Tour, *The Penitent
Magdalen*, ca. 1640. New York,
Metropolitan Museum.

The presence of the painter at work
helps us to understand the true meaning
of the piece: It is an allegory of painting
as a mirror of nature.

The mirror reveals the
"scene beyond." Its surface
reflects the images of the
king and queen of Spain,
the subjects of the large can-
vas in the foreground.

▲ Diego Velázquez, *Las Meninas*,
1656. Madrid, Prado.

The lady of Shalott, in the poem of the same name by Lord Tennyson, watches in her magic mirror as Sir Lancelot approaches her tower.

The mirror is the partition between two cognitive dimensions: the world of ideas and that of sensory reality, its pale, evanescent reflection.

The magic circle holds the young woman prisoner in a web of enchantment.

▲ William Holman Hunt, *The Lady of Shalott*, 1886–1905. Manchester, City Art Gallery.

Cross

Derivation of the name
From the Latin *crux*, "cross"

Characteristics
It represents the axis of the
world, the agent of mediation
between the celestial male
principle (the sky) and the
terrestrial feminine principle
(the earth)

**Religious and philosophical
traditions**
Judaism, Kabbalah, Chris-
tianity, Hermeticism, alchemy

Related gods and symbols
Christ; axis of the world,
omphalos, tree of life,
philosopher's tree, ladder to
Heaven, bridge, mountain,
arrow, androgyne, man as
microcosm, philosopher's
stone, temple, crossroads,
cardinal points, elements,
sky, earth, circle, square

*As an image of the cosmic whole it is the primary attribute of
Jesus Christ, the universal mediator.*

The cross represents the axis of the world and the intersection
between the basic forms of the circle (the heavens) and the
square (the earth). It is the mystical center of the cosmos and
constitutes the means by which souls may ascend to God. In
cosmogony, it is related to the tree of life and symbolizes the
union of opposites. As an agent of "synthesis" and "mea-
sure," it has an ordering function. Its symbolism is highly
complex: spatially the arms of the cross correspond to the
four cardinal points as well as the four elements and their
properties; temporally the shaft represents the rotational
movement of the earth's axis; and existentially it alludes to
the synthesis of man's animal and spiritual natures. In the
image of the Savior, the cross has two aspects: the cross of the
Passion and that of the Resurrection. This division mirrors the
different elements that constitute the cross: the vertical axis of
spirituality and eternal salvation, symbolizing God; and the
horizontal, symbolizing the earthly, animal dimension, pain,
and negativity.

▶ Matthias Grünewald,
Crucifixion, central panel of
the *Isenheim Polyptych*,
1515–16. Colmar, Musée
d'Unterlinden.

Paradise, occupying the
top of the painting, demon-
strates the cross's function
as a ladder to Heaven.

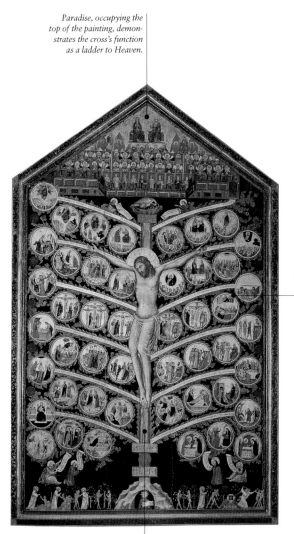

The medallions
illustrate the key
episodes of the life
of Christ.

The tree of life and death is a
symbol of the initiates' jour-
ney, which leads to spiritual
elevation as represented in the
sacrifice of Christ.

▲ Pacino di Bonaguida, *The Tree of
Life*, ca. 1300–1310. Florence, Gallerie
dell'Accademia.

Jerusalem is portrayed as a
fortified medieval city.

The cock, a sym-
bol of Peter's
denial of Christ, is
positioned directly
above the saint
and between
Adam and Eve,
who personify
human weakness.

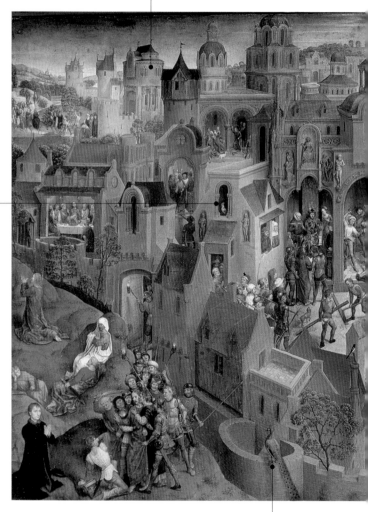

The peacock is a
symbol of rebirth
and redemption.

Mount Calvary dominates the upper part of the composition and represents its narrative destination.

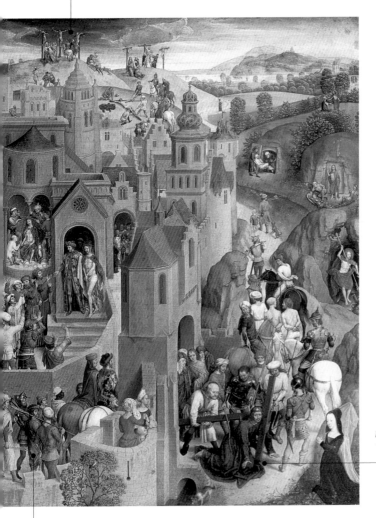

The kneeling figure, who looks out at the viewer, is Jesus Christ.

The painting represents the different scenes of the Passion of Christ simultaneously. Its purpose is to lead the faithful viewer to discover the holy sites of Jerusalem.

▲ Hans Memling, *Passion of Christ*, 1470–71. Turin, Galleria Sabauda.

It is represented as a source of light, of varying color, surrounding the head or body of superhuman beings.

Halo

▶ Paolo Veneziano, *Madonna and Child with Two Patrons*, ca. 1325. Venice, Gallerie dell'Accademia.

The halo is the material, sensory manifestation of the sacred nature (the aura) of a human being. It is represented as a circle of light around beings endowed with great spirituality (such as angels, the blessed, and the saints), and its purpose is to highlight the noblest part of man: the head, seat of the intellect and vehicle of spiritual elevation. In the Christian interpretation, ecstatic communion with the divine and the reception of grace occurred in the part of the rational soul called the *mens* (mind).

The halo can appear in many forms. It is spherical and ovoid in images of the mandorla and egg of light of Christian mysticism, but it is quadrangular when it represents the holy dimension of persons still alive. When it conveys the cosmic whole and manifests the spiritual identification between the world's soul and the human soul, it takes on all the colors of the rainbow; when it symbolizes the immortal soul, it is also associated with shadow and the breath of life. In antiquity,

solar deities such as Jupiter and Apollo, and great Roman and Byzantine emperors, were portrayed with aureoles of light around their heads.

Christ is sometimes enveloped in a cruciform aura, symbol of the Trinity, his sacrifice, and eternal life.

The Madonna and Child are enveloped in a luminous aura, sign of their divine nature.

The symbol of the halo is closely related to that of the sun, from which it takes the motif of the wheel of light. In Western iconography it is often represented as a golden disk.

▲ Matthias Grünewald, *Madonna and Child in a Landscape*, 1508–9. Stuppach (Germany), parish church.

Angel

A winged being of indeterminate gender, the angel is sometimes portrayed in the act of punishing the wicked or expelling demons, or as a protective, consoling presence.

Derivation of the name
From the Greek *angelos*, "messenger"

Origin of the symbol
It derives from the winged Victories and Genii of the Graeco-Roman period

Characteristics
The angel symbolizes a state of existence higher than that of man and fulfills the role of God's messenger. He may be either a protective presence or a force of vengeance

Religious and philosophical traditions
Judaism, Christianity, Gnosticism

Related gods and symbols
God the Father, Christ, Lucifer, Satan, Evangelists, eons; tetramorph, trumpet, sword, lily, halo, phoenix, swan, eagle, light, flame

Feasts and devotions
Easter Monday, called Lunedì dell'Angelo; feast of the Archangels, September 29; feast of the Guardian Angel, October 2

► Guariento di Arpo, *Angels with Lily and Globe* (detail), mid-thirteenth century. Padua, Museo Civico.

The Christian angel is an anthropomorphic synthesis of the sacred animals venerated in the Eastern religions (the eagle, swan, and phoenix, symbols of purity, spirituality, power, and intellectual discernment) and the Hebrew cherubim, with bright-red flaming wings. In the iconography of angels, both of these genealogies are recurrent: the whiteness and purity of the swan, as well as the disruptive power and penetrating vision of the eagle (or solar phoenix).

The angels are divided into cherubim, seraphim, archangels, and rebel angels. Pseudo-Dionysius the Areopagite sorts the angels into hierarchical ranks (seven orders, nine choirs, three triads) and assigns specific astral duties to each.

As an iconographical motif, the winged angel does not appear until the fourth century A.D. Prior to this time, it took the form of an ephebe dressed in a simple tunic.

In Byzantine art, angels commonly hold a banner, a golden rod, and a globe, symbols of the power of God. Their leader, moreover, is usually surrounded by a golden or sky-blue aura. From the twelfth century onward, the tendency is to represent angels only by their head and wings, to underscore their spiritual, incorporeal nature. This iconographic model became particularly widespread in the Baroque era and is the origin of the winged cherubs that people the skies and clouds. Votive images of guardian angels are a recurrent motif in sacred Christian art.

The olive branch symbolizes the
universal peace that will spread
across the earth after the coming of
the Savior.

The archangel
Gabriel has the
task of announc-
ing the births of
John the Baptist
and Jesus.

The lily became
an attribute of
the archangel in
the Middle Ages.
A symbol of
purity and
chastity, it is asso-
ciated with the
moon, over
which Gabriel
holds sway.

The golden color of
his gown reflects
Gabriel's glorious
epithet, "messenger
of God."

▲ Simone Martini, *The Archangel
Gabriel*, detail of the *Annunciation*,
1333. Florence, Uffizi.

The shining armor first appears in the fourteenth century. Before this, Michael was presented in Byzantine military dress.

The dragon represents Azazel, the demon of the Apocalypse, defeated by the power of God.

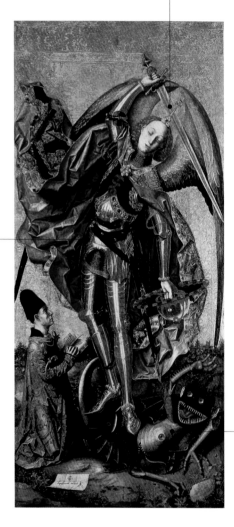

The sword is the archangel's principal attribute. He uses it in battle against the demons (Book of Revelation) and to banish the rebel angels (Apocryphal Book of Enoch).

▲ Bartolomé Bermejo, *Saint Michael Triumphant over the Devil*, ca. 1468. London, National Gallery.

Raphael is the personification of the guardian
angel. He protects travelers (such as Tobias) and
wayfarers, acts as a healer, and guides the souls
of the dead to the afterlife.

The tin may
represent a
censer, an
attribute of
Raphael as the
archangel of
Revelations.

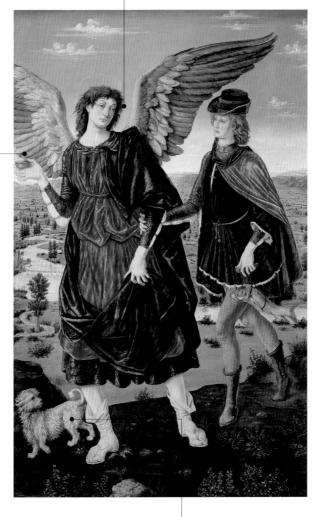

▲ Piero del Pollaiolo, *Young Tobias
and the Angel Raphael*, ca. 1466–67.
Turin, Galleria Sabauda.

The dog may allude to Raphael's role as guide for
the deceased. Catholic exegesis interprets the leg-
end of Tobias as an initiatory journey of the soul,
first blinded by the devil and then saved by divine
intervention.

Angels as musicians and singers symbolize the harmony of the celestial spheres. From the time of Pythagoras, the spheres were considered complex numerical structures governed by musical relationships.

Purely imaginary instruments (such as this hybrid of vielle and flute) serve to underscore the supernatural and spiritual nature of angelic music.

▲ Gaudenzio Ferrari, *Angelic Concert*, (detail), 1534–36. Saronno (Italy), Sanctuary of the Madonna dei Miracoli.

The rabbi with the scrolls of the Law is fleeing the scene to save the religious and cultural patrimony of his people.

The fallen angel represents the tragedy of war and the persecution of the Jews.

The candle represents the faint light of hope in the shadows of obscurantism.

The crucifix is a symbol of the suffering inflicted on the Jews.

The cow alludes to motherhood and the nurturing function of nature.

▲ Marc Chagall, *The Falling Angel*, 1922–47. Basel, Kunstmuseum.

He is represented as a repellent being devouring the damned or threatening the virtue of humankind in various guises.

Satan

Derivation of the name
From the Hebrew *satan*, "to obstruct," "to thwart"

Characteristics
He is God's principal adversary and the symbol of supreme evil opposed to divine Good; he is leader of the ranks of rebel angels

Religious and philosophical traditions
Judaism, Christianity, Islam, Gnosticism, Manichaeanism, Zoroastrianism

Related gods and symbols
Pan, God the Father, Christ, Lucifer, Leviathan, Beelzebub, Antichrist, devil, Eve, Virgin Mary; dragon, tempting snake, goat, evil

▶ Giovanni da Modena, *The Devil Devouring the Damned*, detail of the *Punishments of Hell*, ca. 1410. Bologna, San Petronio.

Visualizations of the demon undergo considerable transformation over the course of Christian history. In early Christian art, in accordance with the Book of Genesis, he is portrayed in the form of a snake; during the Middle Ages, following the identification of Satan with Lucifer by the Church Fathers, he takes the form of a terrifying, two-headed monster. From the tenth century onward, he is presented with broken wings, legacy of his fall from Heaven, and with horns on his head, symbols of defeated paganism. The bat's wings, emblems of the debasement of angelic virtue, were introduced after the Mongol invasions, which brought iconographic motifs of Eastern derivation into twelfth-century Europe. The Greek god Pan, too, is at the origin of some of the demon's features, such as the hairy body, the cloven hooves, and the goat's horns.

The iconography of Satan stabilized between the thirteenth and fourteenth centuries through the work of such artists as Andrea Orcagna, Fra Angelico, Taddeo di Bartolo, and Giotto, who drew their images from the vast body of apocalyptic literature, including the Apocrypha. Dante's *Divine Comedy* is another important source of representations of the devil. There he is a three-headed monster, placed at the bottom of the abyss of Hell. Satan's principal emissaries are Lucifer ("bearer of light"), Beelzebub ("lord of the flies"), the serpent Leviathan ("he who twists himself into coils"), Gog, Magog, and the Antichrist (the false Messiah).

Satan is portrayed, uncharacteristically, with a blue body. In the early Middle Ages, the devil and demons were usually given dark bodies of a different color, such as black, brown, red, or green.

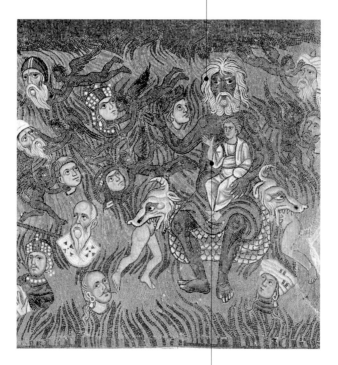

The Antichrist is a false Messiah who will appear on earth before the Last Judgment. In some interpretations, he is the son of the devil and is portrayed as a monstrous beast; in others, he is a man of flesh and blood.

▲ Byzantine school, *Satan Holding the Antichrist in His Arms*, detail of the *Last Judgment*, thirteenth century. Torcello (Italy), cathedral.

The donkey-ears underscore the bestial, evil nature of the devil and are attributes of Lucifer and the Antichrist.

The horns derive from the representation of the Celtic god Cernuunos and are a symbol of the Church's triumph over paganism.

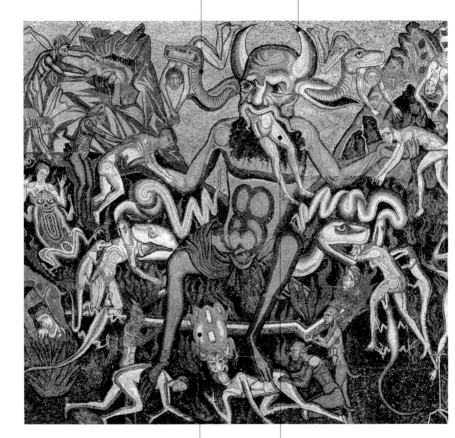

The animals devouring the damned serve to accentuate Satan's insatiable character.

Satan is often portrayed in the act of swallowing the damned. The motif of Hell's "devouring maw" reflects an ancient conception of divinity as both creative and destructive principle.

▲ School of Coppo di Marcovaldo (attributed), *Last Judgment* (detail), thirteenth century. Florence, baptistry.

The dragon Leviathan, the biblical monster described in the Book of Job, embodies the destructive power of evil.

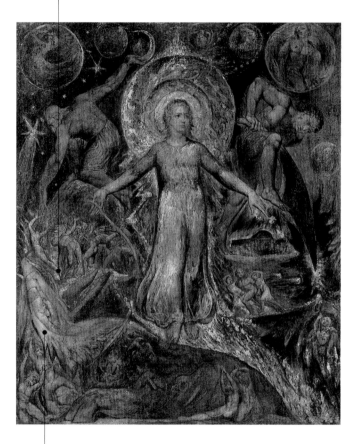

Leviathan's devouring nature is manifested even in relation to the stars, which the monster swallows up on the day of the Apocalypse. The serpent is also sometimes portrayed as a great whale or crocodile.

▲ William Blake, *Leviathan*, ca. 1805–9. London, Tate Gallery.

It is portrayed destroying lands, cities, and crops, mauling princesses, or being smitten by a hero's sword.

Monster

Derivation of the name
From the Latin *monstru(m)*,
"sign of the gods,"
"prodigy"

Origin of the symbol
It derives from a combination
of images from the Far East
whose original symbolic
importance has been lost

Characteristics
It represents all that is dark,
unknown, and mysterious in
the natural universe and the
human mind. In the Chris-
tian Middle Ages, deformity
was considered an outward
manifestation of evil

Related gods and symbols
Titans, Gorgons, Sphinx,
Erinyes, Furies, Minotaur,
Hydra of Lerna, lion of
Nemea, harpies, sirens,
Cerberus, Leviathan, Satan,
Lucifer; dragon, evil, demon

The monster personifies cosmic, social, or spiritual forces that have not yet been harnessed and integrated into a rational order. In ancient Greece, these forces were represented by images of vicious, hybrid creatures such as Cerberus, the Hydra of Lerna, the Gorgons, harpies, and sirens. The Erinyes and Furies, on the other hand, embodied an alteration of the psychic order.

Like many archetypal symbols, the monster displays a variety of aspects. In its role as guardian of treasure (i.e., the apples of the garden of the Hesperides, the Golden Fleece, etc.), it is considered a sign of divine presence. In esoteric traditions, "slaying the monster" means freeing the soul from the psychic bonds that prevent its elevation to a higher spiritual order or stands as a test. Thus Perseus slew the Gorgon Medusa to free himself from his enemy Polydectes.

Courtly literature and Renaissance painting partly revive the theme of the monster as initiation and intellectual trial. The struggle between the knight and the dragon came to stand for the liberation of the soul from the chains of the body, or as a political allegory of resistance to tyranny.

In Christianity, the deformed Lucifer personifies the concept of cosmic evil, and his monstrous aspect represents demonic temptation. This was an extremely widespread iconographic motif, especially in German and Flemish art—for example, in the painting cycles of the temptations of Saint Anthony by Bosch and Grünewald.

▶ Caravaggio, *Head of Medusa*, 1597. Florence, Uffizi.

The dragon represents the prison of the soul and the fetters that hinder its spiritual elevation. As a cosmic force, it combines the celestial nature of fire with the water and earth principles of the reptile, serving an important generative and life-giving function.

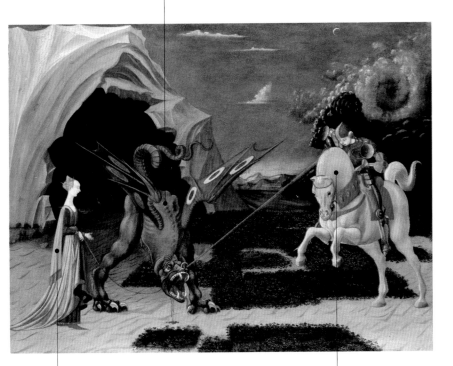

The psychic female principle, the anima, *holds the dark, uncontrollable drives of the unconscious on a leash. The princess has been interpreted as an image of the Church prevailing over the demonic powers.*

Saint George, the hero-knight par excellence, subdues and slays the dragon with his lance.

▲ Paolo Uccello, *Saint George and the Dragon*, ca. 1455. London, National Gallery.

The bound young woman is Andromeda, sacrificial victim and symbol of an ancient lunar deity subdued by the solar hero Perseus.

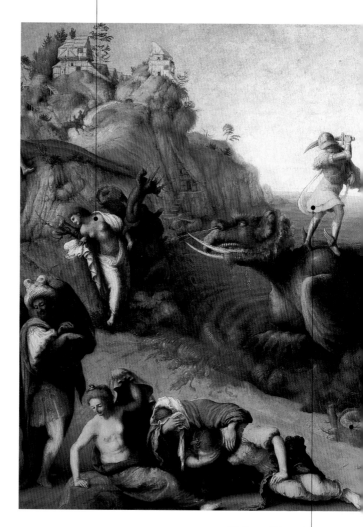

The figure of Perseus is thought to be a veiled portrait of Lorenzo the Magnificent.

▲ Piero di Cosimo, *Perseus Frees Andromeda*, ca. 1513–15. Florence, Uffizi.

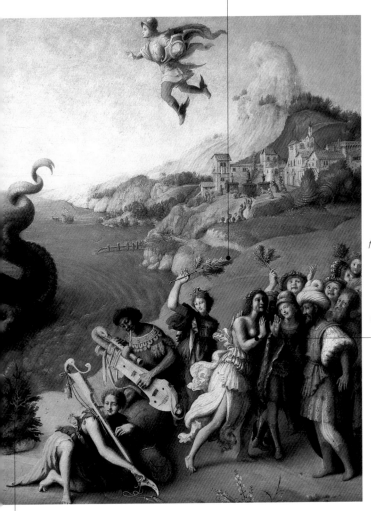

The laurel branch symbolizes the triumph of virtue over vice and, allegorically, of the house of Medici over the "monster" of the Florentine republic.

A number of the mythic heroes are actually Medici family members in disguise. The scene is a kind of carnivalesque masquerade in celebration of the noble family's return to Florence in 1512.

The tree stump in the foreground, with its fresh green growth, has been interpreted as the Medici broncone, emblem of Lorenzo the Magnificent and symbol of the return of the golden age under Medici rule.

Saint Anthony Abbot is being assailed by an infernal horde.

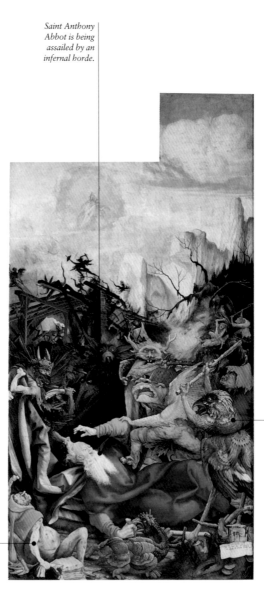

The hybrid monsters (birds with griffin-feet, dragons with batwings, and horned demons) represent the saint's temptations.

The pustules covering the devil's body display the artist's extensive medical knowledge.

▲ Matthias Grünewald, *The Temptations of Saint Anthony*, 1515–16, outer side panel of the *Isenheim Polyptych*. Colmar, Musée d'Unterlinden.

The infernal machine is an allegorical image of the male member.

The human-headed monster represents the destiny of man, condemned to live and die in sin because of his senses.

The musical instruments allude to the sadistic tortures inflicted upon the damned, those sinners who in life were "deaf" to divine law.

Satan devours the damned, expelling them as excrement.

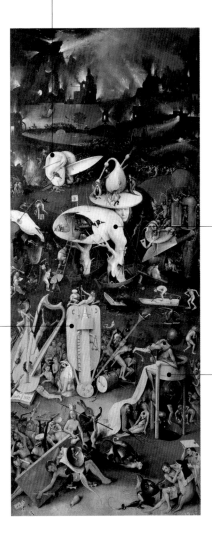

▲ Hieronymus Bosch, *Hell*, right panel of the *Garden of Earthly Delights Triptych*, 1503–4. Madrid, Prado.

A human figure with many heads, he represents the realm of the marvelous and the divine on earth.

Polycephalos

Derivation of the name
From the Greek *poly* (many) and *kephalos* (head)

Origin of the symbol
It derives from a misinterpretation of iconographic motifs from India and the Far East. In classical art it is represented in images of Hecate Trivia, the three-headed goddess who watches over crossroads and the thoroughfares of the dead

Characteristics
It represents an anomalous physical condition or one outside the natural realm

Related gods and symbols
Hecate Trivia, Heracles (Hercules), Janus, Jana, Persephone (Proserpina), Demeter (Ceres); androgyne, monster, crossroads, fork in the road, caduceus of Hermes

The symbolism of the *polycephalos*, or many-headed being, is closely connected to that of the monster. Unlike most of the terrifying creatures that people the Western imagination, however, it also enjoyed a positive connotation as a "marvelous being." Depending on the cosmic and spiritual qualities they represent, the polycephalic creatures of iconography and myth are bicephalic (two-headed), tricephalic (three-headed), or quadricephalic (four-headed). Bicephality represents the duality and complementarity of the masculine and feminine principles. The symbolism of the two heads is at once spatial (right and left), temporal (past and future), and spiritual (the essence and the substance of the universe).

In Western iconography, this concept has been expressed through the theme of the crossroads and the fork in the road, as well as in such two-faced gods as Janus. In the Christian imagination, a two-headed Christ symbolizes the union between spiritual and temporal power. Tricephalic gods express a more complex symbolism closely connected to the hidden face of the deity. Hecate Trivia, queen of the Underworld, is the greatest of the tricephalic divinities.

Quadricephalic beings express either the four-part division of the year into seasons and the correspondence of solstices and equinoxes, or the division of the earth's surface among the four cardinal directions.

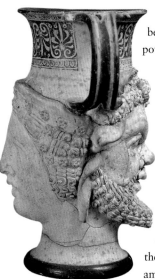

► Two-headed *kantharos* with satyr and maenad, mid-fourth century B.C. Rome, Museo Nazionale di Villa Giulia.

The wolf watches over the "left-hand" path, which coincides with earthly reincarnation.

The faces symbolize the three ages of time and of human life: youth (the past), maturity (the present), and old age (the future). They have also been interpreted as an allegory of prudence.

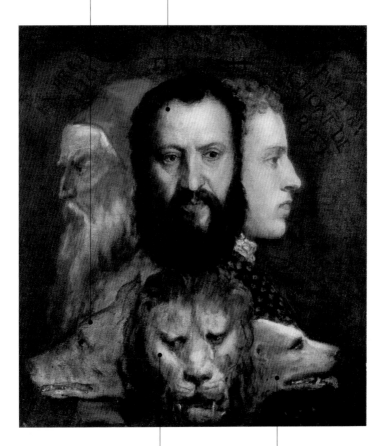

The animals represent the three paths that souls may take after death: the lion represents the solar path outside of time and the world.

The dog represents the path of heavenly rebirth.

▲ Titian, *Allegory of Prudence*, 1566. London, National Gallery.

It is represented by images of the Sphinx and the zoomorphic personifications of the four Evangelists.

Tetramorph

It represents the four-part division of the earth's surface into the cardinal points and four-way partition of the celestial vault into the constellations of Taurus, Leo, Aquila/Scorpio, and Aquarius, which correspond to the positions of the sun at the solstices and equinoxes as calculated during the Babylonian age.

The tetramorph appears in the Jewish Torah in the visions of Ezekiel and in the Book of Revelation (4:6–8), and in the images of the four Evangelists and their attributes. The latter symbolism derives from the sacred animals venerated in Egyptian and Mesopotamian cultures: the lion (Saint Mark); the royal peacock, later transformed into a winged man (Saint Matthew); the eagle (Saint John); the ox (Saint Luke), which may derive from the Babylonian winged bull.

In esoteric traditions these figures are associated with the four cosmic elements and the four qualities of wisdom. The eagle represents air, intelligence, and action; the lion, fire, strength, and movement; the ox, earth, endurance, and sacrifice; the winged man, intuition of the truth. The four human temperaments have also been associated with the tetramorph. Clear traces of this iconography are found in the West in the myth of the Sphinx, whose body and riddle conceal a tetramorphic conception of the cosmos, alluding to a full cycle of the equinoxes.

Derivation of the name
From the Greek *tetra* (four) and *morphos* (form)

Origin of the symbol
It derives from ancient images of animal-headed cherubim and Egyptian and Assyro-Babylonian iconographic motifs

Characteristics
It is the purest anthropomorphic manifestation of the concept of order and the universality of God. It corresponds to the position of the sun at the solstices and equinoxes between 4480 and 2320 B.C.

Religious and philosophical traditions
Judaism, Christianity

Related gods and symbols
Christ, Evangelists; Sphinx, lion, peacock, eagle, ox, bull, elements, cardinal points, solstices, equinoxes, seasons, temperaments

▶ *Tetramorphic Cherubim in the Vision of Ezekiel,* thirteenth century. Anagni (Italy), crypt.

The Sphinx's wings represent Aquila, the eagle of the constellation Scorpio, and the autumn equinox.

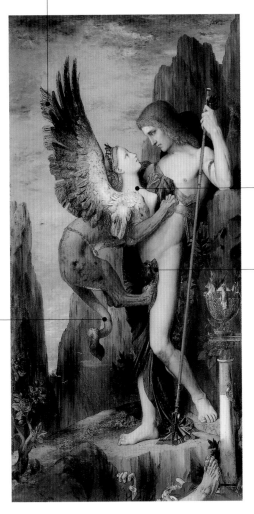

The Sphinx's upper body and face are human in appearance. Man has a privileged position in the symbolism of the tetramorph, being considered the axis and center of all creation.

The lion's tail indicates that the sun was positioned in Leo at the summer solstice, as calculated in ancient times.

The lower limbs originally had bull's hooves. The Babylonian year began with the spring equinox, corresponding to the sun's entry in the Taurus constellation.

▲ Gustave Moreau, *Oedipus and the Sphinx*, 1864. New York, Metropolitan Museum.

It is depicted as a human figure endowed with the limbs or body parts of one or more animals.

Zoomorph

Generally speaking, an animal attribute is a manifestation of the sacred and divine or an ascent to a higher condition than earthly existence. This dimension can be reached only through death (either actual or symbolic, through initiation). The myths of Actaeon, who was transformed into a stag, and of Ganymede, who was abducted by Zeus taking the form of an eagle, reflect this very ancient esoteric tradition, whose roots lie in Assyro-Babylonian and Egyptian solar cults.

The lion represents the highest form of animal transmutation. It symbolizes the fullest manifestation of cosmic energy and maximum earthly regality. An eagle's head symbolizes intellectual acumen, while a bull or ox head represents the lunar power that governs the rhythms of women's lives and the tides. The image of the bull is associated with Zeus (in the myth of Europa), Dionysus, and the terrifying figure of the Cretan Minotaur. One of the most emblematic of zoomorphic creatures is the god Pan, half man, half goat, keeper of the mysteries of the Dionysian cults. In Christian iconography, the principal zoomorphic figures are the four Evangelists. By the thirteenth century, fanciful hybrid creatures, symbolizing the spiritual impression that the human soul imposes on nature, were spread throughout Western iconography.

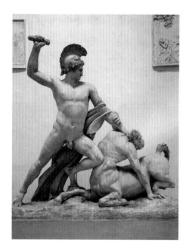

▶ Antonio Canova, *Theseus Defeating the Minotaur,* 1805. Possagno (Italy), Gipsoteca Canoviana.

As the ferryman of Christ (the soul), the figure of Christopher is derived from the dog-faced Egyptian god Anubis. This heritage is reflected in the saint's feast day, which falls in the middle of the "dog days" of summer.

As guide to the afterlife, Saint Christopher has been compared to Cerberus, the three-headed watchdog of the Underworld, and to Hermes. A trace of this transmigration of symbolism can be seen in the cross, derived from the Greek god's caduceus.

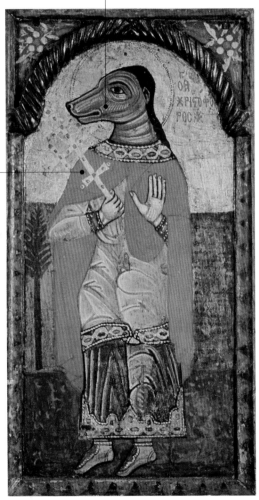

▲ Anonymous, *Saint Christopher with Dog's Head*, 1685. Athens, Byzantine Museum.

The goddess's gesture represents a symbolic transfer of wisdom from the realm of the Dionysiac mysteries to the rational sphere. In the Renaissance, the centaur was considered a symbol of lust and blindness and often represented ignorance.

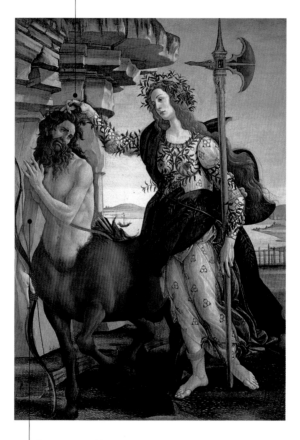

The association of the centaur with the carnal instincts derives from its role in the Dionysiac cults. Pholus the Centaur was the keeper of the mystical vessel (the wineskin), symbol of Dionysus.

▲ Sandro Botticelli, *Pallas and the Centaur*, ca. 1485. Florence, Uffizi.

This fantastic creature is a threefold symbol of birth (egg), death (captured prey), and rebirth (nimbus tail). It is a physical manifestation of the demonic and spiritual aspects of reality, including the souls of one's ancestors and the visions and fancies of men.

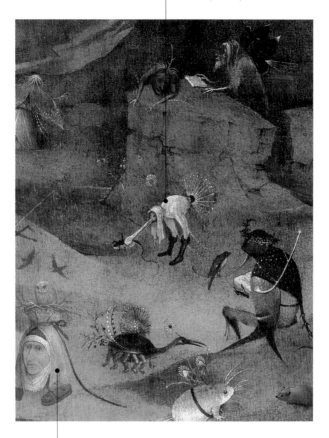

Hybrid creatures such as these grillen *were popular as talismans in late antiquity. They retained human features over only a few parts of the body, such as the head and the feet.*

▲ Hieronymus Bosch, detail of the *Saint Anthony* panel of the *Hermit Saints Triptych*, ca. 1505. Venice, Palazzo Ducale.

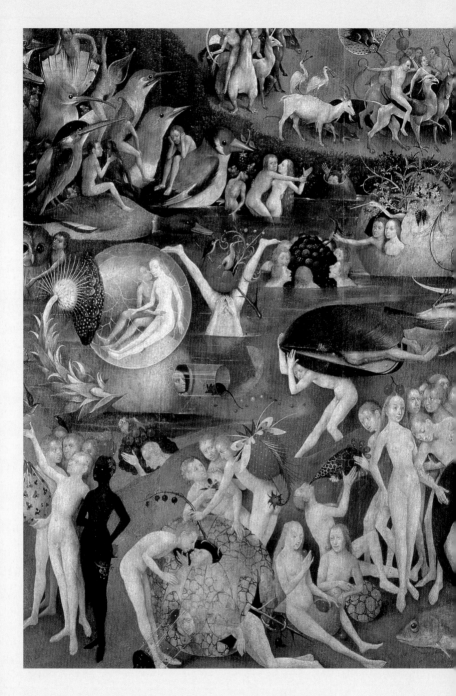

SPACE

Chaos

Derivation of the name
From the Greek *chaos*, "cleavage"

Characteristics
It represents the elemental confusion before the intervention of an ordering principle, and the fiery magma into which Lucifer and the rebel angels were cast down. In psychic terms it corresponds to the state of man after his fall from earthly Paradise

Religious and philosophical traditions
Platonism, Orphism, Hermeticism, Judaism, Christianity, alchemy

Related gods and symbols
Erebus, Night, Demiurge, Eros-Phanes, Sophia, God the Father, Satan, Lucifer; darkness, evil, Hell, void, nothingness, vice

▶ William Blake, illustration from the *Book of Urizen* (Lambeth, England, 1794).

It is represented by an upheaval of natural and psychic forces, by allegorical personifications of the deadly sins, or by images of ancient pagan gods.

Chaos represents the cosmic, psychological, and artistic state that precedes every creative process. It is a state utterly devoid of internal organization, function, or purpose, which must be reconstituted by an ordering principle (Demiurge, Eros, God the Father, Sophia) capable of making it conform to a higher plan. As the primordial womb, however, it is the potentiality from which all things derive, the Erebus or Night from which the world is born.

In Hermetic philosophy, chaos corresponds to the opposition between the elements in the *materia prima* before it has been sublimated by the alchemical process. This formless mass, which the alchemist-artist must bring to a state of perfection, derives from the fall and punishment of Adam after the commission of Original Sin. In the Jewish religion, chaos is identified with evil and the negative principle (the formless)

as opposed to the cosmos. In Greek mythology, the Titans personified forces that inhabited the world before the foundation of the Olympian order. Zeus confined them underground (at Tartarus) to limit their destructive activities.

Christian artists saw chaos as the devil's realm and populated it with monstrous beings derived from pre-Christian gods and beliefs.

Inscribed inside the triangle of
God is the word bereschith,
which means "in the beginning."

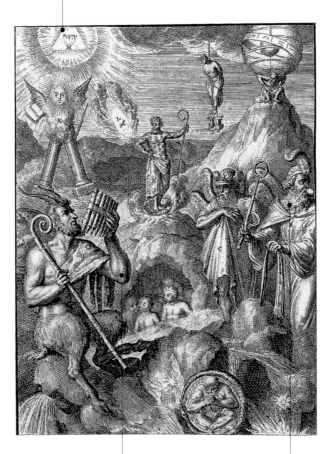

Pan and other pagan gods
symbolize the chaos of pri-
mordial matter.

An Egyptian god holds
the cosmic egg, symbol
of the creative Word, in
his mouth.

▲ Romeyn De Hooghe, *Hieroglyphica,
or Symbols of the Ancients* (Amsterdam,
1744).

The devil in the confessional represents the false spiritual guides to whom we entrust our souls.

The world turned upside down is a symbol of the false values upon which the society of the time rests. Using themes from popular folklore, Bruegel denounces the moral and political chaos of his country.

"Banging one's head against the wall" is the fate of the stubborn.

▶ Pieter Bruegel the Elder, *Flemish Proverbs*, 1559. Berlin, Staatliche Museen.

"Feeding flowers to pigs" means being unable to judge who is worthy of recompense. The painting is based on the Adages *of Erasmus of Rotterdam.*

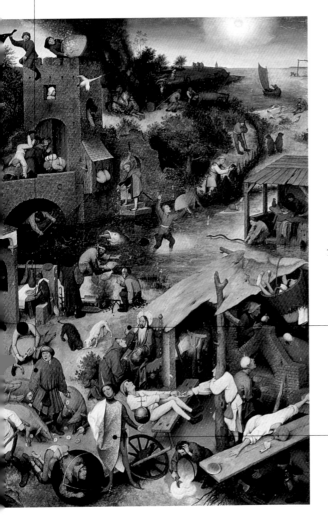

The clergyman sullies himself with blasphemous behavior, such as putting a false beard on the Redeemer.

The nobleman balancing the globe on his thumb represents the whimsy with which the powerful rule the world.

It is a system hierarchically ordered by a higher god and divided into archetypal systems such as the zodiac, the elements, and the cardinal points.

Cosmos

The cosmos is the result of God's organization of the primordial forces. In ancient creation myths, world order was achieved through a violent struggle between opposing cosmic divinities. The first stage of creation consists of separating the primordial elements: light from darkness, sun from moon, water from land. In certain traditions, this process of distinction originates in an external ordering principle (the Platonic Demiurge, the Orphic Eros-Phanes, God the Father); in others it arises from nothingness through a natural reconstitution of matter.

In Christian cosmology, influenced in large part by Platonic thought, the world was created according to a specific mental model: the *unus mundus*, perfect and everlasting, corresponding to the mind of God himself. For the Church Fathers, the universe is the mirror in which the Supreme Being is reflected, manifesting himself to humankind and letting it get to know him (however gradually and imperfectly).

Renaissance natural philosophy is founded on this correspondence. Since the human soul is in harmony with the world's soul, man may grasp the meaning of the structure of the entire universe. On the basis of this axiom, Florentine

Neoplatonists formed their theory of love and conceived of the work of art as a stage in the spiritual ascent toward God.

Derivation of the name
From the Greek *kosmos*, "order" or "world"

Characteristics
It is the orderly whole encompassing all that exists, and it corresponds to the entire universe. It represents the archetype of all creative action and symbolizes the sacred nature of the universe

Religious and philosophical traditions
Platonism, Orphism, Hermeticism, Judaism, Christianity, alchemy

Related gods and symbols
Eros-Phanes, Demiurge, God the Father; chaos, man as microcosm, egg, life, death, struggle, good, evil, Sophia, virtue

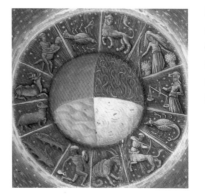

▶ *The Four Elements and the Signs of the Zodiac*, miniature from *De proprietatibus rerum* by Bartholomaeus Anglicus. Paris, Bibliothèque Nationale.

The scepter of government and the lightning bolt of punishment are attributes of Eros-Phanes, who rules over the forces of nature by organizing them according to a higher principle.

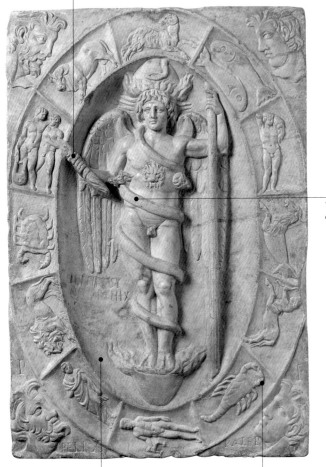

The serpent's coils symbolize the four seasons.

The cosmic egg is the primordial nucleus of the world.

The wheel of the zodiac represents the ordering principle of Phanes, prime mover of the universe.

▲ *Phanes with the Signs of the Zodiac,*
Mithraic relief, third century A.D.
Modena (Italy), Galleria Estense.

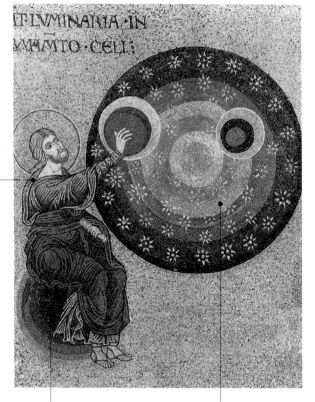

God the Father is portrayed in the act of creating the sun, the moon, and the firmament.

The unus mundus is the immutable, perfect model of the cosmos.

The Christian heavens are divided into ten spheres corresponding to the seven planets; the firmament (the sphere of fixed stars); the primum mobile, or outermost sphere; and the empyrean, or highest heaven.

▲ *The Creation of the Heavens,* mosaic, 1172–76. Monreale (Sicily), cathedral.

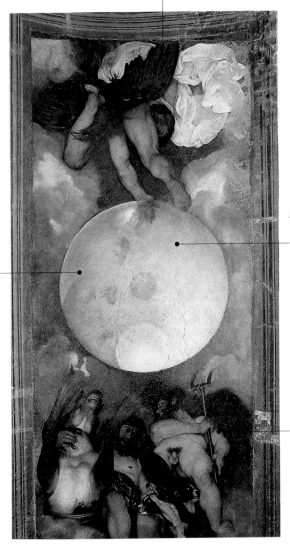

Jupiter, accompanied by an eagle, personifies the transfiguration of matter into the gaseous state (air).

The signs of Aries, Taurus, and Gemini refer to the ideal season (spring) for performing the alchemical Work.

The philosopher's stone is a symbol of cosmogenesis.

Neptune, with Cerberus, and Pluto, with a "sea horse," symbolize the liquid and solid states of matter.

▲ Caravaggio, *Pluto, Neptune, and Jupiter (Allegory of Alchemical Creation)*, ca. 1597. Rome, Casino di Villa Boncompagni Ludovisi.

Pegasus, son of Neptune and
the Gorgon, represents the
synthesis of earth and sky.

The winged girl per-
sonifies precariousness
and dexterity, indis-
pensable qualities for
beginning the creative
process.

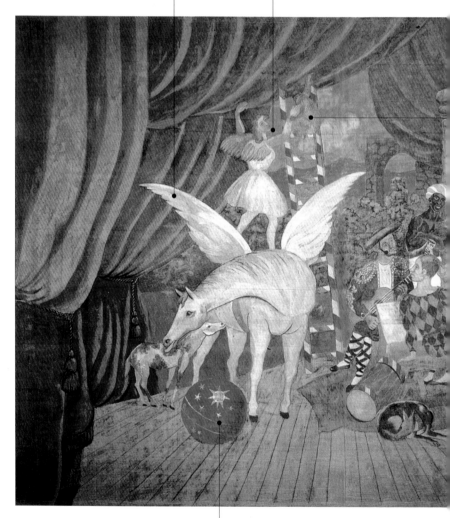

The starry sphere symbol-
izes the cosmos.

The monkey symbolizes either the solar, ordering dimension of creation, or its demonic, subterranean aspect.

The gods, who give order to the cosmos, conceal themselves beneath the acrobats' threadbare costumes.

Harlequin is Mercury transformed into a circus character.

◄ Pablo Picasso, drop curtain for the ballet *Parade*, 1917. Paris, Musée National d'Art Moderne, Centre Georges Pompidou.

It is represented by the god Uranus or motifs such as concentric spheres, celestial maps, or the constellations of the zodiac.

Sky

Derivation of the name
From Old Saxon *skio* and
Old Norse *sky*, "cloud"

Origin of the symbol
In Greek mythology it was
identified with Uranus

Characteristics
It creates and nourishes all
living beings, fertilizing the
earth with its aqueous
humors. It represents con-
sciousness and a higher
dimension than the sensual,
earthly one

**Religious and philosophical
traditions**
Platonism, Hermeticism,
Judaism, Christianity, Islam,
alchemy

Related gods and symbols
Uranus, Gaea, Demiurge,
God the Father; good, man
as microcosm, cosmic egg,
androgyne, circle, earth, bell,
overturned cup, parasol,
dove

It represents the universal order and the higher, active principle in juxtaposition with the earth. It nearly all of its etymologies, it is masculine in gender, even though in Egypt it was associated with the goddess Nut. Symbol of a remote dimension inaccessible to man, the sky is home to the gods and sometimes coincides with divinity itself. In mythology it is populated by a multitude of deities who communicate with the earth through specific premonitory signs: the weather, for example, was thought to depend directly on the will or whim of the gods. Christianity replaced the pagan gods with angels and archangels, each of which was assigned dominion over a planetary sphere.

According to Aristotelian and Ptolemaic doctrine, the celestial spheres are divided into ten skies or heavens, corresponding to the seven planets; the firmament (the sphere and the fixed stars); the *primum mobile,* or outermost sphere; and the empyrean, where God, the angels, and the blessed dwell.

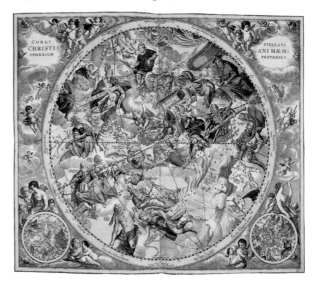

▶ *The Christian Firmament,*
illustration from *Harmonia
macrocosmica,* by Andreas
Cellarius (Amsterdam, 1660).

Splashed across the sky, the milk from Juno's breast will form the Milky Way.

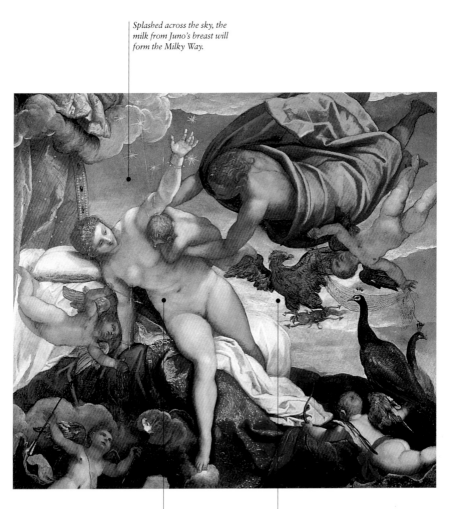

In Renaissance painting, artists commonly used images of the pagan gods to represent the elements of the cosmos.

The eagle clutching thunderbolts in its talons is a symbol of Jupiter, the god who confers order on the cosmos.

▲ Tintoretto, *The Origin of the Milky Way* (detail), ca. 1575. London, National Gallery.

Jupiter is the only planetary god depicted in the fresco. His attributes (the eagle and thunderbolts) are also the heraldic devices of the Farnese family, which commissioned the painting.

Argo Navis, one of the most important constellations in antiquity, has been broken up in the modern age into six smaller constellations and is no longer visible in full from the Mediterranean.

The signs of the zodiac follow one another above or below the line of the ecliptic.

This map of the heavens presents only the major constellations, such as Orion followed by his hounds, Perseus with the Medusa's head, and Hercules with club and lionskin.

The Milky Way is represented as a white ribbon unfurling across the firmament.

◄ Giovanni Antonio Vanosino da Varese, vault of the Sala del Mappamondo (Hall of the World Map), 1573. Caprarola (Italy), Palazzo Farnese.

Jupiter, king of the gods, is depicted on the same plane as the other personifications of the stars.

The signs of the zodiac represent the influence exerted by each deity over a particular month of the year.

Divine Providence, at the center of Olympus, embodies the supremacy of the Christian religion over the pagan cults.

▲ Veronese, ceiling of the Sala dell'Olimpo (Hall of Olympus) (detail), 1559–61. Maser (Italy), Villa Barbaro.

The light source represents the empyrean, the celestial Paradise where God dwells. This view of Heaven can also refer to the heart of Jesus or the Virgin Mary.

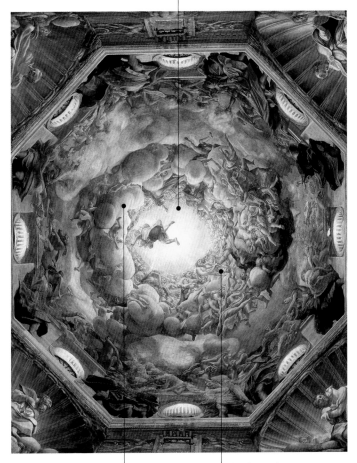

The composition of the clouds underscores the Virgin's skyward movement. The spiral rhythm symbolizes the soul's journey after death.

The Christian heavens are peopled by angels and the souls of the saints and the blessed.

▲ Correggio, *Assumption of the Virgin*, 1525–28. Parma, cathedral dome.

It is represented by the Olympian gods Helios and Apollo and can also emblematically stand for Christ.

Sun

Derivation of the name
From the Old English *sunne* and Old Frisian *sunne, sonne*

Origin of the symbol
It derives from the Egyptian cults devoted to Osiris and Amun-Ra

Characteristics
It is the star of the day around which the earth and the planets rotate. It represents the principal source of cosmic life

Religious and philosophical traditions
Pythagorism, Platonism, Orphism, Hermeticism, Judaism, Christianity, Islam, alchemy

Related gods and symbols
Helios, Phoebus (Apollo), Zeus (Jupiter), Christ; androgyne, chrism, chrysanthemum, lotus, sunflower, eagle, stag, lion, fire, gold, tree of life, day, chariot, wheel, circle, life, spirit, heart, intuitive knowledge

▶ Anonymous, *The Chariot of Apollo*, early nineteenth century. Rome, Palazzo Spada, Hall of the Four Seasons.

Like all archetypal symbols, the sun has a dual, ambivalent nature. It is the source of light, warmth, and life on earth but may also become a source of destruction and drought. The sun's negative attributes are expressed in the myth of Phaeton; its regenerative role is represented in the unending alternation of day and night and the seasonal cycles. In the Christian religion, it symbolizes immortality and resurrection.

As an emblem of Christ, the "new Sun" of justice and truth, it has twelve rays, corresponding to the twelve apostles. Romanesque churches often face the east, celebrating the association of the heavenly orb with Christ, the incarnation of the creative forces represented by the sun.

In alchemy, the image of the sun is split into the daytime orb, golden and life-giving, and the "black sun," the raw material not yet transformed by the Master and the symbol of his nocturnal journey through the Underworld.

The sun is an ordering principle of the cosmos: It governs a temporal cycle and has its own calendar, and its rays represent the different dimensions of space. This role complements the moon's influence on natural growth and women's biological rhythms. The sun is usually portrayed as an astral deity in the form of Helios or Apollo, or as a solar disk with a man's face inscribed in it. It appears as the heart of the world at the center of the zodiac wheel. It is a symbol of fatherhood and royal authority.

Apollo represents an aspect of
intuitive knowledge, which enters
the human heart in the form of
rays of light.

The ordering principle of the
universe, the Sun rules the
sequence of signs in the zodiac.

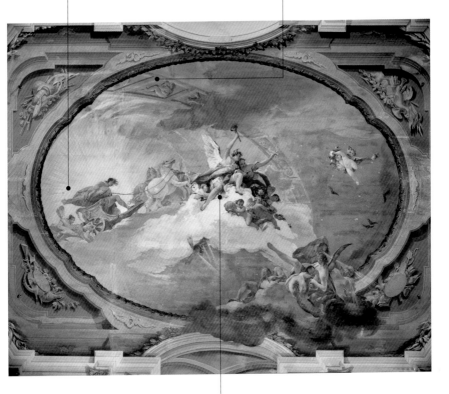

Dawn and Day, flaming torch in hand,
chase away the shadows of Night.

▲ Costantino Cedini, *The Chariot of the
Sun*, seventeenth century. Casalserugo
(Italy), Villa Lion da Zara.

It appears in images of the pagan goddesses Diana and Selene, as they move across the sky in a chariot drawn by a pair of horses, or in representations of the Virgin Mary.

Moon

Derivation of the name
From the Old English *móna*, Old Frisian *môna*

Origin of the symbol
It derives from Egyptian cults devoted to Isis

Characteristics
It represents cosmic flux and the link between earth and the heavens. It governs the tides, the weekly and monthly cycles, the biological rhythms and phases of female fertility

Religious and philosophical traditions
Pythagorism, Platonism, Orphism, Hermeticism, Judaism, Christianity, Islam, alchemy

Related gods and symbols
Ishtar, Isis, Selene, Artemis (Diana), Hecate Trivia, Jana, Medusa, Endymion; the Virgin Mary; water, silver, pearl, bull, life, cosmic egg, androgyne, death, life, night, soul, brain, reflexive knowledge

The moon represents the feminine, passive principle, which is opposite and complementary to the sun. It is the second most important orb in the universe and governs, with its magnetic powers, the earthly waters and the growth cycles of nature. Like Mother Earth, it is considered a receptacle of life and universal fecundity. It has a dual nature: In its frightening aspect it has been identified with Hecate Trivia and the Gorgon Medusa, whose hair is associated with the rays of moonlight. Its pale, ghostly face was, moreover, considered one of the entrances to the Realm of the Dead.

This bipolarity is shared by the various divinities that personify the moon: the Mesopotamian goddess Ishtar (full moon) represents the moon's positive, life-giving aspect; the virgin Diana (crescent moon) embodies its celestial, ordering function; the queen of Hades, Hecate (new moon), is a negative force, subterranean and aquatic; and two-faced Jana, wife of Janus, guards the gates of Heaven and Hell.

The Christian tradition superimposes the figure of Mary, universal mother and dispenser of grace, on the great white goddesses of antiquity, personifying nature's generative function. As Queen of the Apocalypse, the Virgin also expresses the lunar aspect associated with death. From a cognitive perspective, the moon is a symbol of consciousness, the unconscious, creativity, and memory. In alchemy it is the feminine side of the androgynous pair (*rebis*).

▶ Veit Stoss, *Moon*, detail from the *Annunciation*, 1518. Nuremberg, St. Lorenzkirche.

*The moon is personified by
the goddess Diana.*

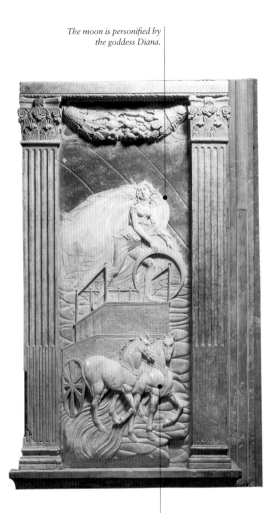

*The lunar chariot is drawn by a pair
of horses, symbols of the orb's two
faces (one deadly, the other fertile).*

▲ Agostino di Duccio, *The Moon*,
1449–57. Rimini, Tempio
Malatestiano, Chapel of the Planets.

Earth

Derivation of the name
From the Old Saxon *ertha*

Origin of the symbol
In Greek mythology, it was identified with the goddesses Gaea and Demeter

Characteristics
It is the cosmic principle that complements the sky

Religious and philosophical traditions
Platonism, Hermeticism, Judaism, Christianity, Islam, alchemy

Related gods and symbols
Gaea, Cybele, Demeter (Ceres), Tellus, Uranus, Demiurge, God the Father; chaos, cosmic egg, man as microcosm, androgyne, elements, square, sky, temple, life, death

Feasts and devotions
Eleusinian mysteries, Dionysian mysteries, Thesmophoria

It is represented by Ceres in her primordial form as a headless goddess, or in maps of the world and allegories of the continents.

Earth is the primordial Mother and receptacle of all living beings. Her generative function is contained in the etymology of the word *humus*, the Latin word for "earth," which derives from the same root as the word *homo*, "man."

According to ancient legends retold in the Sumerian epic of Gilgamesh, in Plato's *Timaeus*, and in the Book of Genesis, God created the human race by combining four different types of earth, gathered at the four cardinal points.

In Greek mythology, Demeter, Mother Earth, is personified by several different goddesses who reflect her seasonal character: Kore, the divine virgin beloved of the Wind, represents the fecundity of nature (the green grain); Persephone, bride of Hades, represents the necessary turn of the seasons (the ripe grain); and Hecate (the harvested grain) stands for the mystery of life's continual regeneration through death. In the Bible, the earth is a negative principle associated with primordial chaos and evil. It is reevaluated in the Middle Ages and likened to the temple and to Christ. In the Renaissance, Earth often appears in allegories of the elements and the continents or is represented as the goddess Ceres, laden with crops.

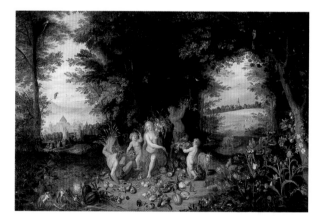

▶ Jan Brueghel the Younger, *Allegory of the Earth*, ca. 1630. Los Angeles, J. Paul Getty Museum.

Shem is portrayed at the center of the composition, in keeping with Christian religious doctrine, which considered Jerusalem the center of the world.

The axis of the earth coincides with the Mediterranean basin.

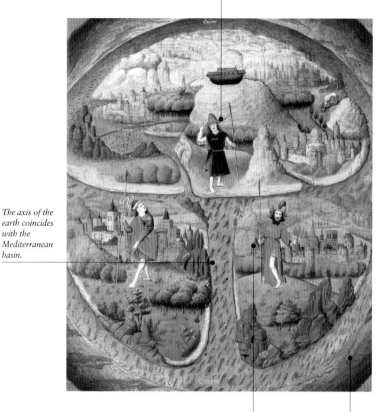

The three sons of Noah represent Asia (Shem), Europe (Japheth), and Africa (Ham).

The river Ocean marks the confines of the known world.

▲ Simon Marmion (attributed), *Mappa Mundi* (detail), miniature from *La Fleur des histoires* by Jean Mansel, 1459–63. Brussels, Bibliothèque Royale Alber 1er.

Earth

The river Nile is identified by the crocodile beside him and the crown of wheat stalks, symbol of the fertility of his banks.

The woman being embraced by the Danube represents Europe.

The black Venus symbolizes Africa. This continent is also sometimes represented by exotic animals such as the lion and elephant.

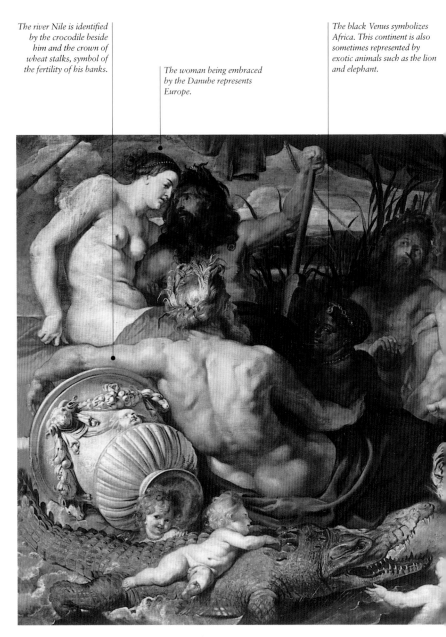

Asia leans on the river Tigris, personified as a robust elderly man accompanied by a tiger.

Allegories of the continents are a recurrent theme in Baroque art. The Catholic Church used them as emblems of the evangelization of the planet.

America is pictured beside the Amazon River. She is often shown with golden coins, an allusion to the myth of Eldorado and her wealth of natural resources.

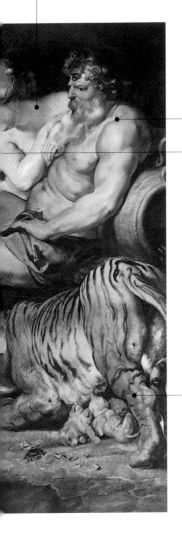

Exotic animals, rare plants, and typical archaeological elements help the viewer to identify the personified continents.

◄ Peter Paul Rubens, *Allegory of the Four Continents*, ca. 1612–14. Vienna, Kunsthistorisches Museum.

The god Bacchus is associated with agrarian rituals and presides over the grape harvest and the production of wine.

Ceres personifies Earth in her role as provider of nourishment, as indicated by the crown of wheat and the cornucopia overflowing with food.

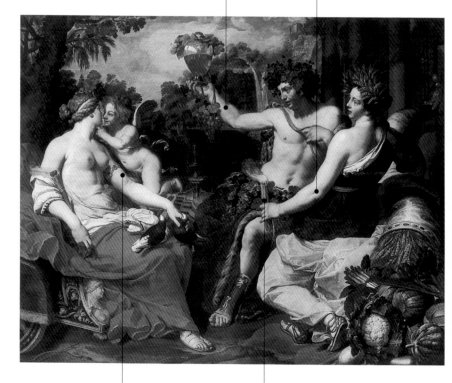

The torch represents the goddess's seasonal character. In winter, Ceres leaves the earth and enters the Kingdom of the Dead to search for her daughter Proserpina (spring).

Venus and Cupid represent the harmony of the natural elements.

▲ Abraham Janssens, *Ceres, Bacchus, and Venus*, after 1601. Sibiu (Romania), Brukenthal Museum.

The primordial theme of the headless goddess is used to represent Mother Earth.

The universal Mother is portrayed reclining, in a position that suggests imminent childbirth or coitus.

▲ Marcel Duchamp, *Given: 1. The Waterfall; 2. The Illuminating Gas*, 1944–66. Philadelphia Museum of Art.

They are represented by gods personifying the forces of nature, or by the various animals and natural products corresponding with each element.

The Elements

Derivation of the name
From the Latin *elementum*

Characteristics
They represent the fundamental principles of the cosmic order and the natural world

Religious and philosophical traditions
Pythagorism, Platonism, Orphism, Hermeticism, Judaism, Christianity, Islam, alchemy

Related gods and symbols
Macrocosm, microcosm, ages of man, seasons, hours of the day, colors, temperaments, cardinal points, signs of the zodiac

Together with the seasons and the human temperaments, the four elements complete the doctrine of correspondences between macrocosm and microcosm: the belief in the analogy between man and the universe as a whole. Water (wet-cold), corresponds to winter and the phlegmatic temperament; fire (dry-hot), to summer and the choleric temperament; earth (dry-cold), to autumn and melancholy; and air (wet-hot), to spring and the sanguine temperament. To this pre-Socratic conception of the world Aristotle added a fifth principle: the ether, immaterial and incorporeal, made of the same substance as God (the Unmoved Mover) and the soul.

In classical antiquity the elements were associated with the planetary gods: Jupiter (air), Neptune (water), Pluto (earth), and Vulcan (fire). These personifications would later become recurrent iconographic motifs in the art of the Renaissance and Baroque periods.

► Jan Brueghel the Younger, Frans Francken II, *Landscape with Allegories of the Four Elements* (detail), ca. 1630. Los Angeles, J. Paul Getty Museum.

The burning brazier symbolizes fire.

The bird represents the airy element.

The vase and pitcher refer to water.

The products of the earth are associated with the senses of taste and smell, in keeping with an iconographic tradition that became widespread in the sixteenth and seventeenth centuries.

▲ Jacques Linard, *The Five Senses and the Four Elements*, seventeenth century. Paris, Louvre.

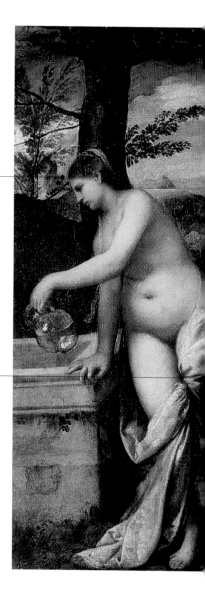

The woman at the well is a
personification of water. She
has also been interpreted as
an allegory of temperance.

The lute-player represents
fire. According to
Pythagorean doctrine, the
entire universe is governed
by mathematico-musical
relationships of harmony.

▶ Titian, *Concert champêtre*, ca. 1510.
Paris, Louvre.

The man whose hair is
disheveled by the wind has
been identified as Air.

The woman seen from behind represents Earth.
The painting expresses the harmony of the cosmic
elements, in keeping with the theories current
among Venetian humanist circles.

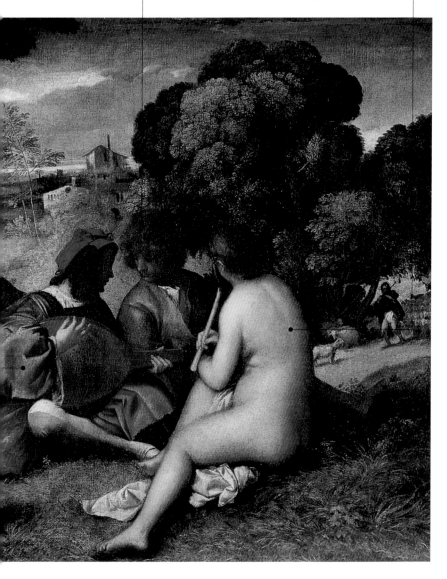

This allegorical portrait, one of four representing the elements, synthesizes the morphologies of many different aquatic species.

The pearl necklace and earring give the portrait a sexual connotation: we recognize the figure to be female.

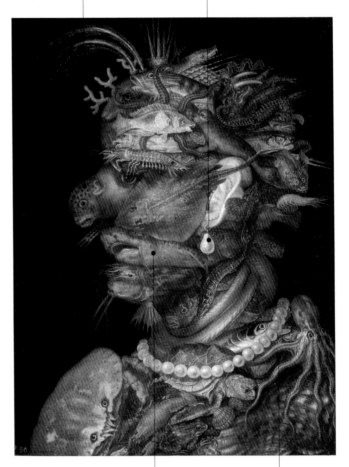

The shark, a predator, is used to represent the mouth.

A number of the animals serve a purely decorative function, representing distinctive parts of the woman's clothing.

▲ Giuseppe Arcimboldo, *Water*, 1566. Vienna, Kunsthistorisches Museum.

The brimming cornucopia is a typical attribute of Ceres.

Eros symbolizes the harmonious union of the elements, indispensable for the fertility of nature.

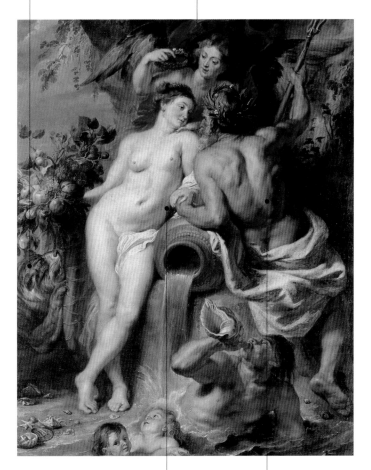

Earth, personified by the goddess Ceres, is presented as a voluptuous, naked woman.

The god of the sea, Neptune, recognizable by his jug and trident, personifies water.

▲ Peter Paul Rubens, *Allegory of Earth and Water*, ca. 1618. St. Petersburg, Hermitage.

The precious objects allude to the brilliant color of flame, which is similar to that of gold.

The golden chandelier evokes fire's illuminating power.

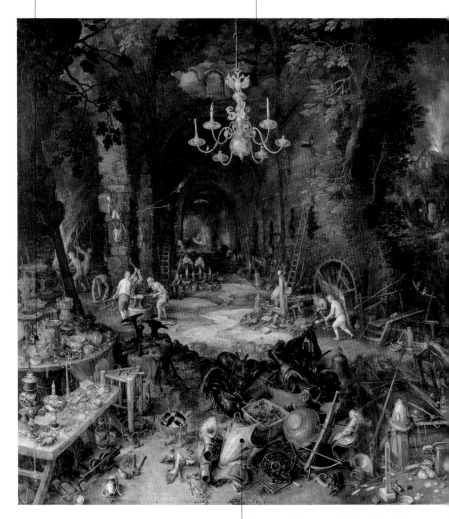

The armor alludes to man's blacksmithing skill and to the power of fire to forge metals.

While the scene on the left shows man's mastery of fire, the conflagration here represents the element's destructive power.

The demonic creatures personify fire's infernal aspect as a primary attribute of the devil.

The alembics and athanor illustrate the role of fire in the alchemical process: to purify and transform base matter into pure.

◄ Jan Bruegel the Elder, *Allegory of Fire*, late sixteenth–early seventeenth centuries. Milan, Pinacoteca Ambrosiana.

It is depicted as a dark, desolate land, inhabited by subterranean deities and by the souls of the dead.

The Hereafter

It represents both the continuation of life after death and the dwelling place of the souls of the dead. It is situated in an unspecified part of the world that the ancients placed in the far north (the realm of the Hyperboreans, the Isle of the Blessed, and the Elysian Fields) or on the Moon. The gates to the hereafter were situated in the West, where the sun begins its nocturnal journey through the Underworld. Starting in the fifth century B.C., the Greeks, under the influence of Eastern traditions, began to distinguish between the different homes of the dead. Tartarus and Avernus were the underground realm of Hades and Persephone, while the Isle of the Blessed was an intermediate, celestial realm where humans live on as shades while awaiting reincarnation.

Hecate Trivia, guardian of crossroads, determined which direction the souls of the dead should take: the road on the right led to immortality and heavenly transfiguration; the road on the left led to earthly reincarnation; and the middle path allowed the celestial gods passage over the earth. The iconography of the afterlife was heavily influenced by classical mythology and later by Dante's *Divine Comedy*. Hades is peopled by monstrous creatures and famous damned people such as Tantalus, Sisyphus, and the Danaids, who defied the gods.

Derivation of the name
The concept derives from the image of the "other bank" of the Acheron, the river that leads to the Realm of the Dead

Origin of the symbol
The image of "beyond the grave" is based on mythological narratives from Graeco-Roman civilization, as found in the *Iliad*, the *Odyssey*, and the *Aeneid*

Characteristics
It is where the souls of the dead live on

Religious and philosophical traditions
Pythagorism, Platonism, Orphism, Hermeticism, Judaism, Christianity, Islam, alchemy

Related gods and symbols
Hades (Pluto), Persephone (Proserpina), Hecate Trivia, Erinyes, Cerberus, Charon; the rivers Acheron, Styx, Cocytus, and Phlegethon; night, moon, horse, West, winter

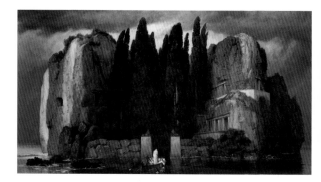

▶ Arnold Böcklin, *The Isle of the Dead*, 1880. Leipzig, Museum der Bildenden Künste.

The white horses are a symbol
of Pluto's lethal power.

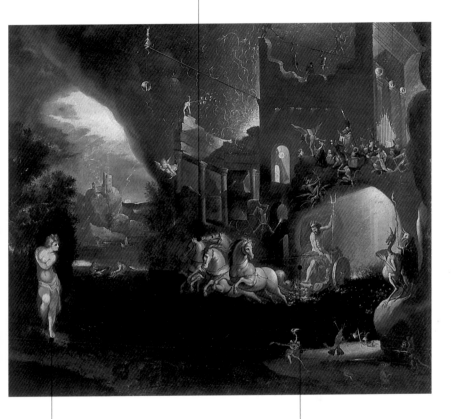

The goddess Venus
orders Cupid to wound
the god of the dead
with his arrows of love.

Hades, whose name means
"the invisible," is sovereign of
the Underworld. The Romans
called him Pluto, "the rich,"
underscoring the god's rule
over the fabulous riches hidden
in the bowels of the earth.

▲ Joseph Heintz the Younger, *Pluto
Arriving in Tartarus*, ca. 1640.
Mariánské Lázně (Marienbad)
(Czech Republic), Mestské Muzeum.

The font of Paradise is the spring from which the river Lethe flows.

The waters of Lethe have the power to make one forget the past and to grant eternal youth.

Charon ferries the souls of the dead to the gates of Hades.

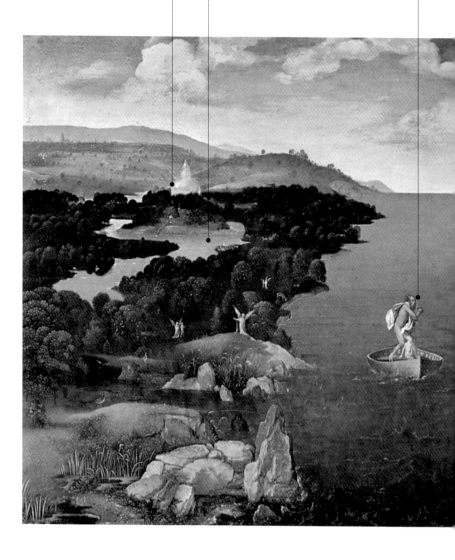

The Styx, one of the four rivers of the Underworld, passes through the darkest, deepest part of Hell: Tartarus.

Cerberus, the three-headed dog, guards the entrance to the Realm of the Dead.

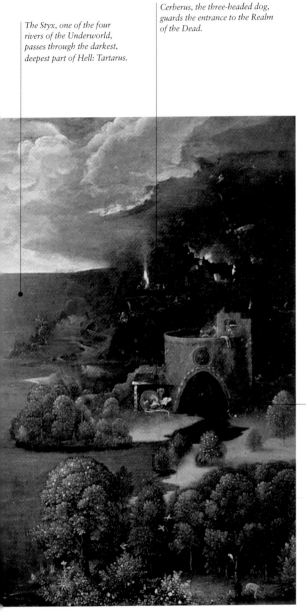

The gate of Hell is depicted as dark and cavernous. According to the Greek writer Pausanias, one of the gates was located at the southern end of the Peloponnesus, in an inlet still visible on the Akra Tainaron (Cape Matapan).

▲ Joachim Patinir, *Landscape with Charon Crossing the Styx*, ca. 1520. Madrid, Prado.

It is depicted as a lush, fertile garden, illuminated by a bright, diffuse light and peopled by angels and the blessed.

Paradise

Paradise, or the Kingdom of Heaven, is the spiritual dimension where God the Father, Christ, the Virgin, the prophets, the patriarchs, and the angels live. It does not appear in Jewish tradition until rather late (the Book of Ezekiel), when it is made to correspond with the place where the body is resurrected.

According to the Church Fathers, the souls of the blessed reach Paradise, situated in the empyrean, by traveling through the heavenly spheres, each of which is watched over by a guardian angel. The theme of the ascent into Heaven recurs repeatedly in religious doctrine, in such episodes as Jacob's dream (Judaism), Mohammed's *miraj* (Islam), and the Christian dogma according to which the bodies of Christ and the Virgin are assumed into Heaven.

The representation of Paradise varies distinctly from one era to another. The Middle Ages favored symbolic depictions of the Heavenly Realm, based on numerology, on harmonic musical and chromatic relationships (the colors of the rainbow), and on images from Holy Scripture, such as the temple, the city (Heavenly Jerusalem), and the contemplation of God.

Derivation of the name
From the Persian *pairi-daeza*, which means "garden surrounded by a wall"

Origin of the symbol
It derives from Eastern beliefs in the resurrection of the body after death

Characteristics
It is the place of eternal beatitude. The soul reaches it via an upward journey, passing through all the heavenly spheres on its way up to the empyrean

Religious and philosophical traditions
Zoroastrianism, Platonism, Judaism, Gnosticism, Christianity, Islam

Related gods and symbols
God the Father, Christ, Virgin Mary; angels, temple, city, Heavenly Jerusalem, East, light

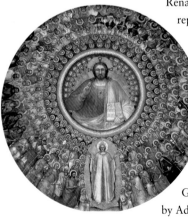

Renaissance artists loved to represent it realistically as a luxuriant garden in which one could cultivate virtuous earthly pleasures: music, conversation, and dance. This image is based on the myth of the Golden Age and Earthly Paradise, the Garden of Eden inhabited by Adam and Eve.

▶ Giusto de' Menabuoi, *Christ, the Virgin, and the Ranks of Saints and the Blessed*, detail of *Paradise*, 1375–76. Padua, baptistry.

Fruit-picking is a recurrent theme in depictions of Paradise. The trees of life and knowledge bestow the gifts of immortality and wisdom.

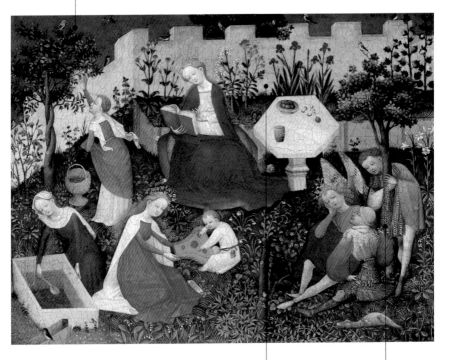

The enclosure wall evokes the motif of the hortus conclusus *of medieval monastic life. This enclosed garden is built in the image and likeness of Earthly Paradise.*

Earthly activities such as reading and conversation often figure in the iconography of Paradise.

▲ Upper Rhenish master, *The Garden of Paradise*, ca. 1410. Frankfurt, Städelsches Kunstinstitut.

It is depicted as a mountain, or as a valley or deep well spanned by a bridge.

Purgatory

It is the place where the souls of the dead, who sullied themselves with venial sins during their time on earth, are cleansed. It is represented as a mountain adjacent either to Earthly Paradise or to Hell, of which it is essentially the reverse side. The distinction between the punitive function of Hell's fire and the cleansing power of Purgatory's fire further underscores the parallelism of the two places, both of which are devoted to the expiation (eternal and temporary) of sins committed.

The Old Testament contains no references to Purgatory, which derives from the Catholic dogma of divine grace incarnate in Christ and from the concept of redemption from sin. Jews, Muslims, and Protestants deny the existence of Purgatory, since it is absent from Holy Scripture.

Following the canonization of this dogma at the Council of Lyon in 1274, the Catholic Church established the doctrine of suffrage, whereby the punishments of the dead could be temporarily alleviated through prayer, pilgrimage, and alms, or through the purchase of indulgences, a practice severely condemned by the Protestant Reformation.

Together with Dante's *Divine Comedy*, Jacobus de Voragine's *Golden Legend* is a fundamental source for the iconography of Purgatory.

Derivation of the name
From the Latin *purgare*, "to purify"

Origin of the symbol
It was established in the thirteenth century as a fundamental dogma of the Catholic Church

Characteristics
It is a place of penance, an intermediate stage on the way to the Kingdom of Heaven in which the dead may once again be led into temptation. An eternal fire burns there, with the power to cleanse the sinner's souls

Religious and philosophical traditions
Catholicism

Related gods and symbols
God the Father, Christ, the Virgin Mary, angels; mountain, bridge, cleansing fire

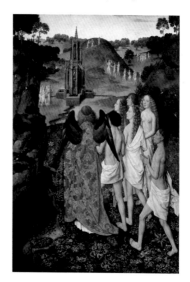

▶ Dieric Bouts, *The Angel Accompanying Souls out of Purgatory*, detail of *The Last Judgment*, ca. 1450. Lille, Musée des Beaux-Arts.

The journey to Paradise is represented as a flight through the heavenly spheres or a climb up a mountain.

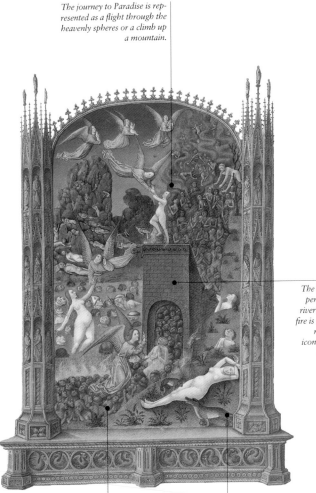

The bridge suspended over a river of pitch or fire is a recurrent motif in the iconography of Purgatory.

The sinners are immersed in freezing waters or fiery rivers, depending on what faults they committed when alive.

▲ Limbourg Brothers, *Angels Lifting the Souls out of Purgatory*, illumination from the *Très Riches Heures du duc de Berry*, ca. 1416. Chantilly, Musée Condé.

Animals such as the otter, the she-wolf, and the serpent symbolize earthly temptations.

The archangel Michael, armed
with flaming sword, stands guard
at the gates of Heaven.

The seven rings of
Purgatory correspond
to the seven deadly
sins: pride, envy,
anger, sloth, greed (or
prodigality), gluttony,
and lust.

The souls of sinners retain
the appearance they had in
life and are portrayed in
attitudes of supplication.

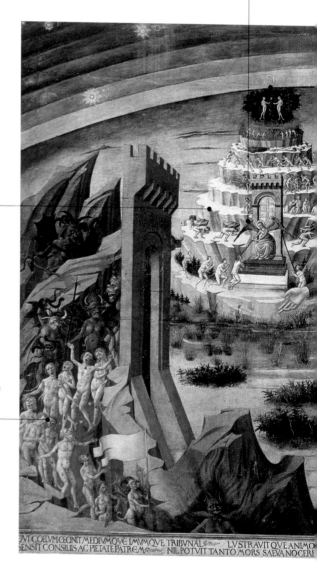

At the summit of the mountain of Purgatory is the Garden of Eden, inhabited by Adam and Eve.

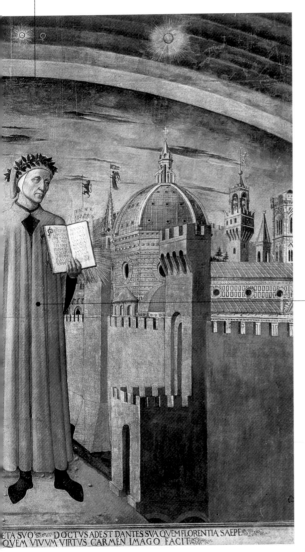

Dante Alighieri here explains the contents of his Divine Comedy, which opens with the famous first lines of the Inferno: "Midway upon the journey of our life / I found myself within a forest dark, / For the straightforward pathway had been lost" (H. W. Longfellow translation).

◀ Domenico di Michelino, *The Mountain of Purgatory*, 1465. Florence, Santa Maria del Fiore.

Limbo

Derivation of the name
From the Latin *limbus*,
"border" or "margin"

Origin of the symbol
The term was popularized in
the thirteenth century by
Peter Lombard

Characteristics
It is the antechamber to Hell
and coincides with the
"breast of Abraham," in
which the souls of the just
rested

**Religious and philosophical
traditions**
Orphism, Judaism, Christian-
ity, Islam

Related gods and symbols
Heracles (Hercules),
Orpheus, Odysseus (Ulysses),
Aeneas, Christ, Archangel
Michael, Hell, cross

*It is the peripheral region of Hell, dwelling place of the souls
of the just who were not baptized or were born before Christ's
coming.*

Limbo is an intermediate region between Hell and Heaven, a
resting-place for the souls of the just who lived before the
birth of Christ, and of babies who died before being baptized.
When Christ descended into Hell in the three days preceding
his resurrection, he freed and bore up to Heaven Adam, the
biblical patriarchs and prophets, and all those who had lived
in faith and in a state of grace while awaiting the coming of
the Messiah. According to some exegetes, later refuted by
Church Fathers Saint Augustine and Saint Thomas Aquinas,
the great men of antiquity (philosophers, scholars, generals,
poets, and literati) were also liberated from Limbo and taken
up to Paradise.

The theme of the descent into the Underworld by a hero or
god derives from ancient initiation rites linked to the cults of
Orpheus and Hercules, where the victory of life over death
was celebrated. In the Orthodox Christian tradition, Christ's
journey into Limbo is an important part of the Easter festivi-
ties. The subject first enters Christian iconography in the
ninth century. The most famous description of Christian
Limbo is in Dante's *Divine Comedy*.

▶ Federico Zuccaro, *Dante and
Virgil Meet the Pagan Souls of
the Just in Limbo* (detail),
1585–88. Florence, Uffizi,
Gabinetto dei Disegni.

Limbo is peopled by the unbaptized souls of the just and by shades of illustrious men from antiquity.

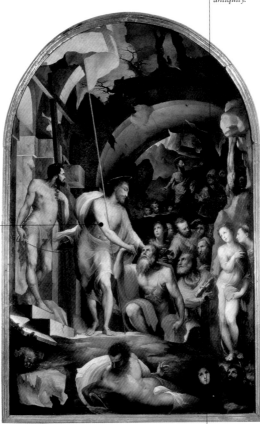

Wrapped in the shroud in which he was buried, Christ descends into Limbo to free the souls of those who lived righteously.

Adam and the biblical patriarchs are the first to be admitted into the Kingdom of Heaven.

▲ Domenico Beccafumi, *Christ's Descent into Limbo*, 1536. Siena, Pinacoteca Nazionale.

Hell

Derivation of the name
Old English *hel(l)*, from the root *hel-, hal-, hul-*, "to conceal." In Old Norse, *Hel* is the name of the goddess of the Underworld

Origin of the symbol
It derives from descriptions found in the apocryphal Gospels and from the visions of medieval monks

Characteristics
It is the place of eternal damnation, where the unrepentant sinners dwell

Religious and philosophical traditions
Judaism, Christianity, Islam, Gnosticism

Related gods and symbols
Satan, Lucifer, Leviathan, Antichrist, rebel angels; the torture wheel, the gridiron of Hell, shadows, destructive fire, death mask, devouring maw

It is depicted as an abyss or a fiery crater. Its nine rings are peopled by the souls of the damned and by demonic creatures.

The realm beyond the grave is located underground and is described as a place of eternal punishment and torment. In the Old Testament, little space is dedicated to describing the afterlife. The Jews believed that the souls of the dead dwelled in a place called Sheol, the Realm of Shadows, regardless of their merits or faults. The apocryphal Book of Enoch, the main iconographical source for the Christian Hell, puts Satan and the rebel angels in this dark abyss.

Hell is commonly divided into nine circles, paralleling Heaven's nine choirs of angels and corresponding to the sins committed on earth, in keeping with the doctrine of *lex talionis* (law of retribution). This iconography of Hell spread in the West in the ninth and tenth centuries, in detailed illuminations illustrating the Book of Revelation. The principal literary source of Christian Hell, however, is Dante's *Divine Comedy*, which shows the combined influence of classical descriptions (Homer, Plato, Virgil, Ovid) of the Realm of the Dead, the apocryphal Gospels, and Arab and Scholastic exegetes. At the bottom of the infernal abyss dwells Satan or three-headed Lucifer, often portrayed devouring the damned.

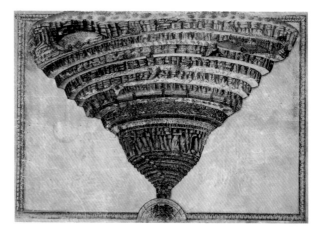

► Sandro Botticelli, *Inferno*, frontispiece to Dante's *Divine Comedy*, with commentary by Cristoforo Landino (Florence, 1481).

Snakes and toads bite the
breasts and genitals of sin-
ners guilty of lust.

Each circle corre-
sponds to the
punishment of a
sin, according to
the doctrine of
lex talionis. In
this ring, the glut-
tons are forced to
abstain from food
and drink.

The iconography
of Christian Hell
abides by rigorously
codified rules, such
as those laid out in
the Elucidarium by
Honorius of Autun,
who divides the
Underworld into
nine concentric
circles.

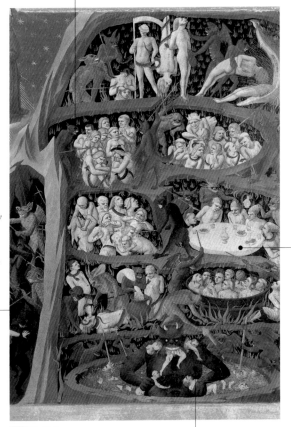

▲ Fra Angelico, *Punishments of the
Damned in Hell*, detail of the *Last
Judgment*, 1432–33. Florence, Museo
di San Marco.

Satan's jaws have the
function of bringing all
created things back to
the state of undifferenti-
ated matter.

It expresses the impulse to search, discover, and seek change. It is depicted as a crossing over the sea or over unfamiliar lands, or as a descent into the Underworld.

Journey

Derivation of the name
From the Old French
journée, "day"

Origin of the symbol
It derives from ancient initiation rites associated with cults of solar deities (Gilgamesh, Orpheus, Hercules, Christ), where one celebrated the victory of life over death

Characteristics
The journey of the soul embodies the search for happiness, truth, and immortality; physical displacement implies the conquest of new territory

Religious and philosophical traditions
Judaism, Christianity, Islam, Gnosticism

Related gods and symbols
Hermes (Mercury), Heracles (Hercules), Orpheus, Christ; Promised Land, dream, death

The journey represents discovery and initiation, and it is presented as an imaginary trip into the realm of the beyond or into uncharted regions.

Many mythological narratives use the motif of the journey to describe an expansion of the boundaries of a given domain. Such stories tell of a people's wanderings after they are expelled from their own land or describe the attainment of a higher spiritual level. Prominent versions of this highly symbolic activity include the journey of the soul after death, that of the hero into the Underworld, of the Magi to Bethlehem, or of the knight-errant into the dark forest.

The descent into the hereafter closely parallels the nighttime traverse of the sun through the realm of the Underworld. This journey is directly tied to the sun's symbolism as a lifegiver, which is regenerated daily by defeating death (the shadows of night). The journey, moreover, represents a return to one's origins, the *regressus ad uterum* into Mother Earth.

The inner journey of the soul, on the other hand, is associated with self-knowledge, an indispensable prerequisite for knowing the world and God.

The quest for the Promised Land, for Paradise Lost, and the pilgrimage to the Holy Land are among the literary, religious, and psychological motifs most representative of this symbolic theme.

▶ Albrecht Dürer, *Gerson Dressed as a Pilgrim,* engraving, 1494, frontispiece of the *Quarta pars operum* of Johannes Gerson (Strasbourg, 1502).

The unfurled sails sym-
bolize the luck that
changes with the wind.

The Pillars of Hercules at the Strait
of Gibraltar represent the outermost
boundary of the ancient world.

The exploits of the
Argonauts are mod-
eled on the Odyssey,
the archetype of all
travel narratives.

The Argonauts have superhuman
moral, intellectual, and physical
qualities.

▲ Lorenzo Costa, *The Expedition of
the Argonauts*, 1484–90. Padua,
Museo Civico degli Eremitani.

The archangel Gabriel is sounding one of the seven trumpets of the Apocalypse.

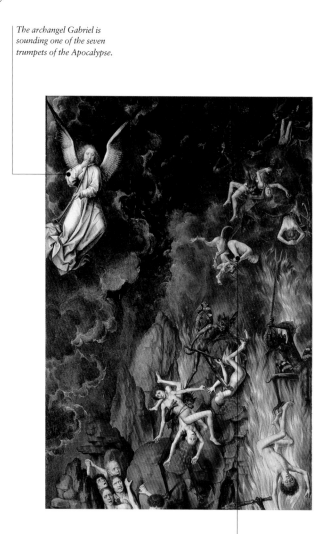

The damned fall through a descending vortex down into the abyss of Hell, where they are greeted by imps and demons.

▲ Hans Memling, *Souls Falling into Hell* (detail), panel of the *Last Judgment Triptych*, 1466–73. Gdańsk, Muzeum Narodwe.

To guarantee passage to the next sphere, the blessed would memorize magic formulas contained in treatises on demonology.

The undying light source is the empyrean. Its etymology means "all fire."

The journey of the blessed souls, each escorted by a guardian angel, is depicted as an upward movement through the heavenly spheres.

▶ Hieronymus Bosch, *Ascent of the Blessed*, panel of *Paradise and Hell*, 1500–1503. Venice, Palazzo Ducale.

The girl with the skein is Ariadne, daughter
of the king of Crete, Minos. She embodies
Theseus's feminine element (anima).

▲ Master of the Cassoni Campana,
Theseus and the Minotaur, 1510–20.
Avignon, Musée du Petit-Palais.

Theseus's triumph over the Minotaur represents the victory of reason over the savage instincts and unconscious drives.

Theseus is portrayed as a sixteenth-century knight. Setting a mythic story in contemporary surroundings was a widespread practice among Renaissance painters.

The labyrinth symbolizes the hero's inner journey into his own unconscious.

The dark cave represents the unknown.

The map of the heavens presents the Aristotelian-Ptolemaic system, on which the disciplines of geography, astronomy, and biblical exegesis were based.

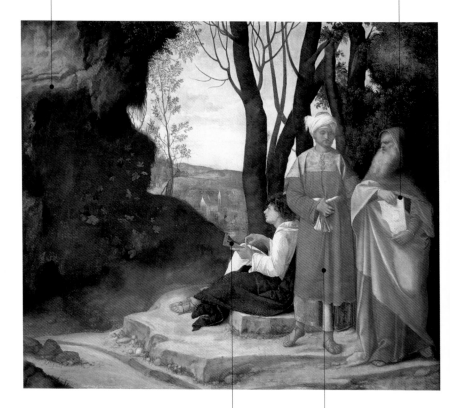

The ruler and compass were essential tools for finding one's way, before the invention of the compass.

▲ Giorgione, *The Three Philosophers*, ca. 1504. Vienna, Kunsthistorisches Museum.

Dressed as ancient philosophers and scholars, the Wise Men represent the union of scientific and esoteric knowledge of the East and West.

The wanderer, a key figure in
Romantic poetry, travels without
any specific destination.

The sea of clouds is a
symbol of the Sublime,
that peculiar "feeling"
one gets when contem-
plating nature.

▲ Caspar David Friedrich,
Wanderer over the Sea of Fog,
1815. Hamburg, Kunsthalle.

Dream

It is depicted as a journey or a vision in which the protagonist is guided by forces beyond the control of his will.

Dreams represent a dimension parallel to reality, one characterized by a privileged relationship with the divine and the unconscious. In Greek mythology, the dream was considered a gift of the god Hypnos, son of primordial Night (Nyx) and brother of Thanatos (Death). Sleep is an ambiguous deity, dispenser of contradictory gifts: nightly rest, through which one recovers from the fatigue of one's daily labors; terrible nightmares; and knowledge of the future, often communicated by the spirits of the dead through prophecies and premonitions. If the nightly dream represents a state of clairvoyance and the union (ecstatic or amorous) between man and divinity, the daydream, on the other hand, is directly connected to the intellectual faculty of fantasy and the imagination. In Renaissance iconography, dream images were drawn from the Bible, from the visions of Christian mystics, from Graeco-Roman literary and mythological texts, and from the *Hypnerotomachia Poliphili* (*The Strife of Love in a Dream*) of 1499 by Francesco Colonna, a vast repository of symbols and emblems.

Derivation of the name
From the Early Middle English *dream*, "dream," and Old English *dréam*, "mirth" or "noise," with possible derivation from Germanic *draugmo-*, related to "to deceive, delude"

Origin of the symbol
It derives from the biblical episode of Jacob's dream, from Cicero's *Somnium Scipionis* (*Scipio's Dream*), from the mystical visions of medieval monks and nuns, and from secular and religious literature

Characteristics
It is a psychic state that entirely evades the rational control of the dreamer and frees his or her unconscious impulses. It may have premonitory, prophetic, introspective, initiatory, visionary, telepathic, or cathartic importance

Related gods and symbols
Night, Hypnos, Thanatos, Eros-Phanes, Morpheus, Phoebus (Apollo), Hermes (Mercury), Orpheus; death, vices, virtues, the hereafter

▲ Pierre Puvis de Chavannes, *The Dream* (detail), 1883. Paris, Louvre.

The angel comes down to earth
to reveal to Constantine a sign
of his future victory against
Maxentius.

The sleepy young
page's task is to watch
over the emperor
while he sleeps.

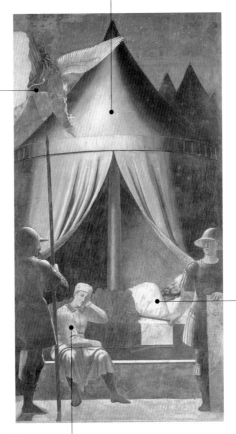

The glow indi-
cates the pres-
ence of God.

The cross on which
Christ was crucified
appears to Constantine
in a dream.

▲ Piero della Francesca, *The Dream of
Constantine*, detail from the *Story of
the True Cross*, ca. 1457–58. Arezzo,
San Francesco.

Dream

The figures in the back-
ground personify the
seven deadly sins.

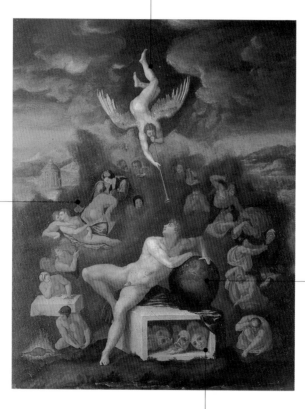

The masks sym-
bolize falsehood
and lies.

The angel,
messenger of
virtue, wakes
the young man
from the tor-
por of vice.

The globe of the earth
symbolizes the instabil-
ity of the human soul,
which constantly
wavers between the
path of vice and the
way of virtue.

▲ Sixteenth-century Italian artist,
The Dream (after Michelangelo).
Florence, Casa Buonarroti.

This little monster, half devil, half monkey, represents the demonic forces that burst forth in nightmares.

The white horse is a visual transcription of a nocturnal demon from Franco-Germanic folklore, the hellish "night mare" that dwells in the bowels of the earth.

The animal's pale, ghostly appearance and its milky, fixed gaze are taken from a famous print by Dürer, The Knight, Death, and the Devil.

▲ Henry Fuseli, *The Nightmare (Incubus)*, 1790–91. Frankfurt, Goethe Museum.

The heroes in the Poems of Ossian *by*
James Macpherson inspired a great
many nineteenth-century artists,
including Runge, Carstens, Fuseli,
and Abildgaard.

The ghosts evoked
by Ossian look and
pose like heroes
from classical
mythology.

Ossian represents the
dream as a source of
poetic inspiration.

▲ Jean-Auguste-Dominique Ingres,
The Dream of Ossian, 1813.
Montauban, Musée Ingres.

*The image is a dream transfigura-
tion of the buzzing of a bee, heard
while the artist was asleep.*

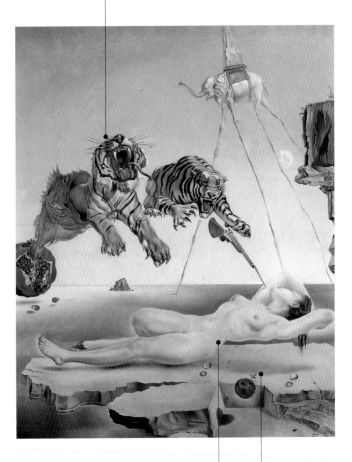

*The painter used
dream-images of his
wife Gala as inspira-
tion for his paintings.*

▲ Salvador Dalí, *Dream Caused by the
Flight of a Bee around a Pomegranate
One Second before Waking Up*, 1944.
Lugano (Switzerland), Thyssen-
Bornemisza Collection.

*The bee that is about to sting
alludes to the moment just
before waking.*

It symbolizes the means to spiritual, intellectual, and moral elevation.

Ladder

Derivation of the name
From Old English *hlaed(d)er*, from *hlinian*, "to lean"

Origin of the symbol
It derives from the ladder of Ra in the Egyptian *Book of the Dead* and the Mithraic mysteries of late antiquity, reinterpreted by the Church Fathers in accordance with Christian eschatology

Characteristics
It embodies the gradual attainment of spiritual elevation and serves as a link between Heaven and earth

Religious and philosophical traditions
Judaism, Mithraic mysteries, Christianity, Islam, Gnosticism, alchemy

Related gods and symbols
Christ, Mithras; mountain, cross, ark, tree, liberal arts, virtues, rainbow, sky, earth, Paradise, Hell

Images of ladders and stairways express the desire to reestablish the broken connection between man and divinity, between earth and Heaven. In Christian iconography, it may have seven or twelve steps. The seven correspond to the different levels of spiritual elevation: the planetary spheres that the soul must cross before reaching the sphere of fixed stars, or the seven liberal arts, symbols of the achievement of perfection through moral and intellectual education. The twelve symbolize the twelve apostles. The "Jacob's ladder" of the Bible (the gateway to Heaven) is the literary and iconographic source on which the Christian Church Fathers based their mystical interpretation of the subject. In the Middle Ages, the Cistercian monastery was defined as a *scala Dei* (ladder to God), highlighting the monks' spiritual ascent through the daily practice of prayer.

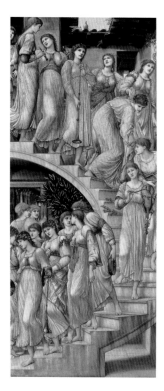

The ladder represents a journey of initiation, whether its destination is Heaven or Hell. Christ's cross takes the ladder's function as a vehicle of mystical asceticism to a sublime level: It becomes the sacrificial instrument through which humankind is redeemed from sin and freed from eternal damnation. In alchemy, the ladder symbolizes the structure of the universe.

▶ Edward Burne-Jones, *The Golden Stairs*, 1880. London, Tate Gallery.

The golden ladder symbolizes the scala Paradisi, *or stairway to Heaven. The thirty rungs correspond to different stages of spiritual elevation.*

The angels represent the different steps along the heavenly ladder.

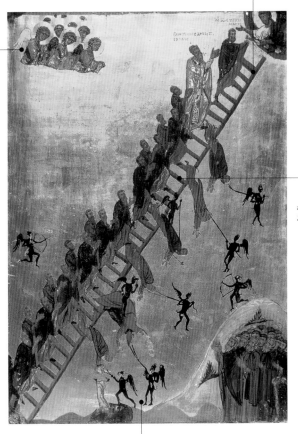

Each rung is associated with a book of Scripture, such as Proverbs, Ecclesiastes, and the Song of Solomon.

The demons, personifying vice, drag back to earth the souls of those who cannot take the ascending steps.

▲ *Icon of the Allegorical Ladder of Saint John Climacus,* late twelfth century. Sinai, Monastery of Saint Catherine.

At the top of the mountain is Heavenly Paradise, abode of God and the angels.

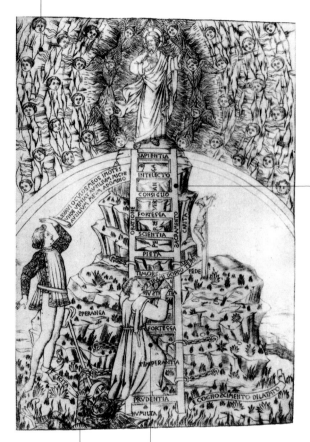

The ladder represents the path to spiritual elevation. The rungs correspond to the twelve apostles and each is labeled with a moral or intellectual virtue.

To reach the Kingdom of Heaven, the adept must strip himself of pride and don the simple garments of humility.

The tempting devil seeks to prevent man from freeing himself from earthly passions and turning his gaze heavenward.

▲ Sandro Botticelli, *The Mountain of the Virtues*, illustration from the *Sacred Mountain of God* by Antonio Bettini (Florence, 1477).

It appears as an inaccessible place, surrounded by insurmountable obstacles: deep lakes, labyrinths, dense layers of clouds.

Mountain

The mountain is where the sacred (hierophany) and the divine (theophany) are made manifest. Mount Tabor, Adam's burial place, marks the *omphalos*, the navel of the world. Moses received the tables of the Law on Mount Sinai, and Christ was crucified on Mount Calvary. Mountains open and close the cycle of Judeo-Christian revelation and mark the passage from the age of divine law to the age of forgiveness illuminated by grace.

The mystical nature attributed to the mountain derives from the fact that at its summit, often hidden under a thick blanket of clouds, the sacred marriage (hierogamy) of Heaven and Earth is consummated. On its slopes, moreover, lie the gates to the Kingdom of the Dead, symbol of the return to the beginning: the womb of the Great Mother. In almost all theogonies, the mountain hosts the greatest concentration of deities. This is particularly true of the Greeks, who make their mountains (Olympus, Parnassus, Helicon) the abodes of the gods.

The sacred mountain rises up at the center of the world and, like the cross, the ladder, and the tree, represents its axis and its root.

Derivation of the name
From medieval Latin
montanea

Characteristics
It represents the center of the world and the vehicle of ascent into Heaven and the return to the beginning

Religious and philosophical traditions
Graeco-Roman religion, Judaism, Christianity, Islam

Related gods and symbols
Zeus (Jupiter), Phoebus (Apollo), Muses; ladder, cross, virtues, Earthly Paradise, Purgatory, center, right triangle, temple, rainbow, cosmic egg, cave, uterus, source

◀ Lorenzo Leombruno,
Olympus Surrounded by the Labyrinth, ca. 1510.
Mantua, Palazzo Ducale,
Sala dei Cavalli.

The image of the mountain as an allegory of human life is drawn from a first-century A.D. philosophical dialogue known as Cebes' Pinax.

The concentric bands represent the various human vices and earthly pleasures that lead man away from the path of virtue.

Venus gives the young man a scented flower, symbolic allusion to lust and the sensual pleasures.

▶ Quentin Varin, *Tabula Cebetis*, 1600–1610.
Rouen, Musée des Beaux-Arts.

At the mountain's summit we find Beatitude, portrayed in the act of crowning a new initiate.

The figures encircling the adept personify the cardinal virtues.

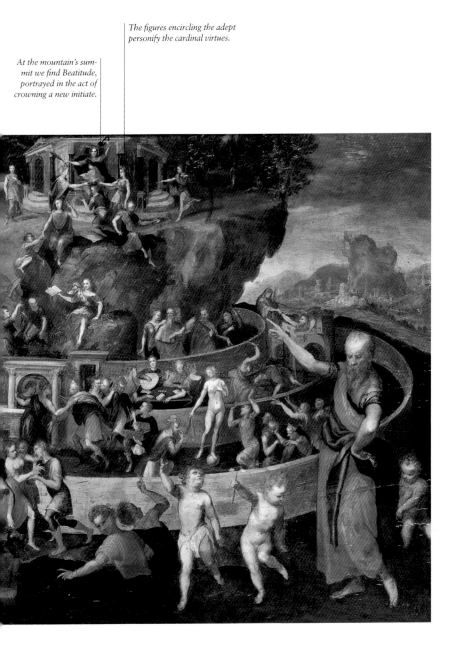

It is depicted as a dark, secluded place with a luminous clearing at its center, symbol of spiritual initiation achieved.

Forest

Derivation of the name
From the late Latin *foresta*,
whose root means "standing
outside of"

Characteristics
It represents the regenerative
capacity of nature and the
realm of the unknown

**Religious and philosophical
traditions**
Graeco-Roman and Celtic
myth, Judaism, Christianity,
Islam

Related gods and symbols
Muses; mountain, Earthly
Paradise, garden, tree,
labyrinth, vices, virtues,
ladder, woman

The forest may be interpreted as either a sacred place or a symbol of the deepest reaches of the unconscious.

The sacred dimension derives from the fact that a forest comprises multitudes of trees, symbols of the vital lymph of the universe and nature's regenerative capacity. Because of the dense tangle of vegetation and shadow within it, however, the forest is also considered the abode of hybrid and demonic creatures (elves, dragons, giants, satyrs, centaurs, nymphs, witches) and associated with the unknown. The most important sylvan dwellers include the Men of the Woods, personifications of untamed nature before the introduction of agriculture. In antiquity, certain woods were venerated, such as the one inhabited by the Muses atop Mount Parnassus or the oak grove of Dodona in Epirus, ancient sanctuary of the Greeks. In courtly literature and the chivalric epics, the passage through the dark forest represents a test of mettle.

Psychologically speaking, the forest is a symbol of unexplored femininity. The heart of the woods, usually represented as a clearing, stands for the sacred enclosure within which the protagonist makes contact with the divine.

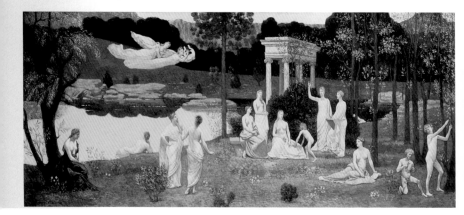

The eternal flame, sacred heart of
the wood, represents the elevation
of nature to the level of the divine.

The procession of veiled maidens is
inspired by ancient images of the
vestal virgins.

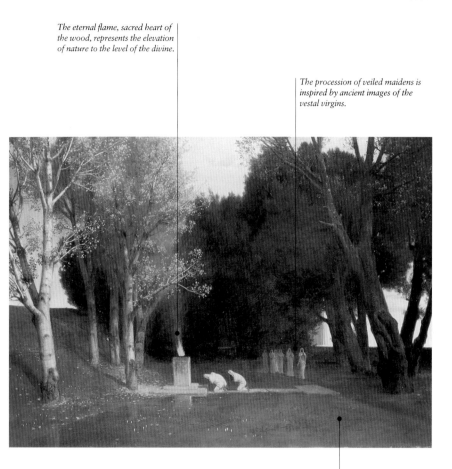

The clearing in the
forest represents a
sacred site.

▲ Arnold Böcklin, *The Sacred Wood*,
1882. Basel, Kunstmuseum.

◄ Pierre Puvis de Chavannes,
The Sacred Wood, 1884. Chicago,
Art Institute.

The stag represents the triumph of
life over death, light over darkness.

The hero and his steed,
adorned with emblems of
the sun, pass through the
darkness with the help of
a spiritual guide: the
crucifix, symbol of faith
in the one true God.

The theme of the solitary
knight venturing into a
dark forest is the courtly
version of the classical
topos of the journey to
the Underworld.

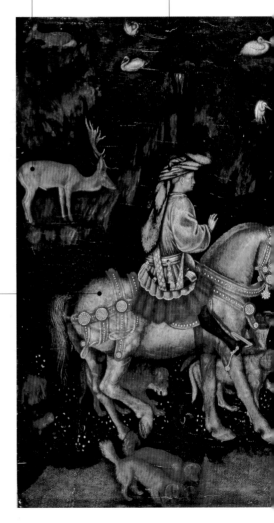

▶ Pisanello, *The Vision of Saint Eustace*,
ca. 1440. London, National Gallery.

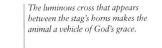

The luminous cross that appears between the stag's horns makes the animal a vehicle of God's grace.

The redemptive symbolism of the stag derives from the fact that its horns periodically regenerate, and that it was once a sacrificial animal. In medieval and Renaissance hunting parties, the rite of sacrifice was repeated in secular form, stripped of all symbolic significance.

Tree

Derivation of the name
From Old English *tréow,*
tríouw, and Old Norse *tré*

Characteristics
It symbolizes a reconciliation
of opposites, representing
either the vehicle of ascent
into Heaven or the return to
the beginning (Mother Earth)

**Religious and philosophical
traditions**
Zoroastrianism, Judaism,
Graeco-Roman mythology,
Christianity, Islam, Kabbalah,
alchemy, Hermeticism

Related gods and symbols
Mother Earth, Christ, the
Virgin Mary; ladder, moun-
tain, Earthly Paradise, heav-
enly city, garden, labyrinth,
source, cross, sun, moon,
planets, sky, earth, life, death,
macrocosm, microcosm,
androgyne, primordial water,
vices, virtues

*It represents the axis and mystical center of the cosmos and
the element of conjunction between the world underground
(roots), the earth (trunk), and the celestial dimension (leaves
and branches).*

A living cosmos in a state of continuous growth, the tree is an
image of life in its totality. For this reason it was venerated by
many peoples. Oak, ash, and linden trees were objects of wor-
ship in northern Europe; fig, pomegranate, and olive trees in
the Mediterranean basin. The cosmic tree thrusts its roots into
the heavens and its boughs into the womb of the earth, infus-
ing it with life-giving celestial sap. Its branches correspond to
the five elements: ether, air, fire, water, and earth.

Many cosmogonic deities were associated with trees: Osiris
(cedar), Jupiter (oak), Apollo (laurel), Diana (hazel), Minerva
(olive). The Virgin Mary herself was likened to the tree of sal-
vation from whose fruit the Redeemer is born.

In the Garden of Eden of Genesis stand the tree of life and
the tree of good and evil, whose wood will be used to make
Christ's cross. Like the cross, they symbolize death and
resurrection—the sprouting of buds after the winter rest—

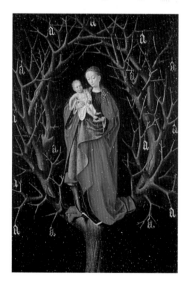

and are vehicles of
spiritual ascent.

As a phallic symbol,
born of Adam's mem-
ber, the tree represents
the union and mutual
correspondence of man
and nature. Its branch-
ing may be genealogi-
cal, as in the tree of
Jesse, or intellectual, as
in the tree of knowl-
edge. The alchemical
tree, in contrast, sym-
bolizes the power of the
creative imagination.

▶ Petrus Christus, *Madonna of
a Dry Tree,* 1465. Madrid,
Museo Thyssen-Bornemisza.

The golden branch represents the fruit of salvation and immortality, and the conquest of the philosopher's stone. This allegory of the alchemical Work is based on an episode in Book 6 of Virgil's Aeneid.

Sylvius gives his father a branch from the tree of life, to protect him on his journey to the hereafter. His black clothing alludes to the nigredo stage of the alchemical Work.

Aeneas's father, Anchises, dressed in white, represents the albedo stage.

Aeneas, dressed in red, represents the rubedo phase.

▲ *The Alchemical Tree*, miniature from Solomon Trismosin's *Splendor Solis*, sixteenth century. London, British Museum.

The tree in the Garden of Eden represents both the source of life and knowledge, and the principle of evil and death.

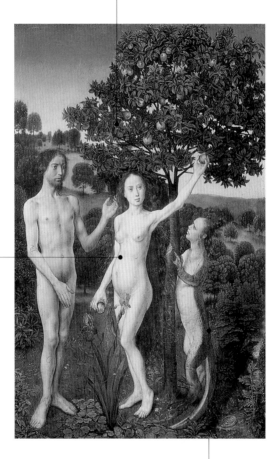

Eve is shown picking the forbidden fruit. Her act will relegate the human race to a fate of sorrow and sin.

The human-headed salamander represents free will, which leads man to break God's commands.

▲ Hugo van der Goes, *Original Sin*, ca. 1473–75. Vienna, Kunsthistorisches Museum.

The Virgin Mary represents the "new Eve" conceived by divine grace, as well as the Catholic Church and the elect in Heaven.

The fourteen kings of Israel (from Abraham to David) are clothed in sumptuous Renaissance dress.

The tree of Jesse, symbol of Christ's genealogy, sprouts from Adam's loins. The main sources for this iconographic motif are the prophet Isaiah and the Gospel according to Matthew.

▲ Geertgen tot Sint Jans,
The Tree of Jesse, ca. 1480–90.
Amsterdam, Rijksmuseum.

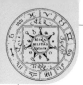

It is presented as a luxuriant, often enclosed space, adorned with splashing fountains, fruit trees, and domesticated animals.

Garden

The garden represents a sacred spot, a place reserved for the initiated, separate from everyday reality. As such it is a protected space, surrounded by walls (the *hortus conclusus*) or by a symbolic fence; it can be guarded by higher beings, such as the angel at the gates of Eden, or by legendary monsters, as in classical myths (the garden of the Hesperides).

Governed by ordering principles such as divine commandment, culture, and art, the symbolic garden is above all a human space, protected from untamed nature and its dangers and snares (ferocious animals, dark woods). It is distinct, however, from the city, the home of commerce and labor, and from the castle, seat of power. Indeed, it is a space designed for the practice of *otium* (rest in the positive sense) and the elevation of the soul.

The Garden of Eden symbolizes the condition of beatitude in which the progenitors of mankind lived before Original Sin. It was a state of perfection to which man has desperately tried to return ever since, as witnessed by his many journeys (real and imagined) in search of the lost Paradise. The courtly garden is a place where sentiment and sensuality are "tamed" through the rituals of conversation, music, and dance; it may also have a mystical, metaphysical connotation, as in Persian literature and late-medieval romance.

Derivation of the name
From the medieval Latin
gardin-um

Characteristics
It represents man's ordering of nature and reason's dominance over unconscious impulses. The walls underscore the garden's significance as a border zone between nature and culture. In the Christian tradition, the *hortus conclusus* is a symbol of the Virgin Mary and the Garden of Eden

Religious and philosophical traditions
Judaism, Christianity, Islam, Kabbalah, alchemy, Hermeticism

Related gods and symbols
Aphrodite (Venus), Eve, Adam, the Virgin Mary; source, life, tree, love, soul, body, androgyne, man as microcosm, mother, water, vices, virtues, dragon, snake, lion, unicorn, stag, birds

▶ *The Courtly Garden*, Missal of Renaud de Montauban, mid-fifteenth century.

The angel of God expels Adam and Eve from the gates of Eden. After Original Sin, this sacred place will forever be forbidden to mankind, guarded by an angel with a flaming sword.

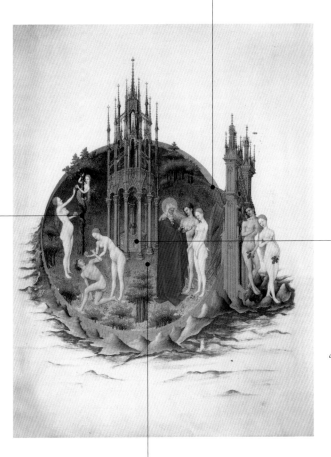

God placed the tree of good and evil in the Garden of Eden.

From the fountain of Paradise spring the earth's four principal rivers: the Tigris, the Euphrates, the Ganges, and the Nile.

In the Book of Genesis, Eden is described as a beautiful garden enclosed by circular walls and rich in beneficent waters and luxuriant fruit trees.

▲ Limbourg Brothers, *Creation, Sin, and the Explusion of Adam and Eve,* illumination from the *Très Riches Heures du duc de Berry,* ca. 1416. Chantilly, Musée Condé.

Minerva, goddess of wisdom, represents the choice of the contemplative life.

Juno personifies the choice of the active life.

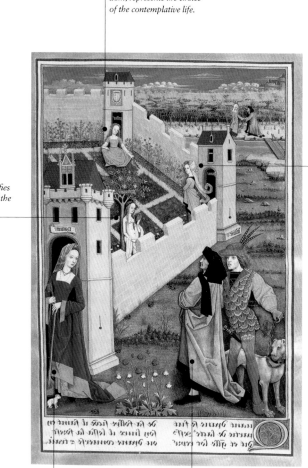

Venus embodies the path of sensual love.

Nature opens the gates of the hortus conclusus *to initiates in the mysteries of love.*

The lover-poet is portrayed standing outside the Garden of Desire, because he has not yet chosen which path he will take in life.

▲ Robinet Testard, *The Gaze of Desire*, miniature from the *Livre des échecs amoureux*, 1496–98. Paris, Bibliothèque Nationale.

The imaginary animal's horn was believed to contain a powerful drug with miraculous curative properties.

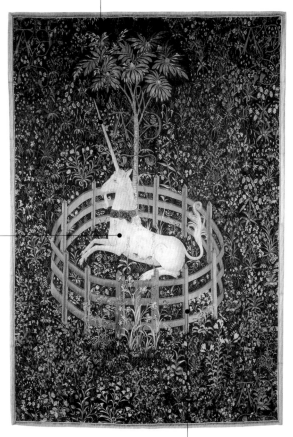

An expression of cosmic fecundity, the unicorn in the Middle Ages became a symbol of purity and chastity. Its capture and death are an allegory of the sacrifice of Christ.

The enclosure, a symbolic image of the garden, is a place where the bestial passions, represented by the dark forest, are tamed.

▲ Flemish tapestry, *The Unicorn in Captivity*, from the cycle *The Hunt for the Unicorn*, 1495–1505. New York, Metropolitan Museum, The Cloisters.

According to the medico-astrological science of the time, the couple, symbol of the concordia oppositorium, *represents the union of the dry-hot humors (man) and the wet-cold ones (woman).*

The egg symbolizes the "reabsorption" into the maternal womb.

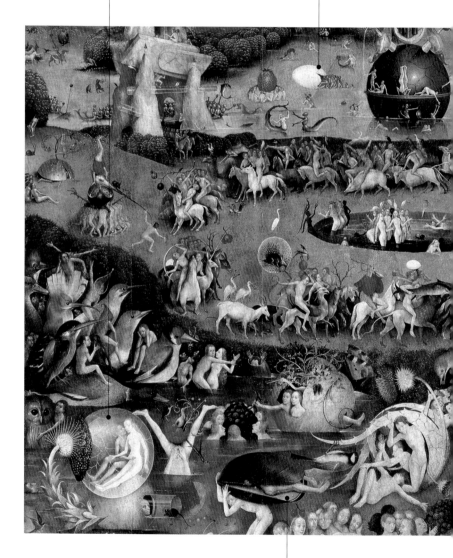

The valve of the mussel shell symbolizes the female sexual organs.

This garden has been interpreted as an allegory of lust.

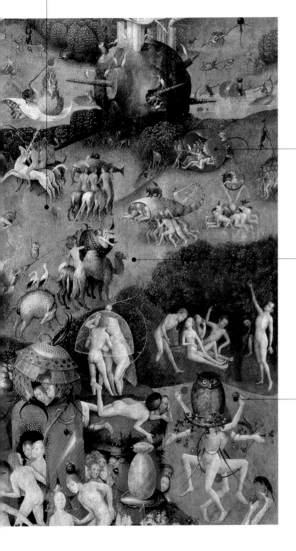

The strawberry and cherry are traditional symbols of lust. Because of the presence of these allusive fruits, this work used to be known as the "strawberry painting."

The parade of exotic and imaginary animals represents the different faces of sin.

The hybrid creatures—part human, part vegetable, and part animal—bespeak the deterioration of humankind and the demonic mingling or "confusion" between the three natural realms.

◄ Hieronymus Bosch, *The Garden of Earthly Delights* (detail), central panel of the *Garden of Earthly Delights Triptych*, 1503–4. Madrid, Prado.

It is depicted at the center of a garden, courtyard, or city, as a symbol of life, youth, and love.

Fountain

A fountain implies the presence of a spring, symbol of the perpetual renewal of nature through the flow of fresh water. As baptismal font, it represents the entrance to a new existential and eschatological state and appears often in esoteric literature. From the fountain of Earthly Paradise spring the four blessed rivers that divide the earth's surface into its four principal regions.

In the iconography of late antiquity, fountains are decorated with human and zoomorphic beings whose organs pour forth fresh water. According to the Orphic tradition, there were two fountains at the entrance to the Underworld: the fountain of memory, which granted immortality and eternal bliss, and the fountain of forgetting. The fountain of youth, a favorite theme of medieval art and a precious image in the rituals of courtly love, served to banish fear of old age and the loss of virility. Among the lower classes it was often associated with the pleasure-baths commonly found in brothels. The relationship between water, the purification of the body, and eroticism finds expression in the *Fountain of Love* by Ambrogio and Cristoforo De Predis, one of the most celebrated illustrations in the fifteenth-century astrological-geographical treatise *De Sphaera*.

Derivation of the name
From the Latin *fons* (*fontis*), "fountain," "spring," "source," "fresh water"

Characteristics
It represents the source of cosmic life that wells up from the center of the earth. In Jungian psychology, it is the symbol of inner life and spiritual energy

Religious and philosophical traditions
Judaism, Christianity, Mithraic mysteries, Orphism, Islam, Kabbalah, alchemy, Hermeticism

Related gods and symbols
The Virgin Mary, Christ; elixir of youth, ambrosia, tree of life, Garden of Eden, Heaven, Hell, love, youth, mother, water, soul, body, man as microcosm, vices, virtues

▶ Giovanni Segantini,
Lovers at the Fountain of Life, 1896. Milan, Galleria d'Arte Moderna.

The animals in the garden symbolize the vanity of love.

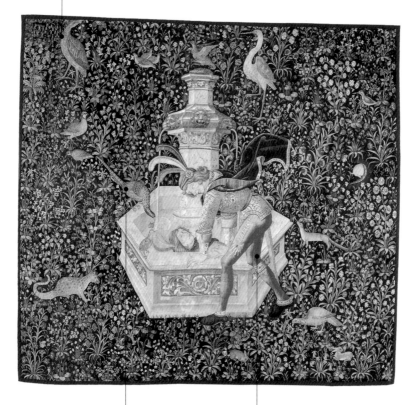

The pheasant is a mirror-image of Narcissus. Due to an odd behavioral characteristic described in medieval bestiaries, it was believed that pheasants were incapable of taking their eyes off their own reflected image, which they mistook for an amorous rival.

Narcissus represents male desire left to languish by the indifference of his beloved.

▲ French tapestry, *Narcissus*, ca. 1500. Boston, Museum of Fine Arts.

Fountain

The fountain is shaped like a baptismal font and represents the entry into a new state of existence.

The top of the fountain is protected by a winged Cupid, who shoots arrows of love at bystanders.

Attendants help the elderly to undress and climb into the miraculous fountain.

The loving couples give the scene a strong erotic connotation.

After their ablutions, the bathers appear completely rejuvenated.

The water has extraordinary therapeutic properties. It gives new life to the bodies of the aged and infuses the lovers with new sexual vigor.

◄ Giacomo Jaquerio, *The Fountain of Youth*, ca. 1420. Saluzzo (Italy), Castello della Manta, Great Hall.

It is depicted as a tortuous, tangled course with no apparent exit.

Labyrinth

Derivation of the name
From the Latin *labyrinthus*

Origin of the symbol
It derives from the ancient solar cults of Minoan civilization associated with the legendary King Minos of Crete

Characteristics
It represents the path of initiation toward a sacred, hidden center. In this secret place, the hero recovers the lost unity of his psyche

Religious and philosophical traditions
Minoan cults, Judaism, Christianity, Islam

Related gods and symbols
Minotaur, mountain, cave, garden, knot of Solomon, braid, spiral, dance, palace, temple, sun, double axe

The labyrinth is a system of defense situated outside a sacred place or a treasure (including abstract prizes such as life or immortality). When it protects a city or temple, it is comparable to a fortress; when it represents a spiritual quality, it stands for a symbolic pilgrimage to the Holy Land (such as the labyrinth at Chartres) or with the tortuous path of virtue away from vice. Those who embrace and exploit the female side of their characters (the *anima*)—represented by the aid that a maiden offers a hero (such as Ariadne's thread)—may find a way out of this potentially endless course.

The journey through the labyrinth can stand for both the inner path toward consciousness (the pure heart or *mens* [mind] of the Christian mystics) and the soul's itinerary after the death of the body. Such trials provide the adept with the qualities necessary to overcome the obstacles impeding his spiritual elevation and give him the tools he needs to break free of the cycle of earthly reincarnation.

The alchemists associate the image of the labyrinth with Solomon's seal, symbol of spiritual death and resurrection. The emblem is also used to represent the concept of infinity.

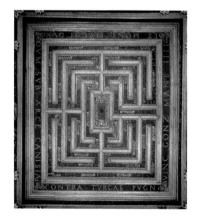

The most famous of the legendary labyrinths is the one built by Daedalus for King Minos of Crete to conceal the Minotaur.

▶ Wooden ceiling of the "Labyrinth Room," sixteenth century. Mantua, Palazzo Ducale.

A crown of thorns is embroidered on the man's cap, an allegorical reference to the difficulties one may encounter on the path through life.

The medallion bears an image of a shipwreck, encircled by the motto Espérance me guide *(May Hope guide me).*

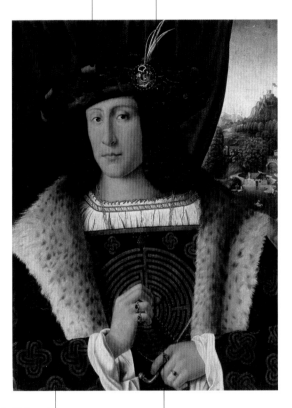

The motif of Solomon's knot alludes to eternity and is associated with the concept of infinity. The spiral, on the other hand, represents perpetual flux.

The labyrinth guards the secrets of the sitter's heart, emphasizing his silence and reserve.

▲ Bartolomeo Veneto, *Portrait of a Man*, ca. 1510. Cambridge, Fitzwilliam Museum.

Two lovers embrace at the entrance to the labyrinth. They are perfectly aligned with the circular edifice (the Tower of Babel) at the top of the composition.

Lovers chase one another through the fragrant hedges, gradually approaching the center of the labyrinth.

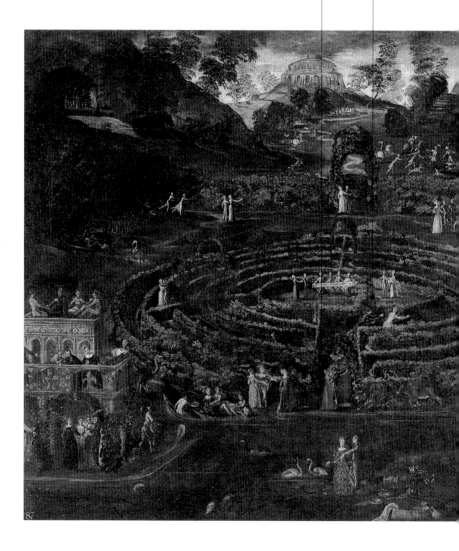

The city is an image of the Heavenly Jerusalem; the maze of hedges stands for Earthly Paradise, the Tower of Babel for Hell.

The horseman crossing the glass bridge alludes to the difficult journey to the hereafter.

The group of four (three women and a man) alludes to the Judgment of Paris.

The labyrinth's form recalls the island of Cythera, where Aphrodite was born.

Because its horns periodically regenerate, the stag quenching its thirst represents the tree of life.

◀ School of Tintoretto, *The Labyrinth of Love*, 1550–60. Hampton Court, Her Majesty Queen Elizabeth II Collection.

It may be represented either realistically or in a fantastic vein, depending on the role it is assigned.

City

Derivation of the name
From the Latin *civitas*, meaning "state," "citizenship"

Characteristics
It can symbolize pride and human vice or, conversely, the union of political, civic, and spiritual virtues (the City of God)

Religious and philosophical traditions
Judaism, Christianity

Related gods and symbols
Tower, church, labyrinth, life, good, evil, vice, virtue, sky, earth, mother, Paradise, square

▶ Anonymous (Luciano Laurana or Francesco di Giorgio Martini?), *The Ideal City*, ca. 1480. Urbino, Galleria Nazionale delle Marche.

As an expression of the cosmic order, the center of the city is likened to the *axis mundi* and is often a holy place. In the early centuries of the Christian era, under the profound influence of the Apocalypse of John, the city became a metaphor of evil (Rome, Babylon), countered by the spirituality of the monastic life. The Augustinian opposition between the real city, center of vice, and the heavenly city, symbol of God's love, derives from the story of Cain and Abel: The former built the first city though he was "a wanderer on the earth."

In medieval iconography, following the rebirth of urbanization, Paradise, originally depicted as a garden, began to assume the features of an urban center. In the Carolingian era, monasteries were built as small, self-sufficient cities, veritable microcosms organized around a spiritual center (the church).

In the age of humanism, the city once again became a symbol of the harmony between the civic and political virtues. Andrea Mantegna, Piero della Francesca, Leon Battista Alberti, Filarete, and Francesco di Giorgio Martini conceived the city according to principles of rationality and symmetry. Thanks to the use of perspective, the urban setting became the highest expression of the humanist revival of classical order.

The phoenix derives from the myth of Heliopolis, the primordial city of the sun.

The Heavenly Jerusalem, celestial ideal of medieval Christianity, is placed at the center of the world.

As a symbol of perfection and stability, the celestial city is enclosed inside a square.

▲ *The Heavenly Jerusalem*, illumination from the *Liber divinorum operum* of Hildegard von Bingen, ca. 1230. Lucca, Biblioteca Governativa.

The city represents the harmonious union of the civic virtues: wisdom, courage, justice, and temperance.

Fourteenth-century Siena, recognizable by its characteristic buildings, becomes the image of the ideal city.

The image of the dance alludes to the theme of Concord, an indispensable virtue for living together in peace.

▲ Ambrogio Lorenzetti, *Effects of Good Government* (detail), 1337–40. Siena, Palazzo Pubblico, Sala dei Nove.

Merchants selling their wares
and peasants transporting live-
stock round out this depiction
of the economic system of
medieval urban centers.

Craftsmen's workshops represent
the productive activities on which
the city's economy is based.

The factory is a symbol of the twentieth-century metropolis.

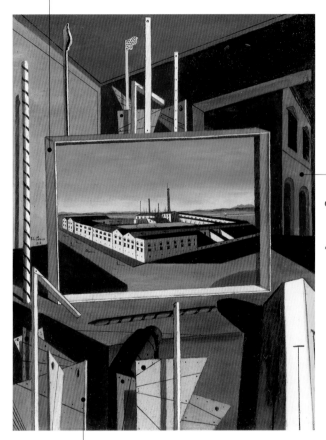

The building in the Classical style represents a utopian wish to return to a city "made to the measure of man."

Drafting tools represent the architectural and engineering professions. These "heroes" of the modern age have the task of redesigning man's environmental and spiritual setting.

▲ Giorgio de Chirico, *Metaphysical Interior with Large Factory*, 1916. Stuttgart, Staatsgalerie.

The vortex of horses and men embodies the propulsive force of the Futurist city, a construction site in perpetual transformation.

The buildings under construction pay homage to the achievements of science and technology, two of the Futurists' favorite themes.

The lines of force and the integration of several different planes in the painting allude to the mobility of the modern metropolis.

▲ Umberto Boccioni, *The City Rises*, 1910–11. New York, Museum of Modern Art.

A structure rising up into the sky, its imposing shape is similar to that of a mountain.

Tower

The tower embodies a multitude of contrasting meanings. For Babylonian civilization, its function was to enable the elect to observe the sky from a privileged position and to channel celestial energies to the earth. In the Jewish religion, it is a symbol of man's rebellion against God. The etymology of "Babel," from the Assyro-Babylonian *babilu* ("gate of god"), reflects the tower's original function as a vehicle of communication between humankind and divinity. Yet as an expression of the polytheistic conception of the divine, it is condemned by Jewish monotheism, which radically reverses its connotation.

Christianity once again assigns the tower a positive role, seeing it as a symbol of vigilance and ascent. As axis of the world and a link between man and God, the tower is likened to the Church and the Virgin Mary, becoming one of the Madonna's principal attributes (as *turris davidica* or *turris eburnea*). Like the ladder, it is a symbol of ascension and every stair within it stands for a stage of spiritual elevation. The erotic, generative function of the tower is expressed in the myth of Danae, who is inseminated by Jupiter after being imprisoned in a golden tower, and in the allegories of courtly love.

► Giorgio de Chirico, *Nostalgia of the Infinite*, 1913. New York, Museum of Modern Art.

The lady with an escort of soldiers is the beloved, the goal of the poet-knight's desires.

The castle keep is an emblem of the feminine sex.

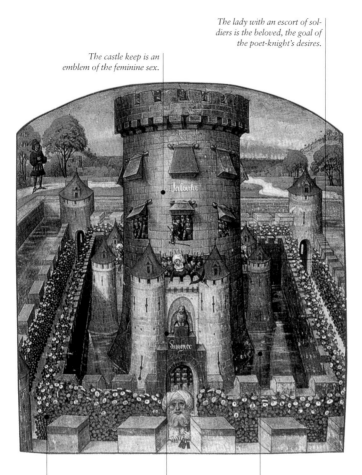

The fortified castle represents the woman's body, which the lover must take by storm.

The water-filled moat alludes to sexual frigidity.

The rose espaliers symbolize purity and virginity.

▲ *The Castle of Jealousy*, miniature from the *Roman de la Rose*, 1490. London, British Library.

Tower

The iconography of this Tower of Babel derives from a series of biblical commentaries widely circulated in the sixteenth century. These "reformed" readings of Holy Scripture underscored the sinful dimension of the Babylonian construction.

The overall image of the tower is based on the ruins of the Colosseum. In the popular imagination, Rome symbolized the martyrdom of the first Christians and was considered the "new Babylon" by the Protestants.

The disparity between the architectural styles used to build the tower (Classical orders next to Gothic and Romanesque elements) alludes to the confusion of tongues and divisions among nations that followed God's punishment.

▶ Pieter Bruegel the Elder,
The Tower of Babel, 1563. Vienna,
Kunsthistorisches Museum.

The structure of concentric rings is based on the typology of Sumerian ziggurats, those mountain-temples built to welcome the deity down to earth.

ALLEGORIES

They embody moral chaos and are depicted as repellent people or animals, often in a contest with the Virtues or in the seductive guise of temptation.

The Vices

Christian morality counts seven major vices (sloth, greed, gluttony, envy, wrath, lust, and pride), also called the seven deadly sins. These mortal offenses, which correspond to the seven circles of Hell described in Dante's *Inferno*, condemn man to eternal damnation. In addition to the capital vices, there are the minor, or venial, sins such as cowardice, fraud, idolatry, inconstancy, infidelity, injustice, folly, intemperance, calumny, and ignorance.

In the medieval era, every vice had its corresponding animal: for lust there was the pig or goat, for greed the wolf, for pride the bat or peacock, for hypocrisy the fox, for sloth the ass, for cowardice the hare. The culture of the age encouraged, moreover, an allegorical reading of the major epic poems of antiquity, assigning each of the gods and heroes a specific moral connotation. Ambiguous deities such as Pan, Dionysus, and Eros, but also hybrid figures such as the satyrs and centaurs or monsters such as the sirens and Gorgons, assumed strongly negative connotations, as they represented natural and psychic energies nearly irreconcilable with the Christian universe and its focus on salvation in the afterlife.

The literature and art of the fourteenth century give particular emphasis to the political and civic vices such as tyranny, violence, bad government, and treason. In the seventeenth century, the sin of vanity acquired an unprecedented importance, becoming one of the central veins of Baroque aesthetics.

Derivation of the name
From the Latin *vitium,* "fault," "vice"

Characteristics
They represent the inability to behave according to proper social norms; they manifest the power of demonic forces on the human soul

Religious and philosophical traditions
Platonism, Orphism, Hermeticism, Judaism, Christianity, alchemy

Related gods and symbols
Night, Eros, Pan, Dionysus (Bacchus), Persephone (Proserpina), Hades (Pluto), Aphrodite (Venus), Eve, Satan, Lucifer; chaos, snake, evil, Hell, darkness, tree of the vices

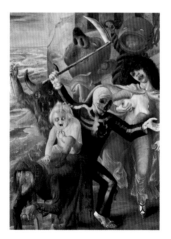

▶ Otto Dix, *The Seven Deadly Sins* (detail), 1933. Karlsruhe, Staatliche Kunsthalle.

The mirror, principal attribute of the proud, is being held by a demon with a wolf's head and a toad's feet.

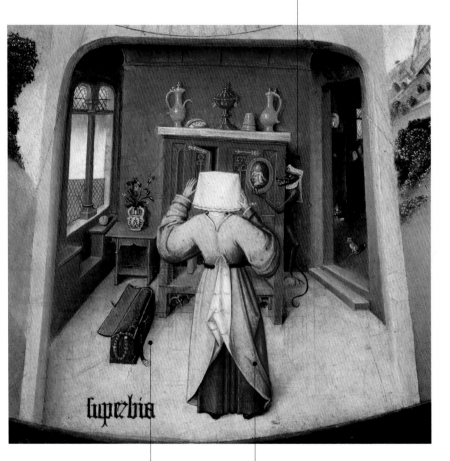

The chest contains gold and jewelry. The iconography of this vice partly follows that for vanity.

Pride is represented as a haughty, elegant young woman.

▲ Hieronymus Bosch, *Superbia* (*Pride*), detail of *The Seven Deadly Sins*, ca. 1480–85. Madrid, Prado.

Jealousy is livid
and screaming
with envy.

Time, with the help of Truth, has
revealed the incestuous congress
between Venus and Cupid.

Fraud is portrayed as a little girl
with a cherubic face, a sphinx's
body, a serpent's tail, and
reversed hands.

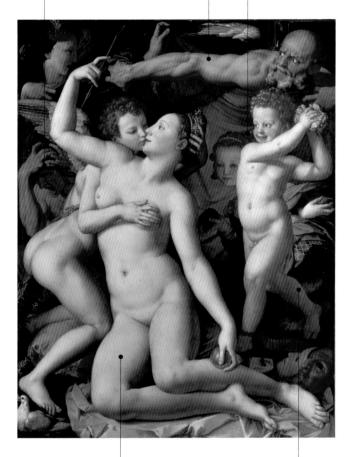

The nudity of Lust alludes to
the main consequence of sin: the
dissipation of spiritual values
and worldly possessions.

▲ Bronzino, *An Allegory with Venus
and Cupid*, ca. 1540–50. London,
National Gallery.

The putto with rose petals
represents Pleasure.

Wrath is represented as a scuffle between two women. The foam at the mouth, the red eyes, and the swollen face are typical of the hot-tempered sanguine temperament.

Tearing out one's hair is a feature not only of wrath, but also of jealousy and envy.

The red dress embroidered in black is another distinct attribute of Wrath, which brings grief and tragedy.

▲ Dosso Dossi, *Wrath* (or *The Scuffle*), also called *Allegorical Scene*, ca. 1515–16. Venice, Fondazione Cini.

The Vices

Inside a shed (whose roof is covered with pies), a noble knight sits with mouth open, ready to satisfy his every desire.

Emerging from a tunnel of buckwheat, the glutton, ladle in hand, gets ready to gorge himself.

The tree of Cockaigne is a metaphor of the sin of gluttony.

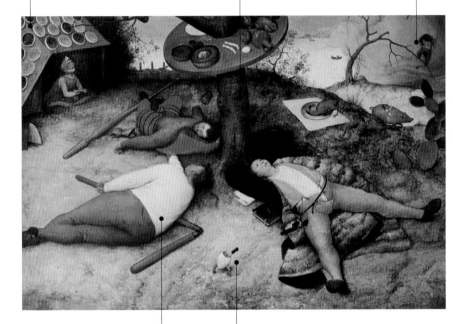

The peasant, the cleric, and the soldier represent the three social strata of the time: the commoners, the clergy, and the nobility.

Gastronomical delights walk about undisturbed, tempting the gluttonous.

▲ Jan Brueghel the Elder, *The Land of Cockaigne*, 1567. Munich, Alte Pinakothek.

The shell alludes to the tortuous, deceptive behavior of envious people.

Envy is usually personified as a man.

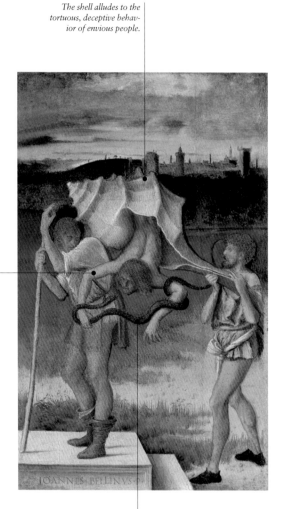

The snake, which like the envious has a forked, poisonous tongue, is a typical attribute of the envious.

▲ Giovanni Bellini, *Allegory of Slander or Envy*, 1490. Venice, Gallerie dell'Accademia.

The devil is using bellows to blow thoughts of
vice into the lazy man's ear, as the medieval
proverb warns: "Sloth is the devil's ear."

The dozing man
personifies the
vice of sloth.

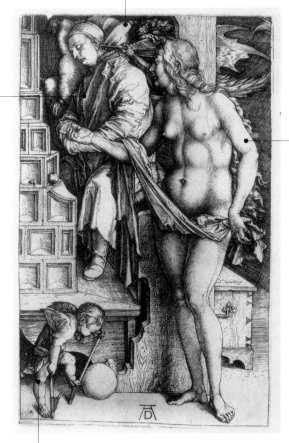

Venus, half-naked,
represents Lust,
who is tempting
the sleeper with an
eloquent gesture of
invitation.

Cupid, mounting a pair of
stilts, tries to climb onto the
wobbly sphere of fortune.

▲ Albrecht Dürer, *The Dream of the
Doctor*, engraving, 1498–99.

Moneychangers and usurers often appear as personifications of greed (avarice).

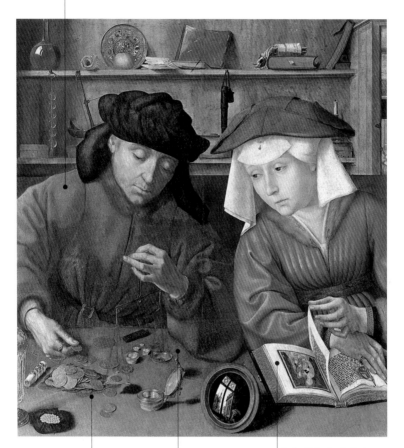

Gold coins are a typical attribute of greed.

In the Netherlands, the practice of moneylending sometimes had a positive, socially acceptable significance, as indicated by the prayer book in the foreground.

The scale indicates the good and bad values attributed to gold.

▲ Quentin Metsys, *The Moneychanger and His Wife*, 1514. Paris, Louvre.

Truth points to the light of day, with which it dispels the shadows of calumny.

The veiled old woman in mourning is Remorse.

Treason and Deception accompany Calumny.

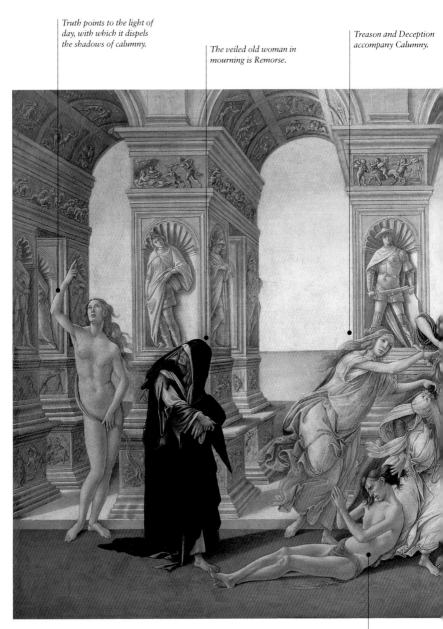

The young man being dragged by the hair personifies innocence.

Donkey-eared King Midas extends a welcoming hand to Calumny, who approaches holding a torch.

This painting, based on a text by Lucian, illustrates the reply of the Greek painter Apelles to the calumnies of his rival Antiphilus.

Ignorance and Suspicion whisper into the king's ears, instilling doubt.

◄ Sandro Botticelli, *Calumny*, ca. 1490. Florence, Uffizi.

The Vices

Avarice (Greed) is
holding a casket
full of gold.

Pride dominates
the city with the
sword and the
yoke.

Vainglory is portrayed as a beautiful
woman gazing into a mirror and
holding a dry branch, symbol of the
vanity of her ambitions.

Justice, deprived of all
adornment, is kept in
chains by the tyrannical
government.

The devil, with horns
and batwings, represents
tyranny.

▲ Ambrogio Lorenzetti, *Effects of Bad
Government* (detail), 1337–40. Siena,
Palazzo Pubblico.

Discord, wielding two blazing torches, enflames the spirits of the two adversaries.

A head writhing with snakes is a distinguishing attribute of Discord.

Mercury's caduceus is a symbol of peace. According to tradition, when it appears, "all discord ceases."

▲ Sebastiano Ricci,
Discord Enflaming the Spirits of Two Warriors, seventeenth–eighteenth centuries. Piacenza, Museo Civico.

"Mad Meg," a character from medieval Germanic folklore, represents blind egotism and civic violence. Her destructive power is represented by her breastplate and the sword in her hand.

The eggshell, an inverted image of the alchemical athanor, is the source of all the world's ills.

The anthropomorphic cave represents the mouth of Hell. The image is taken from the famous French text Les Visions de Tondal (twelfth century), the main reference for the iconography of the afterlife in Northern painting.

Fantastic creatures, called "grillen" in Dutch, recur frequently in the works of Bruegel and Bosch, as symbols of evil and universal disorder.

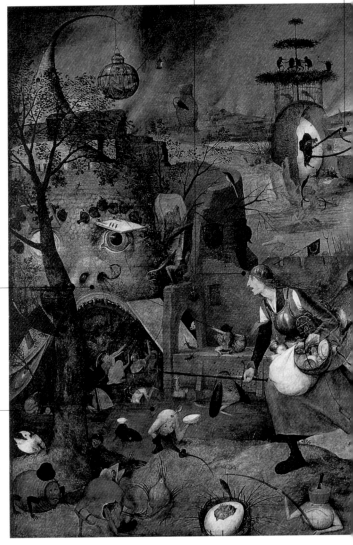

The boat with the crystal sphere is another allusion to the alchemical crucible.

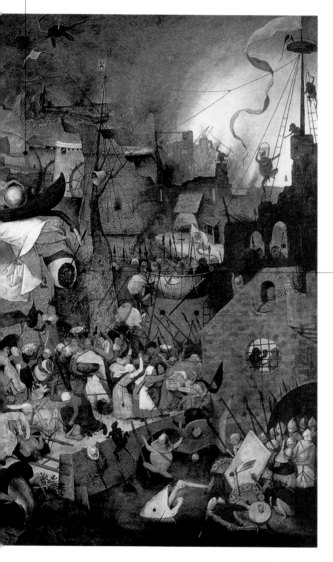

The man with the eggshell hindquarters is expelling excrement and perhaps gold coins, which the crowd beneath him rushes to collect.

▲ Pieter Bruegel the Elder, *Dulle Griet (Mad Meg)*, 1562. Antwerp, Museum Mayer Van den Bergh.

The feather, jewels, vials of perfume, and cut flowers are typical attributes of Vanitas.

The fleeting reflection is a metaphor of vain appearance and the transience of worldly possessions.

Vanity is portrayed as a homely old woman making herself up in the mirror.

▲ Bernardo Strozzi, *Vanity*, 1635–40. Moscow, Pushkin Museum.

*The young woman's half-naked breasts
allude to one of vanity's main characteris-
tics: letting one's thoughts and feelings
show through.*

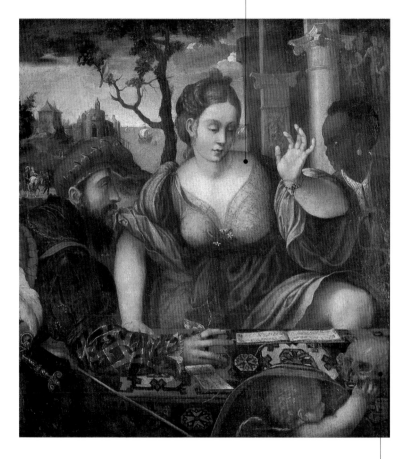

The skull, symbol of Vanitas, *refers
to the fragility of worldly existence
and underscores the dualism
between beauty and death.*

▲ Giulio Campi, *Allegory of Vanity* (?),
1521–24. Milan, Museo Poldi-Pezzoli.

They are represented as young women accompanied by specific attributes and are often shown in battle with the Vices.

The Virtues

They are divided into four cardinal virtues (fortitude, prudence, justice, and temperance) and three theological virtues (faith, hope, and charity). The former are conceived as natural gifts that can be acquired by conforming to the doctrine of the Gospels, and they derive from Socratic, Platonic, and Aristotelian philosophy. The second set are supernatural qualities instilled in a person directly by God; they were first introduced in the Middle Ages by the Church Fathers, who integrated the ethical system of antiquity into the scriptural dogmas.

Medieval Scholasticism identified the virtues with angelic entities or powers that infuse the human soul with divine light. They dwell in the second heavenly sphere, together with the Powers and Dominions, and correspond to the seven principal planets. The works of art that reflect this theological conception of virtue include Giotto's Scrovegni Chapel in Padua, the frescoes of Andrea Bonaiuti in Santa Maria Novella in Florence, the reliefs by Agostino di Duccio in the Tempio Malatestiano in Rimini, and the *Allegories of Good Government* by Ambrogio Lorenzetti in the Palazzo Pubblico of Siena.

Renaissance culture revived the ancient mythological personifications of the virtues, giving special emphasis to the ethic and civic qualities of peace, abundance, and concord, and to the virtue of wisdom. Chastity, fidelity, abstinence, and humility complete the list of virtues.

Derivation of the name
From the Latin *virtus*, which has the same root as *vir*, "man"

Characteristics
They represent the beneficent potential of the human spirit, the faculties of reason, and angelic entities of the Christian cosmos

Religious and philosophical traditions
Platonism, Hermeticism, Judaism, Christianity, alchemy

Related gods and symbols
God the Father, Christ, Eros; good, light, angels, planets, Heaven, tree of the virtues

▶ Giambattista Tiepolo, *Allegory of the Virtues*, 1740. Venice, Scuola del Carmine.

Hope is usually dressed in green.
The crown of flowers alludes to
the birth of future fruit.

Faith is portrayed
holding the cross
and the Eucharis-
tic chalice. Her
distinguishing
color is white.

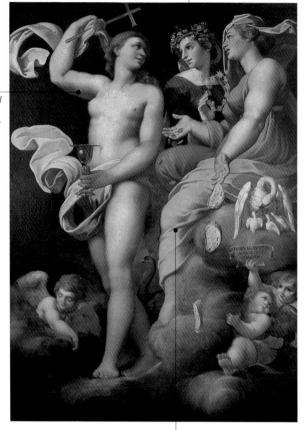

Charity, dressed in red, gives bread
to orphans. At her side, a white
bird—using the traditional iconog-
raphy of the pelican but painted as
a swan—tears its breast to feed its
chicks, a symbol of generosity
toward the needy.

▲ School of Annibale Carracci, *Allegory
of the Theological Virtues*, seventeenth
century. Rome, Palazzo di Montecitorio.

The crucifix beside the chalice, which Faith usually holds in her hand, underscores the object's Eucharistic function.

The hand over the heart, or holding a heart in her right hand, is a characteristic gesture of Faith.

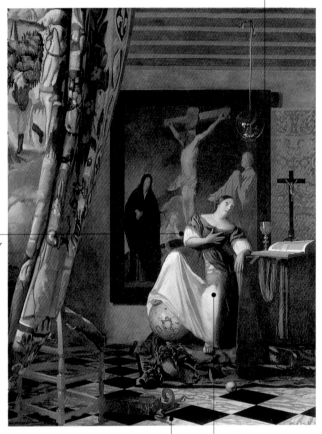

The snake crushed under a stone slab symbolizes Christ's triumph over the devil.

Here the portrait of Faith combines some of the gestures and attributes given her in Cesare Ripa's Iconology.

▲ Jan Vermeer, *Allegory of Faith*, 1675.
New York, Metropolitan Museum.

The little ringing
bell represents the
sense of hearing.

Charity nurses and
cares for needy chil-
dren. Her embrace
symbolizes the sense
of touch.

The cut flowers allude to
the sense of smell.

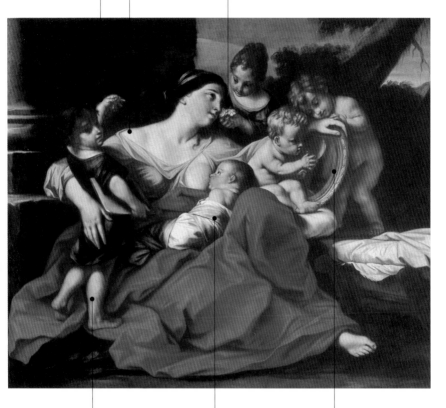

The presence of children
makes it clear that the virtue
of charity also assumes the
qualities of faith and hope.

The mirror stands for
sight. The positive conno-
tation given to the five
senses is due to the pres-
ence of Charity.

The nursing baby in swad-
dling clothes represents the
sense of taste.

▲ Carlo Cignani, *Charity as an*
Allegory of the Five Senses, 1668–79.
Private collection.

The Virtues

The two female figures leading Minerva have been interpreted as personifications of chastity.

The words that appear on the bodies of the vices and on the scroll wrapped around the tree trunk (an echo of the myth of Daphne, who was turned into a laurel tree) enable us to identify the various characters in the scene.

Armed with lance, breastplate, and helmet, Minerva, guardian of the virtues, drives away the vices.

Sloth, dragged along by Idleness, is portrayed without arms, an allusion to his inability to do anything productive.

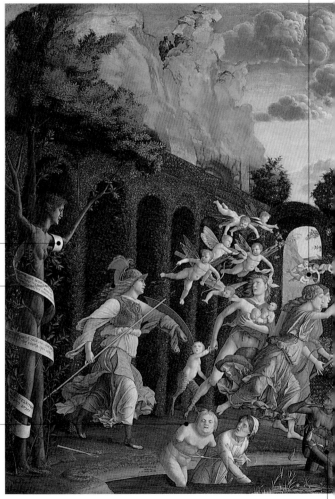

The man-ape hybrid represents hatred, fraud, and malice.

Venus, standing on the centaur's back, represents lust.

The figure with the sword and scale is justice, one of the four cardinal virtues.

The pitcher of water is a distinguishing attribute of Temperance. She is shown pouring liquid from one pitcher into another, mixing water with wine.

Fortitude is recognizable by the lionskin, the club of Hercules, and the column she is holding.

The crowned figure is the personification of ignorance, carried bodily by Greed and Ingratitude.

◄ Andrea Mantegna, *The Triumph of Virtue*, ca. 1499–1502. Paris, Louvre.

The skull reflected in the mirror warns us of the vanity of earthly pleasures.

The young woman personifies prudence.

The stag, a shy, reserved animal, alludes to the melancholic temperament, traditionally associated with prudence.

The serpent crushed underfoot symbolizes the demonic temptations kept in check by this virtue.

▶ Hans Baldung Grien, *Prudence*, 1529. Munich, Alte Pinakothek.

The laurel crown implies that the prudent person ponders and reflects before acting.

In the Gospel of Matthew, prudence is a quality attributed to snakes.

Prudence will not be seduced by fleeting appearances, here represented by the image reflected in the mirror.

Time, hourglass in hand, personifies the art of waiting, a distinctive feature of prudence.

▲ Simon Vouet, *Allegory of Prudence* (detail), ca. 1645. Montpellier, Musée Fabre.

The scale in perfect balance symbolizes impartiality of judgment and the ability to weigh the merits of every situation.

The Last Judgment *in the background helps us to identify the painting's subject as an allegory of Justice.*

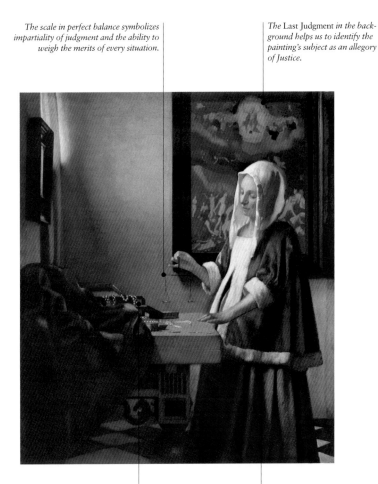

The jewels on the table are symbols of the Blessed Virgin's purity.

The woman's swollen belly is an allusion to the Virgin Mary, mother of the Savior and Queen of the Apocalypse. According to Catholic doctrine, she will intercede to save mankind on Judgment Day.

▲ Jan Vermeer, *Woman Weighing Pearls*, 1660–65. Washington, D.C., National Gallery.

The tamed lion is the main attribute of Fortitude. This iconography derives from the myth of the twelve labors of Hercules.

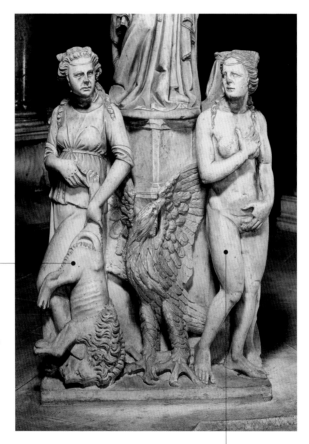

Temperance is represented using the classical motif of Venus pudica, or "modest Venus." She is also sometimes accompanied by a tortoise and a pitcher of water.

▲ Giovanni Pisano, *Fortitude and Temperance*, 1302–10. Pisa, cathedral.

The temple of Modesty is
devoted to Venus Verticordia,
the protector of chastity who
dissuades hearts from the
ardor of passion.

The unicorn is a symbol of
purity and chastity. It could
be approached and captured
only by a maiden.

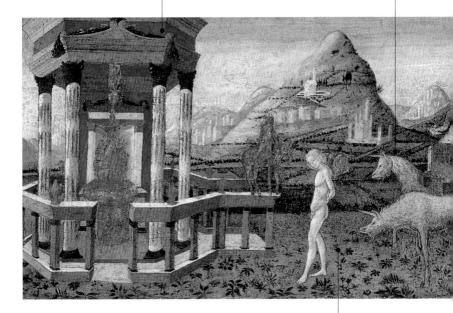

The nude, winged boy is
the god of love, Eros.

▲ Francesco di Giorgio Martini, *The
Triumph of Chastity* (detail), 1463–68.
Los Angeles, J. Paul Getty Museum.

Chastity is portrayed on a triumphal chariot, on her way to the temple of Venus Verticordia. The image is inspired by Petrarch's Triumphs.

The horses drinking at the stream allude to the satisfaction of the sexual impulses.

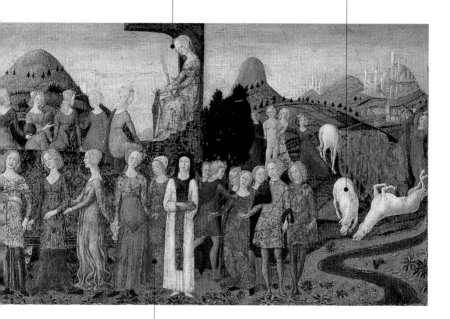

Honesty and Shame, Perseverance and Glory, Sensibility and Modesty are Chastity's handmaidens. Her suite also includes men and heroes who have proved able to resist the lures of the senses, such as Hippolytus, who resisted Phaedra's advances, and Joseph, who spurned Potiphar's wife.

The Virtues

Sophia (Wisdom) represents the highest virtue attainable by man.

Crates, the Cynic philosopher, throws his worldly riches into the sea. They are a useless burden for the virtuous man.

Opportunity unfurls a sail, symbol of mutability and inconstancy.

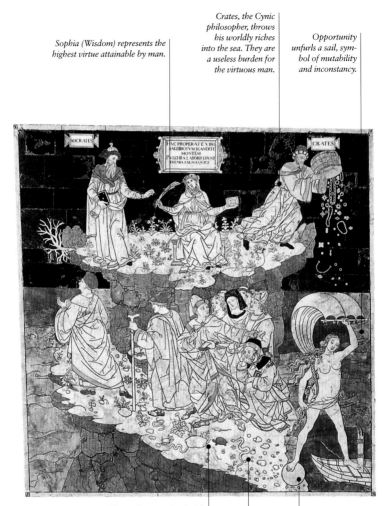

The turtle is associated with the virtues of perseverance and prudence.

The sphere and the boat without oars are symbols of instability.

The snakes represent the obstacles to be overcome along the path to virtue.

▲ Pinturicchio, *The Path of Virtue*, 1505. Floor inlay, Siena, cathedral.

The dragon is typically an attribute of Satan.

With sword drawn, the angel of the Lord puts the demon to flight.

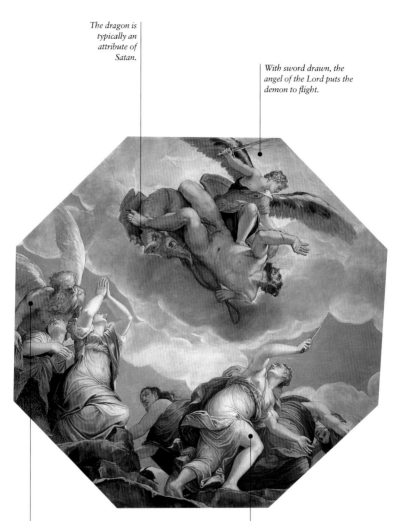

Time, father of Truth, protects Faith and Hope with his presence.

Envy, bare-breasted and wielding a dagger, flees at the sight of God's messenger.

▲ Gian Battista Zelotti, *Time and the Virtues Delivered from Evil and Envy*, 1550–60. Venice, Palazzo Ducale.

The Virtues

Peace is holding
the traditional
olive branch.

Wisdom, perched
above Justice, keeps a
tight grip on the scales.

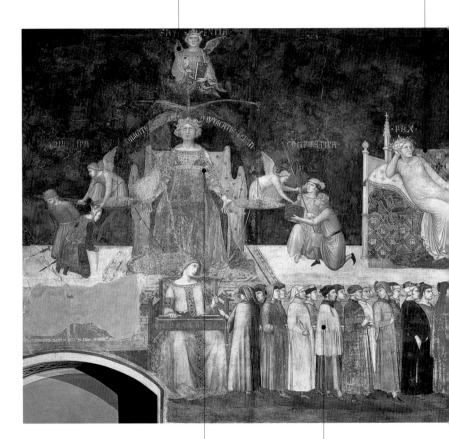

The balance's two arms grow out of
the head of Justice. They will weigh
the qualities of the citizens.

The virtuous citizens are
portrayed as smaller than
the Virtues themselves, as a
sign of their submission to
civic and moral values. They
hold hands as an expression
of concord.

▲ Ambrogio Lorenzetti, *Allegory of
Good Government* (detail), 1337–40.
Siena, Palazzo Pubblico, Sala dei Nove.

The Common Good, accompanied by the cardinal Virtues, is portrayed as an emperor enthroned.

The theological Virtues, hovering around the head of the Common Good, imply that good government is protected by God.

Magnanimity holds gifts in her lap, waiting to bestow them.

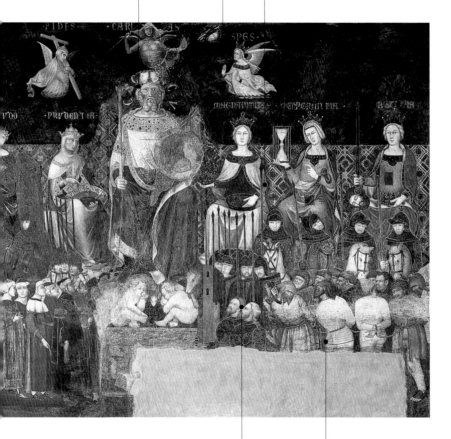

Subdued enemies complete the allegory of good government.

Knights defend the city's peace and harmony with their weapons.

She is represented as a woman turning a wheel, her principal attribute, or else balancing precariously on a rolling sphere.

Fortune

Derivation of the name
From the Latin *fortuna*, derived from *fors*, "chance"

Origin of the symbol
It derives from the conflation, in the Middle Ages, of the Greek god Kairos and the Roman goddess Fortuna

Characteristics
She fosters abundance, fertility, and victory and also represents the fickleness of fate

Related gods and symbols
Tyche, Inconstancy, Isis, Nemesis, Nike, Kairos, Time; wheel, globe, cornucopia, caduceus, sail

Feasts and devotions
The Roman goddess Fortuna was celebrated on April 5 and May 25; Fortuna Virilis, on June 11

Fortune is an ambivalent symbol that can represent both good and bad luck. She is often portrayed holding a cornucopia (the symbol of plenty) and a rudder (with which she steers the ship of life). She is sometimes accompanied by a sail or wings (which change direction depending on the wind), and sometimes holds herself poised precariously atop a sphere, symbol of the inconstancy and perpetual changeability of fate.

Her principal attribute is the wheel, a gigantic gear in continuous motion that can cast people of every rank and condition into the mire or raise them to the pinnacle of society. Princes, peasants, prelates, generals, sages, and philosophers —all are subject to her whims. To underscore the indifference with which she may favor or abandon those she protects, she is sometimes portrayed blindfolded, or as a cruel, blind monster.

In antiquity she was venerated as a female deity—Tyche for the Greeks, Fortuna for the Romans—who determined the outcome, good or bad, of all undertakings. In order to know the gods' intentions, or to placate the whimsy of Fortune, the ancients used to consult oracles. In the Christian era Fortune was identified alternately with divine foreknowledge and with capriciousness.

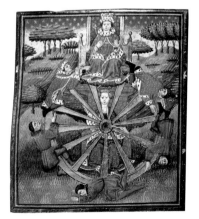

▶ *Wheel of Fortune*, miniature from John Lydgate, *Troy Book and Story of Thebes* (ca. 1455–62).

All the different social classes are represented on Fortune's wheel. She will bestow her fickle favors on all equally.

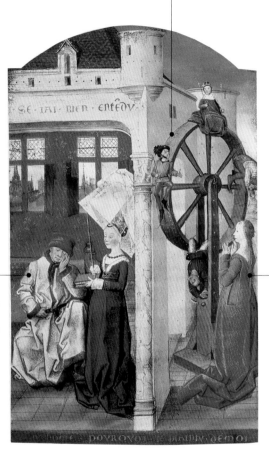

The philosopher Boethius, imprisoned by the Ostrogoth king Theodoric, dictates his spiritual testament, On the Consolation of Philosophy, to Philosophy.

Mercurial Fortune inexorably turns the wheel of good and bad luck.

▲ French School, *The Wheel of Fortune,* illumination from Severinus Boethius, *De consolatione philosophiae,* ca. 1460–70. London, Wallace Collection.

The shock of hair in front, usually paired with baldness in back, derives from the iconography of Kairos. This god embodies opportunity, which may be seized when it is coming toward you but cannot be grasped once the moment is past.

The blindfold represents Fortune's primary characteristic: her blindness in dispensing favors and misfortunes.

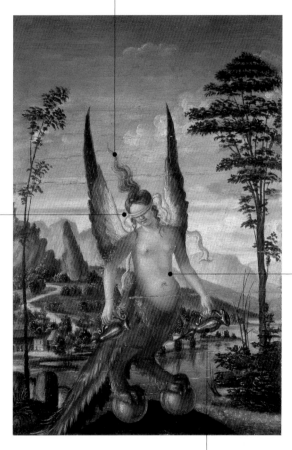

Ill-fate is portrayed as a winged demon with a peacock's tail and a lion's paws.

The two pitchers represent the ambivalent gifts distributed by the goddess.

▲ Giovanni Bellini, *Allegory of Winged Fortune*, 1490. Venice, Gallerie dell'Accademia.

The cup, balanced precariously on her fingertips, symbolizes the instability of Chance's gifts.

The leather straps represent fate's yoke on human life.

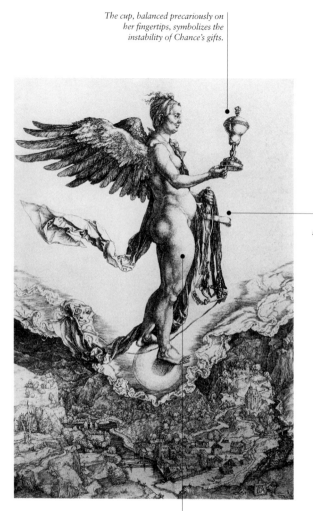

Fortune is portrayed as Nemesis, the Greek goddess of destiny.

▲ Albrecht Dürer, *The Great Fortuna: Nemesis*, engraving, ca. 1501–3.

Good Luck is holding a cornucopia, an ancient attribute of the Greek goddess Tyche, giver of abundance and fertility.

The billowing cape represents the changeability of fortune.

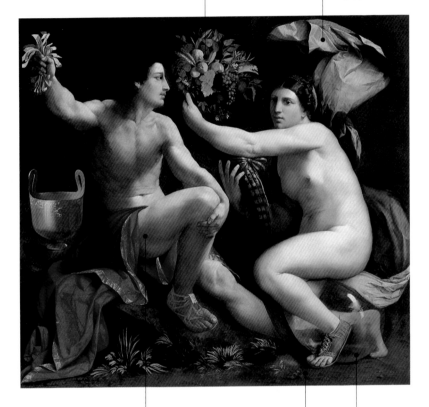

Chance clutches a bunch of tickets for the lottery, a very popular pastime in Renaissance Italy.

The single sandal symbolizes fate, man's inexorable destiny.

The sphere about to burst under the goddess's weight alludes to the instability of luck.

▲ Dosso Dossi, *Allegory of Fortune*, ca. 1535–38. Los Angeles, J. Paul Getty Museum.

The moon alludes to sudden shifts of mood. The image is based on Cesare Ripa's famous depiction of Inconstancy in the Iconology.

The blue dress recalls the color of the ocean's waves, symbols of the continuous transformation of events.

The lobster and the crab are animals traditionally associated with inconstancy, because they randomly walk forward and backward.

▲ Seventeenth-century Dutch artist, *Allegory of Inconstancy.* Copenhagen, Statens Museum for Kunst.

Taking the form of objects, animals, or persons, they represent the human sensory apparatus within a complex moralizing framework.

The Five Senses

Representations of the five senses (sight, hearing, smell, taste, and touch) began to appear in the Middle Ages, as interest in the mechanisms of human intelligence grew. Thus were established the iconographical characteristics of this very distinctive artistic theme, which would enjoy its greatest splendor in the sixteenth and seventeenth centuries.

Origin of the symbol
It derives from the allegorical and moralizing interpretations given to human physiology from the Middle Ages onward

Characteristics
They represent man's sensory faculties as receptors of external stimuli

Related gods and symbols
Zeus (Jupiter), Phoebus (Apollo), Demeter (Ceres), Artemis (Diana); seasons, elements, man as microcosm, animals, flowers, fruit, arts, sciences, mirror, *Vanitas*, temperaments

Under the influence of the medieval conception of religion, which considered the senses dangerous paths leading to sin, many artists interpreted the subject within the thematics of *Vanitas*: painterly allegories on the transience of human life and the vanity of earthly pleasures. Alternatively, they painted Prudence and Temperance, as an admonition against falling into excesses of pleasure. In medieval bestiaries, influenced by Pliny's *Natural History*, each sense was associated with an animal: sight with the cat, lynx, or eagle; hearing with the stag, mole, or boar; smell with the dog or vulture; taste with the monkey; touch with the spider or tortoise. The major Olympian gods were also associated with corresponding senses: Jupiter with sight, Ceres with taste, Apollo with hearing, Diana with smell.

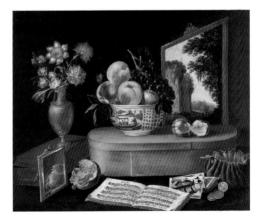

▶ Jacques Linard, *The Five Senses*, 1638. Strasbourg, Musée des Beaux-Arts.

The little girl holding a
nosegay of flowers personifies
the sense of smell.

Taste is represented by the woman with
the lemon and the little monkey eating a
peach. Touch is personified by the woman
holding a parrot.

The little boy with
the mirror alludes
to sight.

The cherub with the
triangle represents
hearing. This sense is
also evoked by the
flute and musical
scores scattered about
in the foreground.

The five senses are
represented as human
beings, in accordance
with Aristotle's treatise
On the Senses.

▲ Gérard de Lairesse, *Allegory of the
Five Senses*, 1668. Glasgow, Art
Museum.

Smell is represented by the woman smelling the flowers, and by the dog, an animal with a highly developed sense of smell.

The reflected image does not correspond to the girl's physiognomy. This discrepancy points to the theme of Vanitas, a warning that beauty is fleeting.

The young woman looking at herself represents sight. She personifies inner vision, which is able to penetrate the superficial appearances of things.

The civet, whose anal gland emits a perfume that was highly prized, is associated with the sense of smell.

Each of these paintings has allegorical significance and a precise moral message. Here the Judgment of Paris *alludes to the sensual life and to divine retribution.*

The Adoration of the Shepherds *and the* Healing of the Blind Man *represent the inner vision of Faith.*

The monkeys looking at the paintings represent the attitudes of the obtuse, who cannot grasp the true value of things.

◄ Jan Brueghel the Elder, *Allegory of Sight and Smell,* late sixteenth–early seventeenth century. Madrid, Prado.

The boy's expression reveals
Caravaggio's interest in
representing the emotions.

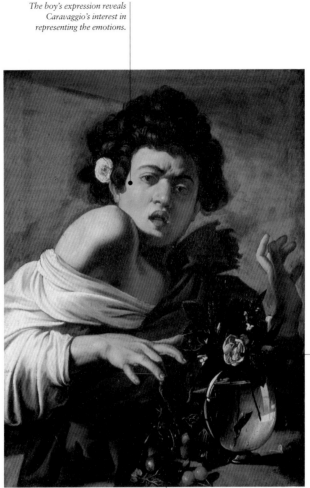

The cut
flowers, whose
beauty quickly
fades, are a
typical symbol
of Vanitas.

The biting lizard alludes to the
sense of touch and to the poetic
theme of the pain hidden in
pleasure (the vase of flowers).

▲ Caravaggio, *Boy Bitten by a Lizard*,
1595–96. Florence, Fondazione
Roberto Longhi.

The stag, an animal very sensitive to
sound, is an allegorical representation
of the sense of hearing.

Hearing is personified
by the woman playing
the lute.

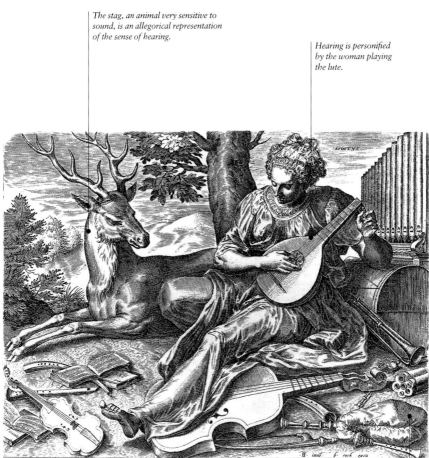

The Latin lines are from
De anima et vita (1538), by
Juan Luis Vives, and give
an anatomical description
of the auditory organs.

▲ Cornelis Cort, Frans Floris, *The Five
Senses: Hearing*, engraving, ca. 1561.

Musical instruments are tradi-
tional attributes of hearing,
which is associated with the
arts of music and song.

This is one of a series of tapestries on the theme of spiritual elevation through love and an understanding of the senses.

The richly attired young woman is a personification of the sense of taste.

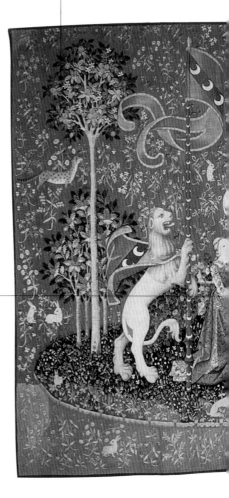

▶ Flemish tapestry, *Taste*, from the *Lady and the Unicorn* series, 1495–1500. Paris, Musée de Cluny.

The parrot, holding a sweet in its claws, is a further allusion to the sense of taste.

The unicorn, a symbol of speed (vistesse in Medieval French), and the lion are heraldic devices of the patrons who commissioned the tapestry, the rich merchant Le Viste family, originally from the city of Lyon.

The wild animals represent the awakening of the sexual instincts in the transition from childhood to adolescence.

The little monkey bringing a berry to its lips echoes the gesture of the girl, who is reaching for a confection.

They are represented by personifications, animals, objects, or colors alluding to the various proclivities of the human character.

The Temperaments

The doctrine of the four temperaments— phlegmatic, bilious, melancholic, and sanguine—is the basis for the representation of the passions and characters in Renaissance art. According to the medical theories of Hippocrates and Galen, every bodily "humor" has its corresponding element, season, and psychological character. Blood is associated with spring, the airy element, the wet-hot, and the sanguine temperament; yellow bile, with fire, the dry-hot, summer, and the bilious or choleric temperament; black bile (*melaina choli*, from which the word "melancholy" derives), with autumn, earth, the dry-cold, and the melancholic temperament; phlegm, with winter, water, the wet-cold, and the phlegmatic temperament.

In the Renaissance the doctrine of the temperaments became part of a complex moral and philosophical system that saw the active life and the contemplative life as two different paths that lead to God. Some of the artworks that best represent this concept are the portraits of Giuliano and Lorenzo de' Medici (Florence, San Lorenzo, Sacrestia Nuova), and Michelangelo's *Moses* and *Saint Paul* for the tomb of Julius II (Rome, San Pietro in Vincoli).

The German painter Dürer was profoundly influenced by the Florentine Neoplatonists' intellectual emphasis on the melancholic temperament, astrologically associated with the god Saturn.

Derivation of the name
From the Latin *temperamentum,* derived from the verb *temperare,* "to mix in the right proportion"

Characteristics
They represent the four fundamental humors of the human organism

Related gods and symbols
Ares (Mars), Zeus (Jupiter), Hades (Pluto), Saturn, apostles; zodiac, planets, seasons, elements, man as microcosm, vices, virtues

▶ Gian Lorenzo Bernini, *Damned Soul*, 1619. Rome, Spanish Embassy to the Holy See, Palazzo di Spagna.

Peter, aging and pale, represents the phlegmatic temperament.

Mark's expression of excitement alludes to the choleric temperament, associated with summer, maturity, and the color of the sun, yellow.

John is associated with the sanguine humor, spring, and the color fire-red.

The saints portrayed here personify the four temperaments in accordance with medieval and Renaissance medical and astrological doctrine.

Paul represents the melancholic humor.

▲ Albrecht Dürer, *The Four Apostles (Allegory of the Four Temperaments),* 1526. Munich, Alte Pinakothek.

The inclined head is the principal attribute of Melancholy; it indicates either spiritual suffering or the contemplative attitude.

The magic square often appears in alchemical imagery.

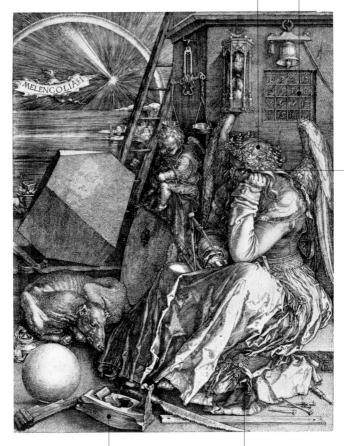

The dark face recalls the nigredo, the first, black phase of the alchemical Work.

The instruments in the composition allude to the different stages of the transformation of matter.

The purse and keys are attributes of Saturn, protector of melancholic temperaments.

▲ Albrecht Dürer, *Melancholy I*, engraving, 1514.

*The woman's ghostly pallor and
pensive pose are typical attributes
of the melancholic humor.*

*Books and paintbrushes, classic
attributes of the arts, symbolize the
vanity of pleasure and knowledge.*

*The skull alludes to the tran-
sience of existence and the
ephemeral happiness allotted
to man on earth.*

▲ Domenico Fetti, *Melancholy*, ca.
1622. Venice, Gallerie dell'Accademia.

Paris represents the sensual temperament, opposed to both the active and the contemplative life.

Juno, queen of the gods, is accompanied by the peacock, an animal sacred to her.

Venus is about to receive the apple of discord from Paris.

Minerva, goddess of wisdom, can be recognized by the shield and breastplate.

▲ Palma the Younger, *The Judgment of Paris*, 1610–15. Private collection.

Hercules represents heroic virtue, as opposed to both the contemplative life and the carnal desires.

Minerva personifies courage, strength, and wisdom.

Venus, goddess of love, tries in vain to tempt the hero with a fragrant flower.

The club and the lionskin are the hero's principal attributes.

The figure of Cerberus, watchdog of Hades, alludes to one of Hercules' twelve labors and the theme of the three paths of the dead.

In Renaissance ethics, which are based on the concept of the "golden mean" developed in Florentine Neoplatonism, the theme of Hercules at the crossroads teaches that the choice of pleasure over virtue leads not to happiness but to divine retribution.

▲ Girolamo Batoni, *Hercules between Love and Wisdom*, 1765. St. Petersburg, Hermitage.

The sword, a symbol of
strength, is associated with
heroic virtue and action.

The myrtle branch, traditionally attrib-
uted to Venus, alludes to the sensitive soul
and the pleasures of the senses.

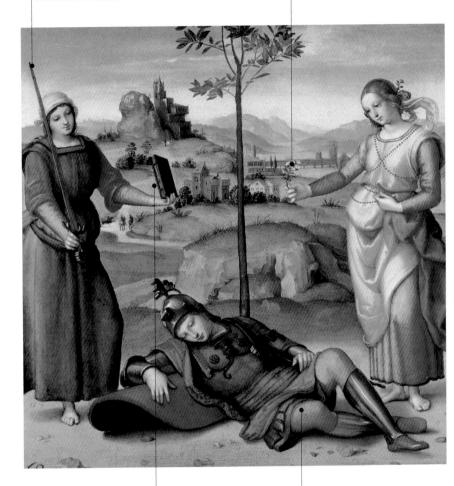

The book represents
intelligence and the
contemplative life.

Scipio is the complete man, in
whom the three different com-
ponents of the soul—mind,
courage, and desire—live in
harmony.

▲ Raphael, *The Dream of Scipio*, 1504.
London, National Gallery.

The young woman represents a Surrealist interpretation of the myth of Pygmalion, king of Cyprus, who decided to renounce sensuality to devote his life to the arts.

The "flowering" woman, whose body is sprouting with luxuriant plant life, represents the fecundity of requited love.

The cold marble statue alludes to the theme of unrequited female desire.

▲ Paul Delvaux, *Pygmalion*, 1939.
Brussels, Musées Royaux des
Beaux-Arts de Belgique.

Giuliano personifies the
active life, one of the two
paths that lead to God.

The scepter alludes to
royal power, typical of
those born under the
sign of Jupiter.

The coins are a symbol of
generosity and represent
the fact that the active
man likes to "expend"
himself in action.

▲ Michelangelo, *Giuliano de' Medici*,
1520–34. Florence, San Lorenzo,
Sacrestia Nuova.

Known by the nickname of
Il Penseroso *(the pensive
one)*, Lorenzo represents the
contemplative attitude.

The index finger
over the mouth
echoes the saturnine
motif of silence.

The shaded face
recalls the facies
nigra of *Saturn,*
protector of
melancholics.

The bent arm is an
iconographic con-
vention for the
melancholic humor.

The closed box is an
allusion to parsimony, a
typical quality of the
saturnine temperament.

▲ Michelangelo, *Lorenzo de' Medici,*
1520–34. Florence, San Lorenzo,
Sacrestia Nuova.

Love

Derivation of the name
From Old English *lufu*, from the same root as the Sanskrit *lobha*, "desire"

Origin of the symbol
In ancient Greece, it was identified with Eros-Phanes, the prime mover of the universe, and with Eros (Cupid), son of Aphrodite (Venus)

Characteristics
It represents the principle of desire and cognition that keeps the world alive and in constant motion

Religious and philosophical traditions
Orphism, Platonism, Kabbalah, alchemy, Neoplatonism

Related gods and symbols
Venus, Wisdom, Virgin Mary, Christ; Church, animals, life, death, vices, virtues, five senses, temperaments, music, alchemy

▶ William-Adolphe Bouguereau, *A Young Girl Defending Herself against Eros*, ca. 1880. Los Angeles, J. Paul Getty Museum.

It can be represented by Cupid, by Venus, or by images of amorous couples.

Over the centuries love has been represented by a vast range of subjects and allegorical motifs that explore both its positive, spiritual aspect and its negative, sensual one. Eros-Phanes, the Orphic principle of creation, embodies the universal desire that gave birth to the world. Eros (Cupid) was sometimes thought to be the son of Penia (Poverty) and Porus (Expediency). As such, according to Plato, he represents the primordial androgynous state to which all creatures tend to return. In the classical era, Eros lost his cosmogonic significance, becoming the irreverent winged boy known also as Cupid, son of Aphrodite (Venus) and Ares (Mars).

In esoteric literature and the arts, love is considered primarily a principle of spiritual elevation that can allow the human heart to experience the divine. The biblical Song of Solomon, the medieval doctrine of courtly love, and the Renaissance concept of Platonic love are its highest expressions. The Florentine philosopher Marsilio Ficino (1433–1499) revived the concept of love as *concordia oppositorum* (the union of opposites), profoundly influencing the art of Botticelli, Giorgione, Titian, and Veronese.

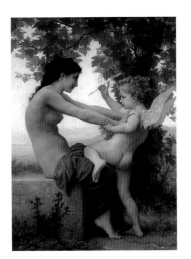

With the rise of the middle class, love was gradually emptied of its mystical and intellectual connotations, being represented instead as a social contract or an everyday bond. Baroque art develops the theme of love in an allegorical vein, making it a sensual metaphor of human life.

The young man personifies male desire.

The objects arranged on the dresser allude to the power of the senses and the temptations of vice.

The girl is lighting the flame of passion with a box of matches.

The parrot is a symbol of lust.

The drops of water falling from the sponge extinguish the fires of love.

The bleeding heart symbolizes woman's power to enchant the psyches of men.

The image as a whole represents the fertility rites traditionally celebrated around the summer solstice.

▲ Rhenish master, *The Spell of Love*, 1470–80. Leipzig, Museum der Bildenden Künste.

The falcon alludes to the woman's role as "huntress" in the game of love. It symbolizes a higher love capable of transcending the pleasure of the senses.

The heart represents the spiritual aspect of male desire: the immaterial, intangible side of passion.

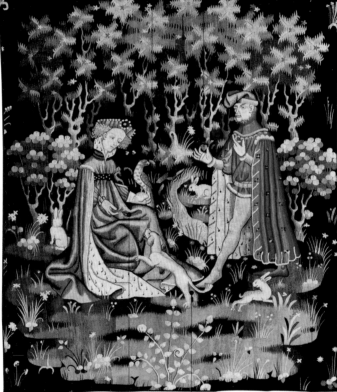

The flower is a symbol of virginity.

The locus amoenus, derived from the woods of Venus, is the appointed place for representations of love.

▲ French tapestry, *The Offering of the Heart*, ca. 1400–1410. Paris, Louvre.

The dog and rabbits stand for the desires of the flesh and sensuality.

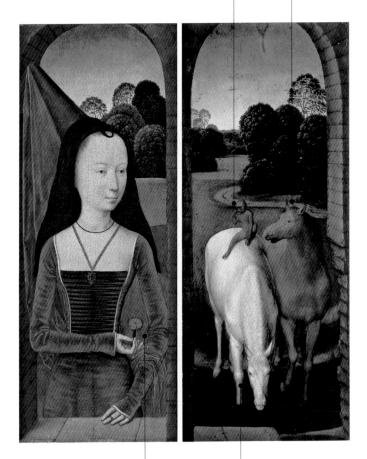

The monkey is traditionally associated with the sin of lust.

The brown horse, looking tenderly at the woman, symbolizes true love.

The carnation is a symbol of conjugal fidelity.

▲ Hans Memling, *Diptych of the Allegory of True Love*, ca. 1485–90. New York, Metropolitan Museum (left panel); Rotterdam, Museum Boymans Van Beuningen (right panel).

The white horse represents the wicked lover, who seeks immediate gratification of his impulses.

The writing on the scrolls reveals
that the loving couple is not married.

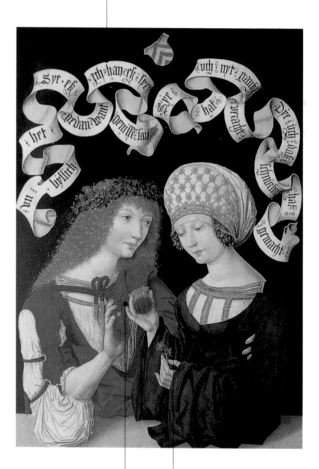

The girl is holding a wild
rose, symbol of her illicit
relationship with her lover.

The finely wrought Schnürlin
is a traditional medieval
ornament for men.

▲ Master of the Book of Reason,
Uncourtly Lovers, southern Germany,
ca. 1484. Gotha (Germany),
Schlossmuseum.

The lighted candle alludes to faith, one of the theological virtues.

The oranges presage fertility.

The witnesses to this happy union are reflected in the mirror. The painting is an allegory of the social ideal of matrimony, which brings wealth, abundance, and prosperity.

The dog and the clogs represent conjugal fidelity.

▲ Jan van Eyck, *The Arnolfini Marriage*, 1434. London, National Gallery.

Mercury, chasing away the clouds with his caduceus, has the task of "unveiling" the mysteries of love.

Castitas (Chastity) is initiated into love's mysteries by her sisters Voluptas (Sensuality) and Pulchritudo (Beauty).

Cupid is shown firing the flame of passion into the heart of Castitas.

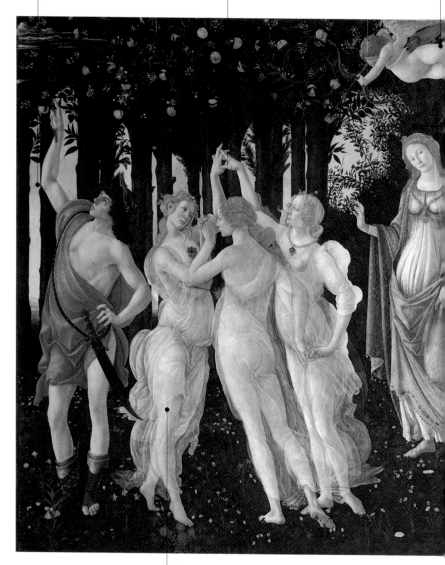

The three Graces symbolize concord and disinterested love, which gives all and demands nothing in return.

Venus represents the virtue of humanitas *and spiritual love, which can raise the soul up to God and make it immortal.*

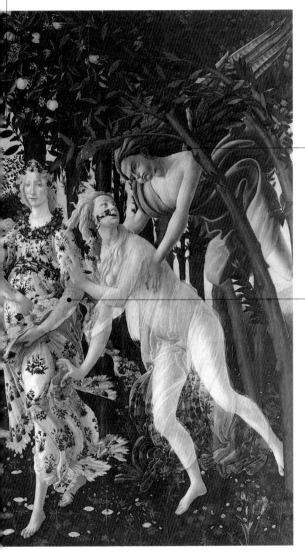

Zephyr, the spring wind, makes the virgin Chloris fertile with the "breath of passion." The painting is a visual translation of De nuptiis philologiae et Mercurii *(The Marriage of Philology and Mercury) by Martianus Capella.*

The image of Flora, goddess of spring, is based on a passage of Ovid's Fasti. *She represents the union of the opposite principles of chastity (Chloris) and love (Zephyr).*

◄ Sandro Botticelli, *Spring*, ca. 1482–83. Florence, Uffizi.

Galatea looks up to the heavens, the realm of the divine, expressing her decision to lead a chaste, virtuous life.

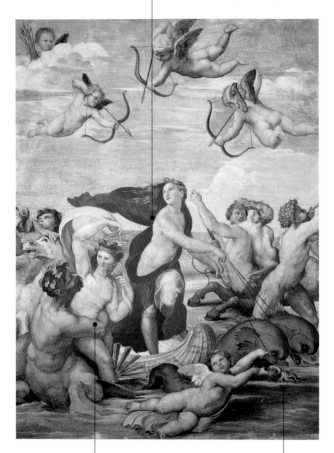

Nymphs and tritons, struck by the arrows of love, symbolize sensual passion.

This image, drawn from Florentine Renaissance poet Poliziano's Stanze per la Giostra *(Stanzas for the Tournament of the Magnificent Guiliano de' Medici) and inspired by the writings of Philostratus, illustrates the opposition between carnal and spiritual love.*

▲ Raphael, *Triumph of Galatea,* 1511–12. Rome, Villa Farnesina.

Anteros, symbol of spiritual love, hides behind Venus.

The bow is the regulatory instrument of passion: It requires skill and mastery to use and symbolizes the moderation of the instinctual drives.

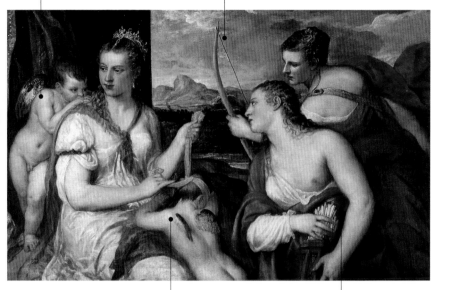

Blindfolded Eros represents the unquestioning, irrational nature of sensual love.

▲ Titian, *Venus Blindfolding Cupid,*
ca. 1565. Rome, Galleria Borghese.

The arrows allude to amorous glances that pierce the heart like darts.

*The presence of Cupid
identifies the font as the
fountain of love.*

*The myrtle crown is a
symbol of marital fidelity.*

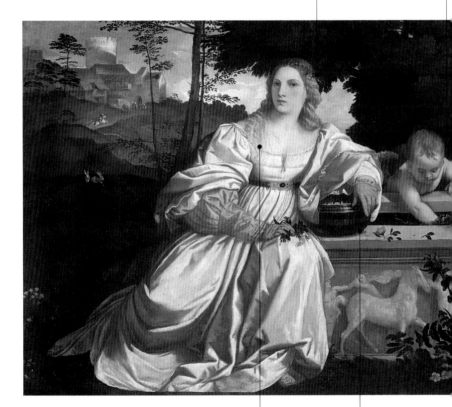

*The clothed woman is
an idealization of
earthly love.*

*The bowl of jewels has
been interpreted as an
allusion to fleeting happi-
ness, the only kind that
can be attained on earth.*

▲ Titian, *Sacred and Profane Love*,
1514. Rome, Galleria Borghese.

Venus Urania represents eternal, celestial happiness and the intelligible principle of spiritual love.

The red cape and burning flame symbolize the passionate nature of Venus.

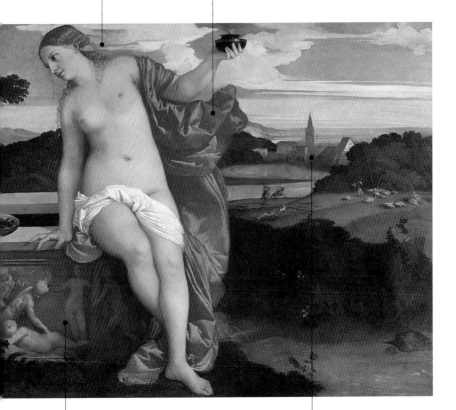

The violent scenes of castigation carved into the sarcophagus show that sensual passion must be punished and held in check.

The church in the background echoes the sacred character of the celestial Venus.

The stormy seas represent unhappy love and a long-distance relationship.

The young woman has just received a love letter.

The servant girl's gesture "uncovers" the key to the entire painting.

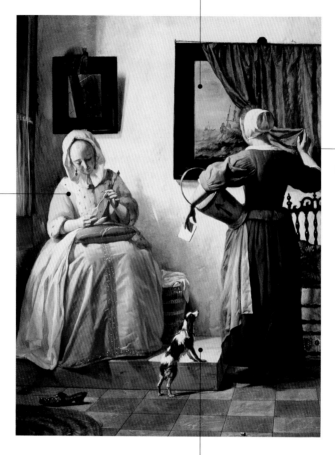

The restless attitude of the expectant dog echoes the impetuous tone of the letter.

▲ Gabriel Metsu, *Woman Reading a Letter*, ca. 1663. Dublin, National Gallery of Ireland.

The bride alludes to the androgynous nature of virginity, which levels all differences between male and female.

The squirts are a materialization of male desire, which culminates in a solitary orgasm.

The propeller is associated with the wheel and the alchemical fire. That is, it is the active agent of transmutation.

The bachelor is represented by an image of a machine: a chocolate grinder.

▲ Marcel Duchamp, *The Bride Stripped Bare by Her Bachelors, Even (The Large Glass)*, 1915–23. Philadelphia Museum of Art.

They are represented as seven women of virtuous appearance accompanied by their traditional attributes.

The Arts

The seven liberal arts in the medieval system of learning are divided into the disciplines of the trivium (grammar, rhetoric, and dialectics) and the quadrivium (astronomy, music, geometry, and arithmetic).

Derivation of the name
From the Latin *ars* (*artis*)

Characteristics
They represent the seven branches of knowledge and man's creative qualities

Related gods and symbols
Sacraments, Muses, zodiac, planets, ages, virtues, temperaments, macrocosm, microcosm, sciences, crafts, mechanical arts

Their iconography is based on the model of the classical muses, the goddesses that personified the various artistic and intellectual disciplines for the Greeks and Romans. It was thought that, like the signs of the zodiac and the elements, they exercised an astrological sort of influence on man's character. For this reason they were sometimes prescribed as therapy for certain illnesses. The connection between the arts and the planets dates back to Pythagoras, who formulated a complex system of harmonic correspondences between the Muses and the heavenly bodies. In the Middle Ages, Thomas Aquinas reformulated classical philosophy in a religious and moral vein, assigning to each of the arts a corresponding virtue and sacrament. This doctrine, also used by Dante in the *Convivio*, would become the model for the iconography of the liberal arts throughout the Middle Ages. It would be illustrated by the preeminent artists of the fourteenth century, such as Giotto, Andrea Pisano, and Andrea Bonaiuti. The personi-

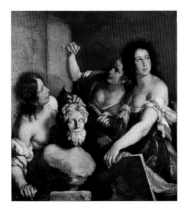

fications of the arts were often accompanied by paradigmatic portraits of their legendary inventors (Orpheus, Hermes Trismegistus, Pythagoras, Plato, Aristotle, and Zoroaster).

▶ Bernardo Strozzi, *Allegory of the Arts*, first half of the seventeenth century. St. Petersburg, Hermitage.

The mask is the attribute of Erato, muse of lyric poetry. Next to her we may recognize Terpsichore, muse of the dance, Polyhymnia, muse of mime, and Urania, muse of astronomy.

Melpomene, muse of tragic poetry, is represented as a pensive young woman.

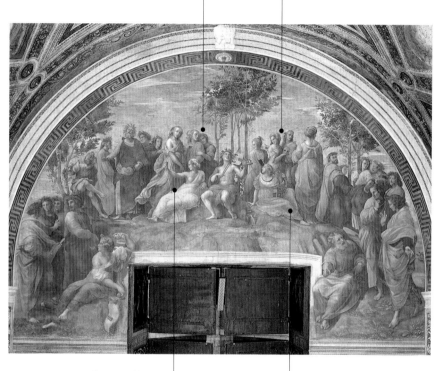

Clio, muse of history, is recognizable by the clarion of fame. Beside her are Euterpe, patroness of music, and Thalia, muse of comedy.

Calliope, muse of epic poetry, is holding a seven-string lyre, symbol of the harmony of the heavenly spheres.

▲ Raphael, *Parnassus*, 1509–10.
Vatican City, Vatican Palaces,
Stanza della Segnatura.

Geometry may be recognized by her square and the presence of Euclid, her greatest exponent.

Saturn, with his sickle and spade, is associated with astronomy. In Thomist doctrine, every moral quality had its corresponding planet in the zodiac.

According to the Book of Genesis, music was associated with the biblical figure of Tubalcain the blacksmith, who forged the first instruments.

Ptolemy the astronomer is portrayed in regal dress; the artist confused him with the sovereign of the same name.

The figure of Mathematics is accompanied by Pythagoras.

Grammar is often associated with idealized portraits of Priscian and Donatus, both renowned grammarians.

Cicero is portrayed at the feet of Rhetoric.

Aristotle was traditionally considered the inventor of logic.

◄ Andrea Bonaiuti, *The Seven Liberal Arts*, 1365–67. Florence, Santa Maria Novella, Spanish Chapel.

The Genius with the torch represents inspiration.

Vulcan is forging musical notes on his anvil.

The clothed figure has been interpreted as a personification of profane music, the nude as sacred music.

The three hammers allude to the different resonances that can be obtained depending on shape and size.

The tablets are inscribed with musical canons. The triangular inscription bears the words "Trinitas in unum" *(three in one), an allusion to the harmony of opposites in divine unity.*

The viola abandoned on the ground stands for the supremacy of polyphony (the canons on the tablet) over the musical instrument.

▲ Dosso Dossi, *Allegory of Music,* ca. 1525. Florence, Fondazione Horne.

The perfectly depicted map alludes to painting's ability to faithfully reproduce reality.

The young woman is portrayed as Clio, muse of history and fame.

The art of painting is represented through the allegory of the painter at work.

▲ Jan Vermeer, *Allegory of Painting*
(*The Studio*), ca. 1672. Vienna,
Kunsthistorisches Museum.

They are represented variously as women, as philosophers, scientists, and inventors, and as the related scientific instruments.

The Sciences

Visual representation of the sciences generally takes the form of ideal portraits of historical figures traditionally considered the greatest innovators in the different areas of study.

Derivation of the name
From the Latin *scientia,*
derived from the verb *scire,*
"to know"

Characteristics
They represent the various
disciplines into which man's
speculative activities may be
divided

Related gods and symbols
Arts, virtues

Humanistic culture gives particular emphasis to man's intellectual capacities in the great painting cycles, such as Raphael's frescoes in the Vatican. Over the course of the 1500s, the rediscovery and diffusion in print of the major scientific texts of antiquity expanded interest in the physical sciences, which soon became the prestigious domain of nobles, artists, and intellectuals. Leonardo da Vinci, who embodied the Renaissance ideal of the artist-inventor, left behind precious examples of his working method, which aimed at conjoining reason (the theoretical knowledge of the age) with experience.

With the specialization of learning and the spread of revolutionary discoveries in astronomy and optics in the seventeenth century (from Copernicus and Galileo to Tycho Brahe, Kepler, and Newton), the iconography of the sciences gradually evolved. From the detailed rendition of objects and instruments of science—such as we find in wood inlays and still lifes, in portraits, and in the allegorical representations of the *Vanitas* theme—it turns into the celebration of famous scientists. In representations of space, atmospheric phenomena, and the celestial bodies, artists convey the new image of reality offered by science.

▶ *Science,* illustration from
Cesare Ripa's *Iconology,*
1618.

The cherub is carrying the globe of the world on his back.

The wings and eyes turned skyward show that Mathematics, through the use of the intellect, can rise to the contemplation of abstract matters.

The compass is a typical attribute of Geometry and Geography. It provides the proportion, rule, and measure of things.

The astrolabe and astronomical tables allude to the study of heavenly phenomena.

▲ Sebastiano Conca, *Allegory of Science*, seventeenth century. Rome, Palazzo Corsini, library.

The Sciences

This fresco aims at illustrating the synthesis of the different fields of knowledge: metaphysics, natural philosophy, theology, and magic.

Plato, with the Timaeus *in hand, and Aristotle, holding the* Ethics, *represent the two highest branches of learning: speculative philosophy and moral philosophy.*

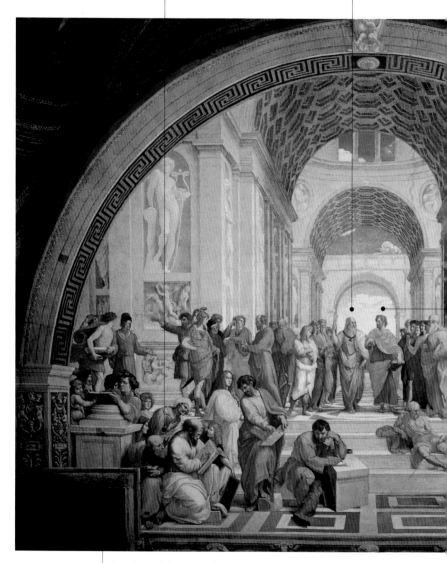

Zeno, the bearded man on the left, looks on as Epicurus uses the base of the column as a lectern.

Aristotle, founder of naturalist thought, is gesturing toward the ground; Plato, who brought together and systematized the cosmological doctrines of antiquity, is pointing to the heavens.

On the right are the natural philosophers and the major followers of Aristotelian doctrine.

Zoroaster, the legendary author of the Chaldaean Oracles, *is holding up a globe of the heavens. His position is mirrored by that of Ptolemy, who holds a globe of the earth, symbolizing the influences of the heavens over the earth.*

Euclid is shown illustrating one of his theorems.

◄ Raphael, *The School of Athens*, 1510. Vatican City, Vatican Palaces, Stanza della Segnatura.

The hexoctahedron symbolizes the perfection of mathematical knowledge.

Luca Pacioli epitomizes the austere scientist, unapproachable and detached from the world.

The equilateral triangle inscribed in the circle is drawn from a famous Euclidean theorem.

▲ Jacopo de' Barbari, *Portrait of the Mathematician Fra' Luca Pacioli and an Unknown Young Man*, first quarter of the sixteenth century. Naples, Capodimonte.

The book on the table is a copy of the first printed edition of Euclid's Elementa.

The family setting in which the experiment is being conducted shows that scientific knowledge has become common property, without regard to sex or age.

As a subject of painting, the experiment offers a lively, communicable image of science.

The frightened children symbolize the fear of the unknown (we are always afraid of what we don't understand), which science strives to dispel.

▲ Joseph Wright of Derby, *An Experiment on a Bird in the Air Pump*, 1768. London, National Gallery.

Its representations combine a variety of symbolic motifs (flowers, fruits, musical instruments) that allude to the transience of human life.

Vanitas

Derivation of the name
From the Latin adjective *vanus*, "empty," "fleeting," "ephemeral"

Origin of the symbol
It developed as a painting genre in the early seventeenth century, as an expression of the sense of precariousness invading European culture

Characteristics
It represents the fleeting nature of existence, the inexorable passage of time, and the insubstantiality of earthly pleasures

Related gods and symbols
Time, seasons, life, death

A *Vanitas* is a representation of human life using symbolic subjects to highlight its tenuousness and fragility. It developed as an independent genre of painting in the early seventeenth century and is closely connected to the sense of precariousness that pervaded Europe following the Thirty Years' War and the flood of plague epidemics. Together with the moralizing theme of the transience of existence, political and religious themes can also be found in allegorical form in the extremely rich iconography of the *Vanitas*.

The inexorable passage of time is represented by the erosion of surfaces, by the layers of dust that slowly accumulate on things—as in a number of celebrated musical still lifes of Evaristo Baschenis—and by the presentation of materially "insubstantial" subjects such as song, smoke, and music. The sophisticated depiction of inanimate objects, carried to the most ostentatious levels of virtuosity, allowed seventeenth-century painters to parade their own mastery at reproducing reality.

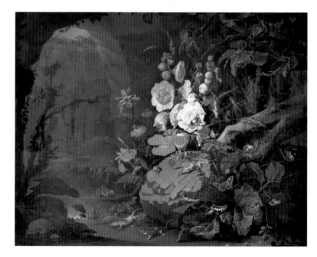

▶ Abraham Mignon, *Nature as a Symbol of Vanitas*, 1665–79. Darmstadt, Hessisches Landesmuseum.

The musical and scientific instruments are highly symbolic, concealing a complex message about the transience of beauty, harmony, and art.

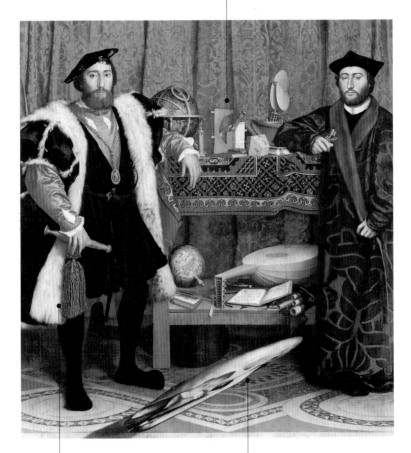

The richly attired ambassador is holding a telescope, symbol of his profession.

The death's-head in the foreground, rendered almost unrecognizable by the distorting technique of anamorphosis, reveals the painting's hidden meaning: It is a refined allegory of the vanity of ambition and worldly knowledge.

▲ Hans Holbein the Younger, *The Ambassadors*, 1533. London, National Gallery.

Vanitas

The extinguished candle, skulls, hourglass, and armor all allude to the decline of the Spanish Empire and the wars that were waged to preserve it.

The globe of the earth represents the extent of the imperial possessions, from the Americas to Eastern Europe.

The cameo held up by the angel is a portrait of Charles V von Habsburg.

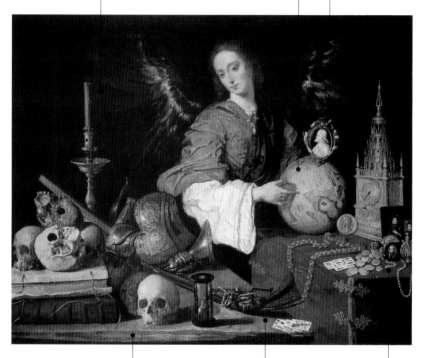

The foreground features a well-used table covered with objects emblematic of the Vanitas theme.

In front of the skull in the foreground, as though scratched into the table, are the words nihil omne, "all is nothing."

Displayed on the table covered with red cloth are a number of precious objects symbolizing the wealth of Spain at the time of Charles V. The painting is a Vanitas with a political undertone; it illustrates the loss of Spanish supremacy in seventeenth-century Europe.

▲ Antonio de Pereda,
Vanitas Vanitatum, 1640–45.
Vienna, Kunsthistorisches Museum.

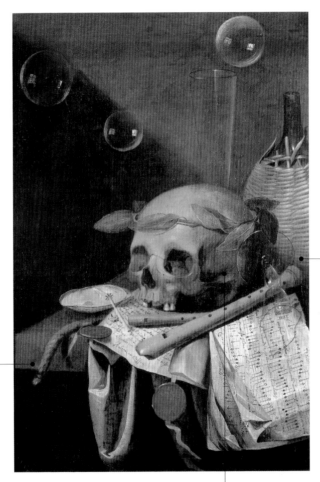

The flute and score allude to the ephemeral joys of music.

The lit fuse tells us how quickly our earthly existence is dissipated.

▲ Simon Renard de Saint-André, *Vanitas*, ca. 1650. Lyon, Musée des Beaux-Arts.

Skulls and broken or twisted objects are expressions of the inner dialogue of the painter confronting the inevitability of human destiny.

The motif of the soap bubble recalls that of the homo bulla *(man is a bubble), a harsh allegory of the transience and fragility of human existence.*

The torch and the brazier in the middle ground are symbols of how rapidly life is consumed.

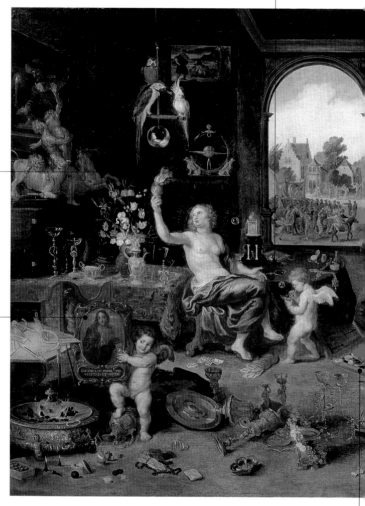

The image of the Redeemer alludes to the afterlife, man's true destiny.

▲ Jan Brueghel the Elder, Peter Paul Rubens, *Allegory of the Transience of Human Life,* 1615–18. Turin, Galleria Sabauda.

Games of chance such as cards, chess, and backgammon allude to the insubstantiality of earthly pleasures.

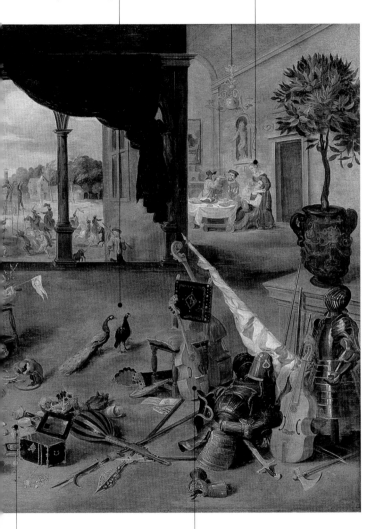

The peacock is associated with pride and vanity.

The banquet scene is a reference to the sin of gluttony and the vice of intemperance.

Precious objects, gold coins, and jewels are clear reminders of the vanity of external wealth.

Musical instruments are a recurrent motif in seventeenth-century allegories of Vanitas.

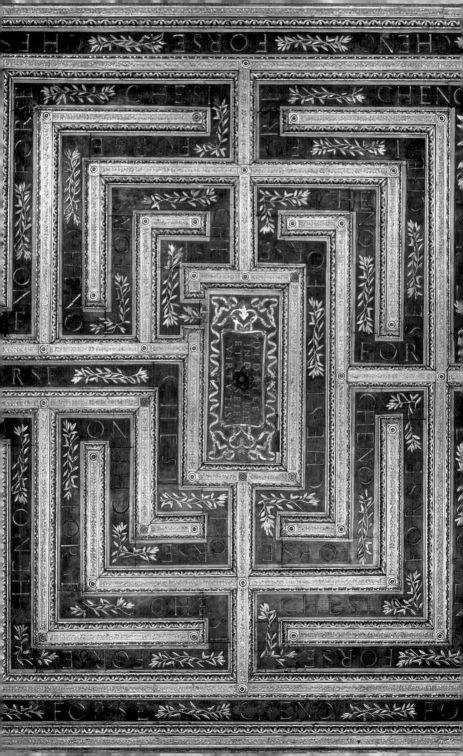

Index of Symbols and Allegories

Sources

OUROBOROS

Plato, *Timaeus*, *Politicus*; Macrobius, *Saturnalia*;
Piero Valeriano, *Hieroglyphica*; Horapollo,
Hieroglyphics; Ovid, *Metamorphoses*; Claudianis,
Gigantomachia; Francesco Petrarch, *Triumphs*;
Marsilio Ficino, *Platonic Theology*; Pico della
Mirandola, *De ente et uno*, *Disputationes
adversus astrologiam divinatricem*; Pietro
Pomponazzi, *Tractatus de immortalitate animae*;
Francesco Colonna, *Hypnerotomachia Poliphili*;
Cesare Ripa, *Iconology*.

OCEANUS

Homer, *Iliad*, *Odyssey*; Hesiod, *Theogony*;
Heraclitus of Ephesus, *Fragments*, "On the
Nature of Things"; Plato, *Cratylus*, *Phaedrus*,
Theaetetus, *Timaeus*; Aristotle, *Metaphysics*;
Apollonius of Rhodes, *Argonautica*; *Orphic
Hymns*; Lucretius, *On the Nature of Things*;
Pliny the Elder, *Natural History*.

OPPORTUNITY

Hesiod, *Theogony*, *Orphic Hymns*; Prudentius,
Psychomachia; Piero Valeriano, *Hieroglyphica*;
Horapollo, *Hieroglyphics*; Joannes Ridevallus,
Fulgentius metaforalis; Pierre Bersuire,
Reductorium morale; *Gesta Romanorum*;
Robertus Holkot, *Moralitates*; Vincent of
Beauvais, *Speculum doctrinale*; Brunetto Latini,
Tesoro; Bartolomeo da San Concordio,
Ammaestramenti degli antichi; Albricus
Philosophus, *De imaginibus deorum*;
Mythographus 1–3; Dante Alighieri, *Convivio*,
The Divine Comedy; Francesco Petrarch,
Triumphs; Giovanni Boccaccio, *Genealogia
deorum gentilium*; Andrea Alciati, *Emblemata*;
Cesare Ripa, *Iconology*; Christoforo Giarda,
Icones Symbolicae.

EON

Epistles of Paul (Corinthians, Hebrews,
Ephesians); Joachim of Fiore, *Liber Concordiae
Novi ac Veteris Testamenti*, *De unitate seu
essentia Trinitatis*, *Liber figurarum*.

TIME

Hesiod, *Theogony*; Plato, *Euthyphro*, *Gorgias*,
Cratylus, *Symposium*, *Euthydemus*, *Politicus*,
Timaeus, *Laws*; Aristotle, *Metaphysics*, *Physics*;
Ovid, *Fasti*; Plutarch, *De Iside et Osiride*;
Hyginus, *Poetica astronomica*; Saint Augustine,
City of God; Macrobius, *Saturnalia*; Martianus
Capella, *The Marriage of Philology and Mercury*;
Philippe de Vitry, *Ovid moralisé*; Fabius
Fulgentius, *Mythologiae*; Rabanus Maurus, *De
universo*; Pierre Bersuire, *Reductorium morale*;
Joannes Ridevallus, *Fulgentius metaforalis*;
Francesco Petrarch, *Triumphs*; Cesare Ripa,
Iconology.

CHRIST CHRONOCRATOR

Gospel of John, Book of Revelation; Saint
Augustine, *On Christian Teaching*; Isidore of
Seville, *Etymologies*; Lambert of Saint Omer,
Liber floridus, "The Order of the Seven Planets,
the Heavens, and the Earth."

THE ZODIAC

Homer, *Iliad*; Plato, *Timaeus*; Eudoxus of Cnidus;
Solensis Aratus, *Phaenomena*, *Aratea*; Marcus
Manilius, *Astronomica*; Firmicus Maternus,
Ancient Astrology: Theory and Practice
[*Matheseos* 8]; Hyginus, *Poetica astronomica*,
Genealogiae, *Fabulae*; Columella, *De re rustica*;
Ptolemy, *Almagest*, *Tetrabiblos*; Lactantius,
Divinae institutiones; Macrobius, *Commentary
on the Dream of Scipio*, *Saturnalia*; Saint
Augustine, *City of God*; Abū Ma'shar

[Albumasar], *Introduction to Astrology*; Alexander Neckam, *De naturis rerum*; Thomas Aquinas, *Summa theologiae*; Lambert of Saint Omer, *Liber floridus*; Petrus de Apono, *Astrolabium Planum*; Pierre d'Ailly, *Imago mundi*; Dante Alighieri, *Convivio*, *The Divine Comedy*; Coluccio Salutati, *De fato et fortuna*; Leonardo Dati, *La sfera*; Franchino Gaffurio, *Practica musicae*, *The Theory of Music*; Marsilio Ficino, *The Book of Life*; *Picatrix*; Basinio da Parma, *Astronomicon*; Agrippa von Nettesheim, *Three Books of Occult Philosophy*; Giorgio Vasari, *Ragionamenti*; Jacopo Zucchi, *Discorso sopra li dei de' gentili*; Vincenzo Cartari, *Imagini de i dei*; Cesare Ripa, *Iconology*.

THE SEASONS
Hesiod, *Theogony*, *Works and Days*; Ovid, *Metamorphoses*; Virgil, *Georgics*; Giorgio Vasari, *Ragionamenti*; Jacopo Zucchi, *Discorso sopra li dei de' gentili*; Vincenzo Cartari, *Imagini de i dei*; Cesare Ripa, *Iconology*.

SPRING
Hesiod, *Theogony*, *Works and Days*; Plato, *Cratylus*, *Meno*, *Laws*; Ovid, *Metamorphoses*; Virgil, *Georgics*; Giorgio Vasari, *Ragionamenti*; Jacopo Zucchi, *Discorso sopra li dei de' gentili*; Vincenzo Cartari, *Imagini de i dei*; Cesare Ripa, *Iconology*.

SUMMER
Hesiod, *Theogony*, *Works and Days*; Ovid, *Metamorphoses*; Virgil, *Georgics*; Giorgio Vasari, *Ragionamenti*; Jacopo Zucchi, *Discorso sopra li dei de' gentili*; Vincenzo Cartari, *Imagini de i dei*; Cesare Ripa, *Iconology*.

AUTUMN
Hesiod, *Theogony*, *Works and Days*; Plato, *Symposium*, *Phaedrus*, *Laws*, *Axiochus*, *Gorgias*, *Cratylus*, *Philebus*; Ovid, *Metamorphoses*; Philostratus, *Imagines*; Virgil, *Georgics*; Giorgio

Vasari, *Ragionamenti*; Jacopo Zucchi, *Discorso sopra li dei de' gentili*; Vincenzo Cartari, *Imagini de i dei*; Cesare Ripa, *Iconology*.

WINTER
Hesiod, *Theogony*, *Works and Days*; Plato, *Gorgias*, *Axiochus*, *Laws*, *Cratylus*; Ovid, *Metamorphoses*; Virgil, *Georgics*; Giorgio Vasari, *Ragionamenti*; Jacopo Zucchi, *Discorso sopra li dei de' gentili*; Vincenzo Cartari, *Imagini de i dei*; Cesare Ripa, *Iconology*.

THE MONTHS
Book of Genesis; Hyginus, *Poetica astronomica*; Vincent of Beauvais, *Speculum doctrinale*; Books of Hours; Francesco Petrarch, *Triumphs*; Dante Alighieri, *Convivio*; Leonardo Dati, *La sfera*; Giorgio Vasari, *Ragionamenti*; Jacopo Zucchi, *Discorso sopra li dei de' gentili*; Vincenzo Cartari, *Imagini de i dei*; Cesare Ripa, *Iconology*.

DAWN (AURORA)
Homer, *Iliad*; Cesare Ripa, *Iconology*.

NOON
Homeric Hymn to Pan; John Cassian, *The Institutes*; Cesare Ripa, *Iconology*.

TWILIGHT
Cesare Ripa, *Iconology*.

NIGHT
Homer, *Iliad*; Hesiod, *Theogony*, *Works and Days*; *Orphic Hymns*; Cesare Ripa, *Iconology*.

THE HOURS
Homer, *Iliad*; Hesiod, *Theogony*, *Works and Days*; *Orphic Hymns*; Cesare Ripa, *Iconology*.

LIFE
Homer, *Iliad*; Hesiod, *Theogony*, *Works and Days*; Plato, *Symposium*, *Republic*, *Laws*; *Orphic Hymns*; Ovid, *Metamorphoses*; New Testament

Gospels; Vincent of Beauvais, *Speculum naturale*; Cesare Ripa, *Iconology*.

DEATH

Homer, *Iliad*; Hesiod, *Theogony, Works and Days*; Plato, *Phaedrus, Symposium, Republic, Laws*; Orphic Hymns; Virgil, *Georgics*; Ovid, *Metamorphoses*; Hyginus, *Genealogiae, Fabulae*; Catullus, *Carmina*; Apollodorus of Damascus, *The Library of Greek Mythology*; New Testament Gospels, Book of Revelation; Vincent of Beauvais, *Speculum naturale*; Cesare Ripa, *Iconology*.

THE AGES OF THE WORLD

Homer, *Iliad*; Hesiod, *Theogony, Works and Days*; Plato, *Gorgias, Statesman, Euthyphro, Cratylus, Timaeus, Euthydemus, Symposium, Republic, Laws*; Virgil, *Aeneid*; Lucretius, *De rerum natura*; Ovid, *Metamorphoses, Fasti*; Pliny the Elder, *Natural History*; Diodorus Siculus; Vitruvius, *De architectura*; Petrus Comestor, *Sermones, Historia scholastica*; Isidore of Seville, *Etymologies*; Lambert of Saint Omer, *Liber floridus*; Brunetto Latini, *Tesoro*; Giovanni Boccaccio, *Genealogia deorum gentilium*.

THE AGES OF MAN

Niccolò Macchiavelli, *The Prince*; Baldassare Castiglione, *The Book of the Courtier*; Pietro Bembo, *Gli Asolani*.

ANDROGYNE

Plato, *Symposium*; Book of Genesis; Marsilio Ficino, *Commentary on Plato's Symposium on Love*; Salomon Trismosin, *Splendor Solis*; Jacob Böhme, *Aurora*; Basilius Valentinus, *Twelve Keys*; Michael Maier, *Atalanta fugiens*; Altus, *Mutus Liber*.

MICROCOSM

Plato, *Timaeus*; Aristotle, *De anima*; Plotinus, *Enneads*; Theocritus, *Idylls*; Cicero, *Tusculan Disputations, The Nature of the Gods*; Ovid,

Metamorphoses; Vitruvius, *De proportione*; Pliny the Elder, *Natural History*; Marcus Manilius, *Astronomica*; Firmicus Maternus, *Matheseos*; Hildegard von Bingen, *Liber divinorum operum (De operatione Dei)*; Isidore of Seville, *De natura rerum, Etymologies*; Honorius of Autun, *De imagine mundi*; Albertus Magnus; Vincent of Beauvais, *Speculum maius, Speculum doctrinale*; Agrippa von Nettesheim, *De occulta philosophia*; Bernard Silvestris, *De mundi universitate sive megacosmus et microcosmus*; Pierre d'Ailly, *Imago mundi*; Alexander Neckam, *De naturis rerum*; Marsilio Ficino, *Platonic Theology, Corpus hermeticum, Commentary on Plotinus's Enneads*; Pico della Mirandola, *Disputationes adversus astrologiam divinatricem*; Franchino Gaffurio, *Practica musicae, The Theory of Music*; Giovanni Paolo Lomazzo, *Trattato dell'arte della pittura, Idea del tempio della pittura*; *Picatrix*; Paracelsus, *Opus Paramirum, Paragranum*; Giambattista della Porta, *Magiae naturalis*; Robert Fludd, *Utriusque Cosmi 1*; Andreas Cellarius, *Harmonia macrocosmica*; Jacob Böhme, *Aurora*; John Milton, *Paradise Lost*.

CHRIST

Song of Solomon; New Testament Gospels, Acts of the Apostles; Gospel of John, Book of Revelation; Apocrypha (Book of James [Protevangelium], Gospel of Pseudo-Matthew); Saint Augustine, *On Christian Teaching*; Jacobus de Voragine, *The Golden Legend*.

THE VIRGIN MARY

Song of Solomon; New Testament Gospels, Acts of the Apostles, Book of Revelation; Apocrypha (Book of James [Protevangelium]); Saint Augustine, *On Christian Teaching*; Jacobus de Voragine, *The Golden Legend*.

THE TRINITY

Plato, *Timaeus*; Plotinus, *Enneads*; Proclus, *Commentary on Plato's Timaeus*; Ovid, *Fasti*;

Book of Genesis; New Testament Gospels, Acts of the Apostles; Epistle of Paul to the Romans; Saint Augustine, *On the Trinity*; Boethius, *De trinitate*; Joachim of Fiore, *De unitate deu essentia trinitatis*, *Liber figurarum*; Gemistus Plethon, *On the Procession of the Holy Spirit*; Marsilio Ficino, *De rationibus trinitatis*; Pico della Mirandola, *De ente et uno*; Francesco Colonna, *Hypnerotomachia Poliphili* (*The Strife of Love in a Dream*).

EVE
Book of Genesis; Altus, *Mutus liber*.

MOTHER
Euripides, *Helen*; Aristophanes, *The Birds*; *Orphic Hymns*; Lucian, *Dialogues*; Book of Genesis; Altus, *Mutus liber*; Hildegard von Bingen, *Liber scivias*; Francesco Colonna, *Hypnerotomachia Poliphili*.

EGG
Euripides, *Helen*; Aristophanes, *The Birds*; *Orphic Hymns*; Lucian, *Dialogues*; New Testament Gospels, Epistles of Peter; Hildegard von Bingen, *Liber scivias*; Salomon Trismosin, *Splendor solis*; Francesco Colonna, *Hypnerotomachia Poliphili*.

MIRROR
Socrates; Diogenes Laertius, *Lives of Eminent Philosophers*, *Epigrams*; Ovid, *Metamorphoses*; Philostratus, *Images*; Cesare Ripa, *Iconology*.

CROSS
New Testament Gospels, Acts of the Apostles; Apocrypha (Gospel of Nicodemus); Pseudo-Bonaventure, *Meditations on the Life of Christ*; Bernard of Clairvaux, *Sermon on the Song of Songs*; Jacobus de Voragine, *The Golden Legend*.

HALO
Gospel of John, Book of Revelation.

ANGEL
Books of Genesis and Tobias; Gospel of John, Book of Revelation; Apocrypha (Book of Enoch); Saint Justin Martyr, *Apologies*; Pseudo-Dionysius the Areopagite, *De caelesti hierarchia*; Thomas Aquinas, *Summa theologiae*; Saint Anselm, Archbishop of Canterbury, *Elucidarium*; Jacobus de Voragine, *The Golden Legend*; Dante Alighieri, *The Divine Comedy*; Agrippa von Nettesheim, *De occulta philosophia*; John Milton, *Paradise Lost*.

SATAN
Books of Genesis, Exodus, Isaiah, Leviticus, Chronicles; New Testament Gospels, especially Gospel of John, Book of Jude, Second Epistle of Peter; Revelation; Apocrypha (Book of Enoch, Gospel of Nicodemus, Apocalypse of Paul, Apocalypse of Peter, The Trier Apocalypse); Origen of Alexandria, *Contra Celsum*; Saint Augustine, *City of God*, *On the Trinity*; Pseudo-Dionysius the Areopagite, *De caelesti hierarchia*; *Menology of Basil*; *Les Visions de Tondal*; Thomas Aquinas, *Summa theologiae*, *Summa contra gentiles*; Jacobus de Voragine, *The Golden Legend*; *Roman de Fauvel*; Dante Alighieri, *The Divine Comedy*; Heinrich Krämer, *Malleus Maleficarum*; Agrippa von Nettesheim, *De occulta philosophia*; Franciscus Junius, *The Junius Manuscript*; Torquato Tasso, *Jerusalem Delivered*; John Milton, *Paradise Lost*; Christopher Marlowe, *Doctor Faustus*.

MONSTER
Homer, *Iliad*, *Odyssey*; Hesiod, *Theogony*; Plato, *Letters*, *Phaedrus*, *Statesman*, *Axiochus*, *Republic*, *Laws*; *Orphic Hymns*; Virgil, *Aeneid*; Lucretius, *De rerum natura*; Ovid, *Metamorphoses*; Book of Job; Moralized Bibles; Anglo-Norman Apocalypses; Apocalypse of Toulouse; Evangeliaries; Psalteries; Books of Hours; Breviaries; Bestiaries; Buzurg ibn Shahriyär, *The Book of the Marvels of India*; *Ars moriendi*; *Calendrier des Bergers* [Shepherds' Calendar]; Thomas de Cantimpré, *De natura rerum*;

Les Visions de Tondal; The Revelation to the Monk of Evesham [Eynsham]; Ralph of Coggeshall (attr.), Vision of Turkill; Dante Alighieri, The Divine Comedy; Cesare Ripa, Iconology.

POLYCEPHALOS

Homer, Iliad, Odyssey; Hesiod, Theogony; Plato, Letters, Phaedrus, Statesman, Axiochus, Republic; Orphic Hymns; Virgil, Aeneid; Lucretius, De rerum natura; Ovid, Metamorphoses; Book of Job; moralized Bibles; Anglo-Norman apocalypses; Apocalypse of Toulouse; evangeliaries; psalteries; books of hours; breviaries; bestiaries; Buzurg ibn Shahriyär, The Book of the Marvels of India; Ars moriendi; Calendrier des Bergers [Shepherds' Calendar]; Thomas de Cantimpré, Liber de natura rerum; Dante Alighieri, The Divine Comedy; Cesare Ripa, Iconology.

TETRAMORPH

Sophocles, Oedipus Rex; Apollodorus of Athens, On the Gods, Chronicles; Hyginus, Genealogiae, Fabulae; Old Testament; Gospel of John, Book of Revelation; Apocrypha (Book of Enoch); Liber Scali Machometi.

ZOOMORPH

Homer, Iliad, Odyssey; Hesiod, Theogony; Plato, Letters, Phaedrus, Statesman, Axiochus, Republic; Orphic Hymns; Virgil, Aeneid; Lucretius, De rerum natura; Ovid, Metamorphoses; Book of Job; moralized Bibles; Anglo-Norman apocalypses; Apocalypse of Toulouse; evangeliaries; psalteries; books of hours; breviaries; bestiaries; Buzurg ibn Shahriyär, The Book of the Marvels of India; Ars moriendi; Calendrier des Bergers [Shepherds' Calendar]; Thomas de Cantimpré, De naturis rerum; Dante Alighieri, The Divine Comedy; Cesare Ripa, Iconology.

CHAOS

Plato, Timaeus, Critias, Republic; Aristophanes,

The Birds; Aristotle, Politics; Book of Genesis; Gospel of John, Book of Revelation; Agrippa von Nettesheim, De occulta philosophia; Jacob Böhme, Aurora; Athanasius Kircher, Mundus subterraneus; John Milton, Paradise Lost; Romeyn De Hooghe, Hieroglyphica; William Blake, The Book of Urizen.

COSMOS

Plato, Timaeus, Critias, Republic; Aristophanes, The Birds; Aristotle, Metaphysics, Physics; Book of Genesis; Gospel of John, Book of Revelation; Hugo of Saint-Victor, Didascalion; Bernard Silvestris, De mundi universitate; al-Qazwīnī, Cosmography; Marsilio Ficino, De christiana religione; Platonic Theology; Pico della Mirandola, De ente et uno, Disputationes adversus astrologiam divinatricem; Paracelsus, Opus Paramirium, Paragranum; Giambattista della Porta, Magiae naturalis; Agrippa von Nettesheim, De occulta philosophia; Jacob Böhme, Aurora; Athanasius Kircher, Mundus subterraneus; John Milton, Paradise Lost; Robert Fludd, Utriusque Cosmi 1; Andreas Cellarius, Harmonia macrocosmica; Romeyn De Hooghe, Hieroglyphica; William Blake, The Book of Urizen.

SKY

Homer, Odyssey; Hesiod, Theogony; Plato, Timaeus, Euthyphro, Symposium, Epinomis, Republic; Aristotle, Metaphysics, Physics; Aristophanes, The Birds; Ovid, Metamorphoses; Books of Genesis and Ezekiel; Gospel of John, Book of Revelation; Apocrypha (Book of Enoch); Koran; Liber Scali Machometi; Solensis Aratus, Phaenomena, Aratea; Marcus Manilius, Astronomica; Firmicus Maternus, Ancient Astrology: Theory and Practice [Matheseos 8]; Hyginus, De astronomia, Genealogiae, Fabulae; Pseudo-Dionysius the Areopagite, De caelesti hierarchia; Saint Augustine, City of God; Bernard Silvestris, De mundi universitate; Hildegard von

Bingen, *Liber scivias*, *Liber divinorum operum (De operatione Dei)*; Thomas Aquinas, *Summa Theologiae*; Hugo of Saint-Victor, *Didascalion, Commentariorum in hierarchiam coelestem*; Jacobus de Voragine, *The Golden Legend*; Ghazzālī, *Alchemy of Happiness*; Dante Alighieri, *The Divine Comedy*; Petrus de Apono, *Astrolabium planum*; Leonardo Dati, *La sfera*; Marsilio Ficino, *De christiana religione*; *Platonic Theology, De vita coelitus comparanda*; Pico della Mirandola, *De ente et uno, Disputationes adversus astrologiam divinatricem*; Paracelsus, *Opus Paramirium, Paragranum*; Jacob Böhme, *Aurora*; Robert Fludd, *Utriusque Cosmi* 1; Andreas Cellarius, *Harmonia macrocosmica*; Giorgio Vasari, *Ragionamenti*; Jacopo Zucchi, *Discorso sopra li dei de' gentili*; Vincenzo Cartari, *Imagini de i dei*; Cesare Ripa, *Iconology*.

SUN

Hesiod, *Theogony*; Plato, *Timaeus, Apology of Socrates, Laws*; Aristotle, *Metaphysics, Physics*; Aeschylus, *Choephori*; Ovid, *Metamorphoses*; Plutarch, *On Isis and Osiris*; Solensis Aratus, *Phaenomena, Aratea*; Marcus Manilius, *Astronomica*; Firmicus Maternus, *Ancient Astrology: Theory and Practice [Matheseos 8]*; Old Testament; Gospels, especially the Gospel of John, Book of Revelation; Hildegard von Bingen, *Liber divinorum operum (De operatione Dei)*; Saint Francis of Assisi, *Canticle of the Creatures*; *Tabula smaragdina*; *Chanson de Roland*; Bernard of Clairvaux, *On Loving God*; *La Queste du Saint Graal*; Dante Alighieri, *The Divine Comedy*; Petrus de Apono, *Astrolabium planum*; Leonardo Dati, *La sfera*; Marsilio Ficino, *De sole, De christiana religione, Platonic Theology, De vita coelitus comparanda*; Pico della Mirandola, *De ente et uno, Disputationes adversus astrologiam divinatricem*; Paracelsus, *Opus Paramirium, Paragranum*; Jacob Böhme, *Aurora*; Giambattista della Porta, *Magiae naturalis*; Salomon Trismosin, *Splendor Solis*; Robert Fludd, *Utriusque Cosmi* 1;

Andreas Cellarius, *Harmonia macrocosmica*; Michael Maiers, *Atalanta fugiens*; Athanasius Kircher, *Ars magna lucis et umbrae*; Giorgio Vasari, *Ragionamenti*; Jacopo Zucchi, *Discorso sopra li dei de' gentili*; Vincenzo Cartari, *Imagini de i dei*.

MOON

Hesiod, *Theogony*; Plato, *Timaeus, Phaedrus, Epinomis, Republic, Laws*; Aristotle, *Metaphysics, Physics*; Aeschylus, *Choephori*; Ovid, *Metamorphoses*; Plutarch, *On Isis and Osiris*; Aratus, *Phaenomena, Aratea*; Marcus Manilius, *Astronomica*; Firmicus Maternus, *Ancient Astrology: Theory and Practice [Matheseos 8]*; Old Testament; Gospels, especially the Gospel of John, Book of Revelation; Hildegard von Bingen, *Liber divinorum operum (De operatione Dei)*; Saint Francis of Assisi, *Canticle of the Creatures*; *Tabula smaragdina*; Dante Alighieri, *The Divine Comedy*; Petrus de Apono, *Astrolabium planum*; Leonardo Dati, *La sfera*; Marsilio Ficino, *De christiana religione*; *Platonic Theology, De vita coelitus comparanda*; Pico della Mirandola, *De ente et uno, Disputationes adversus astrologiam divinatricem*; Paracelsus, *Opus Paramirium, Paragranum*; Jacob Böhme, *Aurora*; Giambattista Della Porta, *Magiae naturalis*; Robert Fludd, *Utriusque Cosmi* 1; Andreas Cellarius, *Harmonia macrocosmica*; Michael Maier, *Atalanta fugiens*; Athanasius Kircher, *Ars magna lucis et umbrae*; Giorgio Vasari, *Ragionamenti*; Jacopo Zucchi, *Discorso sopra li dei de' gentili*; Vincenzo Cartari, *Imagini de i dei*.

EARTH

Homeric Hymn to Demeter; Hesiod, *Theogony*; Plato, *Timaeus, Symposium, Axiochus, Cratylus, Laws*; Aristotle, *Metaphysics, Physics*; Aeschylus, *Choephori*; Ovid, *Metamorphoses*; Books of Genesis and Ezekiel; Gospel of John, Book of Revelation; Apocrypha (Book of Enoch); Hildegard von Bingen, *Liber divinorum operum (De operatione Dei)*; Marsilio Ficino, *Platonic*

Theology; Pico della Mirandola, *De ente et uno*, *Disputationes adversus astrologiam divinatricem*; Paracelsus, *Opus Paramirium, Paragranum*; Jacob Böhme, *Aurora*; Giambattista Della Porta, *Magiae naturalis*; Robert Fludd, *Utriusque Cosmi* I; Athanasius Kircher, *Mundus Subterraneus*; Cesare Ripa, *Iconology*.

THE ELEMENTS
Thales of Miletus; Anaximenes of Lampsacus; Anaximander; *Homeric Hymn to Demeter*; Hesiod, *Theogony*; Plato, *Timaeus, Axiochus, Cratylus, Laws*; Aristotle, *Metaphysics, Physics*; Ovid, *Metamorphoses*; Pliny the Elder, *Natural History*; Isidore of Seville, *Allegoriae, Etymologiae*; Honorius of Autun, *Elucidarium*; Alanus de Insulis, *De Planctu naturae*; Hugo of Saint-Victor, *Didascalion, Commentarium in Hierarchiam coelestem*; Bernard Silvestris, *De mundi universtitate*; Hildegard von Bingen, *Liber scivias, Liber divinorum operum (De operatione Dei)*; Albertus Magnus, *Philosophia naturalis*; *Tabula smaragdina*; Marsilio Ficino, *Platonic Theology*; Pico della Mirandola, *De ente et uno, Disputationes adversus astrologiam divinatricem*; Paracelsus, *Opus Paramirium, Paragranum*; Girolamo Cardano, *Opera omnia*; Jacob Böhme, *Aurora*; Giambattista della Porta, *Magia naturalis*; Robert Fludd, *Utriusque Cosmi* I; Agrippa von Nettesheim, *De occulta philosophia*; Cesare Ripa, *Iconology*.

THE HEREAFTER
Homer, *Odyssey*; Hesiod, *Theogony*; Plato, *Apologia, Phaedrus, Axiochus, Critias, Timaeus, Lesser Hippias, Ion, Gorgias, Symposium, Carmides, Cratylus, Republic, Laws*; Aristotle, *Metaphysics*; Cicero, *The Dream of Scipio*; Virgil, *Aeneid*; Ovid, *Metamorphoses*; Pliny the Elder, *Natural History*; Dante Alighieri, *The Divine Comedy*.

PARADISE
Book of Genesis; New Testament Gospels, Book of Revelation; Apocrypha (Apocalypse of Paul); Koran; *Liber Scali Machometi*; Saint Augustine, *Confessions, City of God*; Pseudo-Dionysius the Areopagite, *De caelesti hierarchia*; Hildegard von Bingen, *Liber divinorum (De operatione Dei)*; Thomas Aquinas, *Summa theologiae*; Dante Alighieri, *Convivio, The Divine Comedy*; Agrippa von Nettesheim, *De occulta philosophia*.

PURGATORY
Plato, *Gorgias*; Epistle of Paul to the Corinthians; Saint Augustine, *De anima*; Gregory the Great, *Dialogues*; *Saint Patrick's Purgatory (Tractatus de Purgatorio Sancti Patricii)*; Thomas Aquinas, *Summa theologiae*; Jacobus de Voragine, *The Golden Legend*; Dante Alighieri, *Convivio, The Divine Comedy*; Catherine of Genoa, *Treatise on Purgatory*; Roberto Bellarmino, *Disputationes*.

LIMBO
Gospel of Luke, Epistles of Peter, Epistle of Paul to the Ephesians; Apocrypha (Gospel of Bartholomew, Gospel of Nicodemus); Dante Alighieri, *The Divine Comedy*.

HELL
Old Testament; Gospel of John, Book of Revelation; Apocrypha (Book of Enoch, Apocalypse of Peter; Apocalypse of Paul, Revelation of Esdras, *Pistis Sophia*, Acts of Thomas; Letter of Pseudo-Titus); Saint Augustine, *City of God*; Honorius of Autun, *Elucidarium*; *Les Visions de Tondal*; *Revelation to the Monk of Evesham [Eynsham]*; Ralph of Coggeshall (attr.), *Vision of Turkill*; *Ars moriendi*; *Calendrier des Bergers [Shepherds' Calendar]*; Dante Alighieri, *The Divine Comedy*.

JOURNEY
Epic of Gilgamesh; *Orphic Hymns*; Homer, *Iliad, Odyssey*; Apollonius of Rhodes, *Argonautica*;

Cicero, *The Dream of Scipio*; Virgil, *Aeneid*; Ovid, *Metamorphoses*; Books of Exodus and Daniel; Gospel of Matthew; Apocrypha (Acts of Thomas); Muhyddin ibn Arabi, *Book of the Night-Journey*; *The Voyage of Saint Brendan*; Thomas Malory, *King Arthur and the Quest of the Holy Grail*; *Les Visions de Tondal*; *Saint Patrick's Purgatory*; Jacobus de Voragine, *The Golden Legend*; Giocoma da Verona, *De Jerusalem celesti* and *De Babilonia, civitate infernali*; Bonvesin da la Riva, *Book of the Three Scriptures*; Dante Alighieri, *The Divine Comedy*; Flavius Josephus, *Jewish Antiquities*; *Alexander the Great's Journey to Paradise*; John Mandeville, *Mandeville's Travels*; Francesco Colonna, *Hypnerotomachia Poliphili*.

DREAM

Epic of Gilgamesh; Homer, *Iliad*, *Odyssey*; Plato, *Timaeus*; Apollonius of Rhodes, *Argonautica*; Cicero, *The Dream of Scipio*; Virgil, *Aeneid*; *Orphic Hymns*; Book of Daniel; Apocrypha (Gospel of Pseudo-Matthew, Book of James [Protevangelium], Acts of Thomas); Muhyddin ibn Arabi, *Book of the Night-Journey*; Macrobius, *Commentary on Cicero's Dream of Scipio*; Jacobus de Voragine, *The Golden Legend*; Hildegard von Bingen, *Liber scivias*; Thomas Malory, *King Arthur and the Quest of the Grail*; Dante Alighieri, *The Divine Comedy*; Francesco Colonna, *Hypnerotomachia Poliphili*; Cesare Ripa, *Iconology*.

LADDER

Plato, *Timaeus*; Books of Genesis, Kings, Ezekiel, Psalms, Song of Solomon; Apocrypha (Acts of Thomas); Origen of Alexandria, *Homilies on the Song of Songs*; Pseuso-Dionysius the Areopagite, *De caelesti hierarchia*; Bernard of Clairvaux, *The Twelve Steps of Humility and Pride*; Johannes Scotus Erigena, *De divisione naturae*; *Passion of Saint Perpetua*; John Climacus, *The Ladder of Divine Ascent*; Ramon Llull, *Breviculum, De*

cognitione Dei; Thomas Malory, *King Arthur and the Quest of the Grail*; Dante Alighieri, *The Divine Comedy: Paradiso*; Nicholas of Cusa, *De coniecturis*; Agrippa von Nettesheim, *De occulta philosophia*; Athanasius Kircher, *Musurgia universalis*, *Ars magna sciendi*; Robert Fludd, *Philosophia sacra*.

MOUNTAIN

Hesiod, *Theogony*; Plato, *Timaeus, Laws*; Books of Genesis, Kings, Judges, Isaiah, Ezekiel, Psalms; Gospel of John, Book of Revelation; Apocrypha (Book of Enoch); Ovid, *Metamorphoses*; Thomas Malory, *King Arthur and the Quest of the Grail*; Dante Alighieri, *The Divine Comedy*.

FOREST

Hesiod, *Theogony*; Plato, *Timaeus*; Books of Genesis, Kings, Judges, Isaiah, Ezekiel, Psalms; Gospel of John, Book of Revelation; Apocrypha (Book of Enoch); Ovid, *Metamorphoses*; Thomas Malory, *King Arthur and the Quest of the Grail*; Dante Alighieri, *The Divine Comedy*.

TREE

Books of Genesis, Exodus, Isaiah, Psalms, Proverbs; Gospel of Matthew, Book of Revelation; Buzurg ibn Shahriyär, *The Book of the Marvels of India*; al-Qazwīnī, *The Wonders of Creation*; *Physiologus*; Rabanus Maurus, *Allegoriae in universam Sacram Scripturam*; *Passion of Saint Perpetua*; *Cistercian Legends* and *Martyrology*; Bernard de Clairvaux, *First Sermon for Advent*; Hugo of Saint-Victor, *De fructibus carnis et spiritu*; Herbariums; *Romance of Alexander*; Dante Alighieri, *The Divine Comedy: Paradiso*.

GARDEN

Books of Genesis, Kings, Isaiah, Ezekiel, Song of Solomon; Apocrypha (Apocalypse of Moses; Life of Adam and Eve); Flavius Josephus, *Jewish Antiquities*; *Alexander the Great's Journey to Paradise*; Herbariums; Guillaume de Lorris,

Roman de la rose; Dante Alighieri, *The Divine Comedy: Purgatorio*; John Mandeville, *Mandeville's Voyages*; Francesco Colonna, *Hypnerotomachia Poliphili*.

FOUNTAIN
Books of Genesis, Song of Solomon; Apocrypha (Life of Adam and Eve); Flavius Josephus, *Jewish Antiquities*; *Alexander the Great's Journey to Paradise*; *Romance of Alexander*; *De sphaera*; Guillaume de Lorris, *Roman de la rose*; Dante Alighieri, *The Divine Comedy: Purgatorio*; *The Symbolic Garden*; Leonardo Dati, *La sfera*; Francesco Colonna, *Hypnerotomachia Poliphili*.

LABYRINTH
Plato, *Laws*; Diodorus Siculus, *Library*; Plutarch, *Theseus*; Hyginus, *Genealogiae, Fabulae*; Philostratus the Athenian, *Imagines*; Book of Kings; Johan Amos Comenius, *Labyrinth of the World and Paradise of the Heart*; Sebastiano Serlio, *The Five Books of Architecture*; Athanasius Kircher, *Turris Babel, sive Archontologia*.

CITY
Plato, *Timaeus, Critias, Republic, Laws*; Aristophanes, *The Birds*; Aristotle, *Politics*; Vitruvius, *De architectura*; Book of Genesis; Gospel of John, Book of Revelation; Saint Augustine, *City of God*; Giacomo da Verona, *De Jerusalem celesti* and *De Babilonia, civitate infernali*; Leon Battista Alberti, *De re aedificatoria*; Thomas More, *Utopia*, Tommaso Campanella, *The City of the Sun*.

TOWER
Book of Genesis; *Pastor Hermae*; Bonvesin da la Riva, *Book of the Three Scriptures*; Tarot; Sebastian Brant, *The Ship of Fools*; Athanasius Kircher, *Turris Babel, sive Archontologia*.

THE VICES
Hesiod, *Works and Days*; Homer, *Iliad, Odyssey*;

Aesop, *Fables*; Xenophon, *Memorabilia*; Plato, *Timaeus, Theaetetus, Phaedrus, Republic*; Aristotle, *Nicomachaean Ethics, Poetics, Rhetoric*; Plutarch, *Moralia*; Virgil, *Aeneid*; Ovid, *Fasti, Metamorphoses*; Horace, *Ars Poetica*; Lucian, *Dialogues*; Martianus Cappella, *The Marriage of Mercury and Philology*; Piero Valeriano, *Hieroglyphica*; Horapollo, *Hieroglyphics*; Lucius Cornutus, *Theologiae grecae compendium*; Saint Augustine, *On the Trinity*; Prudentius, *Psychomachia*; Servius, *Commentary on Virgil's Eclogues*; Pseudo-Dionysius the Areopagite, *De caelesti hierarchia*; Fabius Fulgentius, *Mythologiae*; Isidore of Seville, *Etymologiae*; Rabanus Maurus, *De universo*; Hugo of Saint-Victor; *De fructibus carnis et spiritu*; Alanus de Insulis, *Anticlaudianus*; Vincent of Beauvais, *Speculum doctrinale*; Thomas Aquinas, *Summa theologiae, Summa contra gentiles, De malo*; Philippe de Vitry, *Ovide moralisé*; Joannes Ridevallus, *Fulgentius metaforalis*; Pierre Bersuire, *Reductorium morale*; Alexander Neckam, *De naturis rerum*; Brunetto Latini, *Tesoro*; Dante Alighieri, *Convivio, The Divine Comedy*; Francesco Petrarch, *Triumphs*; Giovanni Boccaccio, *Genealogia deorum*; Sebastian Brant, *The Ship of Fools*; Robertus Holkot, *Moralitates*; *Gesta Romanorum*; Albricus Philosophus, *De imaginibus deorum*; *Mythographus 1–3*; Cristoforo Landino, *Disputationes Camaldulenses, Comento sopra la Comedia*; Andrea Alciati, *Emblemata*; Cesare Ripa, *Iconology*; Christoforo Giarda, *Icones Symbolicae*; Claude-François Ménestrier, *Art des emblems*.

THE VIRTUES
Hesiod, *Works and Days*; Homer, *Iliad, Odyssey*; Aesop, *Fables*; Xenophon, *Memorabilia*; Plato, *Euthydemus, Lysis, Charmides, Laches, Lesser Hippias, Protagoras, Meno, Euthyphro, Phaedo, Timaeus, Theaetetus, Phaedrus, Republic*; Aristotle, *Nicomachaean Ethics, Poetics, Rhetoric*; Plutarch, *Moralia*; Virgil, *Aeneid*; Ovid, *Fasti*,

Metamorphoses; Horace, *Ars Poetica*; Lucius Cornutus, *Theologiae grecae compendium*; Piero Valeriano, *Hieroglyphica*; Horapollo, *Hieroglyphics*; Lucian, *Dialogues*; Lactantius, *Commentary on Statius' Thebaid*; Servius, *Commentary on Virgil's Eclogues*; Martianus Cappella, *The Marriage of Mercury and Philology*; Fabius Fulgentius, *Mythologiae*; Old Testament; Saint Augustine, *On the Trinity*; Prudentius, *Psychomachia*; Pseudo-Dionysius the Areopagite, *De caelesti hierarchia*; Isidore of Seville, *Etymologiae*; Rabanus Maurus, *De universo*; Albricus Philosophus, *De imaginibus deorum*; *Mythographus 1–3*; Hugo of Saint-Victor; *De fructibus carnis et spiritu*; Alanus de Insulis, *Anticlaudianus*; Vincent of Beauvais, *Speculum doctrinale*; Thomas Aquinas, *Summa theologiae, Summa contra gentiles, De malo*; Philippe de Vitry, *Ovide moralisé*; Joannes Ridevallus, *Fulgentius metaforalis*; Pierre Bersuire, *Reductorium morale*; Alexander Neckam, *De naturis rerum*; Brunetto Latini, *Tesoro*; Dante Alighieri, *Convivio, The Divine Comedy*; Francesco Petrarch, *Triumphs*; Giovanni Boccaccio, *Genealogia deorum*; Sebastian Brant, *The Ship of Fools*; Robertus Holkot, *Moralitates*; *Gesta Romanorum*; Cristoforo Landino, *Disputationes Camaldulenses, Comento sopra la Comedia*; Andrea Alciati, *Emblemata*; Cesare Ripa, *Iconology*; Christoforo Giarda, *Icones Symbolicae*; Claude-François Ménestrier, *Art des emblems*.

FORTUNE

Prudentius, *Psychomachia*; Piero Valeriano, *Hieroglyphica*; Horapollo, *Hieroglyphics*; Severinus Boethius, *On the Consolation of Philosophy*; Albricus Philosophus, *Libellus de deorum imaginibus*; *Mythographus 1–3*; Vincent of Beauvais, *Speculum doctrinale*; Philippe de Vitry, *Ovide moralisé*; Joannes Ridevallus, *Fulgentius metaforalis*; Pierre Bersuire, *Reductorium morale*; Robertus Holkot,

Moralitates; Brunetto Latini, *Tesoro*; Dante Alighieri, *Convivio, The Divine Comedy*; Francesco Petrarch, *Triumphs, Remedies for Fortune Fair and Foul*; Giovanni Boccaccio, *Genealogia deorum, The Fall of Princes*; Coluccio Salutati, *De fato et fortuna*; Andrea Alciati, *Emblemata*; Cesare Ripa, *Iconology*; Christoforo Giarda, *Icones Symbolicae*; Claude-François Ménestrier, *Art des emblèmes*.

THE FIVE SENSES

Plato, *Timaeus, Theaetetus, Phaedrus, Republic*; Aristotle, *Metaphysics, Nicomachaean Ethics, On the Soul, On the Senses*; Plotinus, *Enneads*; Cicero, *The Nature of the Gods*; Lucretius, *De rerum naturae*; Ovid, *Fasti, Metamorphoses*; Pliny the Elder, *Natural History*; Origen of Alexandria, *Contra Celsum*; Saint Augustine, *Confessions, De spiritu et anima*; Alanus de Insulis, *Anticlaudianus*; Vincent of Beauvais, *Speculum doctrinale*; Richard de Fournival, *Bestiaire d'amour*; Francesco Colonna, *Hypnerotomachia Poliphili*; Ignatius of Loyola, *Spiritual Exercises*; Cesare Ripa, *Iconology*.

THE TEMPERAMENTS

Plato, *Timaeus*; Aristotle, *On the Soul*; Hippocrates, *On the Nature of Man*; Plotinus, *Enneads*; Hermes Trismegistus, *Asclepius*; Ovid, *Heroides*; Lucian, *Dialogues*; Hyginus, *De astronomia, Genealogiae, Fabulae*; Galen, *Commentaries on Hippocrates, Ars magna, Ars parva*; Petrus de Apono, *Liber physionomiae*; Coluccio Salutati, *De nobilitate legume et medicinae*; Agrippa von Nettesheim, *De occulta philosophia*; Marsilio Ficino, *The Book of Life, Platonic Theology*; Pomponio Gaurico, *De sculptura*; Cristoforo Landino, *Disputationes Camaldulenses*; Leonardo da Vinci, *Treatise on Painting*; Paracelsus, *The Great Surgery Book*; Girolamo Cardano, *De subtilitate, De rerum varietate, Metoposcopia*; Giambatista della Porta, *Della fisionomia dell'huomo*; Giovanni Paolo

Lomazzo, *Trattato dell'arte della pittura*, *Idea del tempio della pittura*; Cesare Ripa, *Iconology*; Thomas Hobbes, *Man and Citizen*; Descartes, *Passions of the Soul*; Pieter Paul Rubens, *Theory of the Human Figure*; Charles Le Brun, *A Method to Learn to Design the Passions*; Denis Diderot, *The Nun*, *Encyclopedia*.

LOVE

Hesiod, *Theogony*; Homer, *Iliad*, *Odyssey*; Plato, *Symposium, Phaedrus*; Theocritus, *Idylls*; Virgil, *Aeneid*; Catullus, *Carmina*; Horace, *Carmina*; Ovid, *Metamorphoses*, *Ars amatoria*, *Remedia amoris*, *Fasti*; Propertius, *Elegiae*; Seneca, *On Benefits*, *Octavia*; Apuleius, *The Golden Ass*; Lucian, *Dialogues*; Martianus Cappella, *The Marriage of Mercury and Philology*; Piero Valeriano, *Hieroglyphica*; Horapollo, *Hieroglyphics*; Song of Solomon; Saint Augustine, *Confessions*; Rabanus Maurus, *De universo*; Bernard of Clairvaux, *Sermon on the Song of Songs*, *De diligendo Deo*; Joannes Ridevallus, *Fulgentius metaforalis*; André le chapelain, *On Love*; Ramon Llull, *Ars amativa*, *Tree of Love*; Jacobus de Voragine, *The Golden Legend*; *Carmina Burana*; *Roman de la rose*; *Roman de la poire*; *Romance of Alexander*; Guillaume de Machaut, *Remède de fortune*; Richard de Fournival, *Bestiaire d'amour*; Bartholomaeus Angelicus, *De proprietatibus rerum*; Arnaldus de Villanova, *Rosarium philosophorum*; Dante Alighieri, *La vita nuova*, *Convivio*, *The Divine Comedy*; Francesco Petrarch, *Canzoniere*, *Triumphs*; Giovanni Boccaccio, *Amorosa visione*, *Genealogia deorum*; Cristoforo Landino, *Quaestiones Camaldulenses, Comento sopra la Comedia*; Agnolo Poliziano, *Le stanze per la Giostra*; Marsilio Ficino, *De voluptate, Platonic Theology*; Francesco Colonna, *Hypnerotomachia Poliphili*; Baldassare Castiglione, *The Book of the Courtier*; Pietro Bembo, *Gli Asolani*; Judah Léon Abrabanel [Léon Hebreo], *Dialoghi d'amore*; Andrea Alciati, *Emblemata*; Pietro Aretino,

Sonetti; Marcantonio Raimondi, *Modi*; Giulio Romano, *Gli amori de i dei*; Cesare Ripa, *Iconology*; Christoforo Giarda, *Icones Symbolicae*.

THE ARTS

Plato, *Timaeus, Critus, Phaedrus, Alcibiades, Ion, Ethydemus, Symposium, Cratylus, Republic, Laws*; Aristotle, *Poetics, Rhetoric*; Cicero, *De inventione, Ad Herennium*; Ovid, *Metamorphoses*; Pliny the Elder, *Natural History*; Martianus Cappella, *The Marriage of Mercury and Philology*; Rabanus Maurus, *De universo*; Thomas Aquinas, *Summa theologiae*; Dante Alighieri, *Convivio*; Cennino Cennini, *Il libro dell'arte*; Franchino Gaffurio, *Practica musicae*, *The Theory of Music*; Andrea Alciati, *Emblemata*; Cesare Ripa, *Iconology*.

THE SCIENCES

Cicero, *De inventione, Ad Herennium*; Martianus Cappella, *The Marriage of Mercury and Philology*; Cennino Cennini, *Il libro dell'arte*; Andrea Alciati, *Emblemata*; Cesare Ripa, *Iconology*.

VANITAS

Book of Ecclesiastes.

Index of Artists

Bibliography

Baltrusaitis, Jurgis, *Le Moyen Âge fantastique* (Paris, 1981).

Battistini, Matilde, "L'uovo: An archetipo universale," *Ovazione* (Milan, 1999).

Berti, Giordano, *I mondi ultraterreni* (Milan, 1998).

Burckhardt, Jacob, *The Civilization of the Renaissance in Italy*, rev. ed. (New York, 2002).

Calvesi, Maurizio, with Mino Gabriele, *Arte e alchimia* (Florence, 1986).

Camille, Michael, *The Medieval Art of Love: Objects and Subjects of Desire* (New York, 1998).

Campbell, Joseph, *The Inner Reaches of Outer Space: Metaphor as Myth and as Religion*, repr. ed. (Novato, CA, 2002).

Carr-Gomm, Sarah, *Hidden Symbols in Art* (New York, 2001).

Cassirer, Ernst, *The Philosophy of Symbolic Forms*, Ralph Mannheim, trans. (New Haven, 1953–96).

Cattabiani, Alfredo, *Lunario. Dodici mesi di miti, feste, leggende e tradizioni popolari d'Italia* (Milan, 2002).

Champeaux, Gerard de, *Introduction au monde des symbols* (Saint-Leger-Vauban, 1966).

Chevalier, Jean, and Alain Gheerbrant, *A Dictionary of Symbols* (New York, 1996).

Cirlot, Juan Eduardo, *A Dictionary of Symbols*, 2nd ed. (New York, 1971).

Culianu, Ioan P., *Eros and Magic in the Renaissance*, Margaret Cook, trans. (Chicago, 1987).

Davy, Marie-Madeleine, *Essai sur la symbolique romane* (Paris, 1977).

Durand, Gilbert, *Les Structures anthropologiques de l'imaginaire: Introduction à l'archétypologie*, 2nd ed. (Paris, 1963).

Eliade, Mircea, *Images and Symbols: Studies in Religious Symbolism*, Philip Mairet, trans., repr. ed. (Princeton, 1991).

Ferino-Pagden, Sylvia, *Immagini del sentire. I cinque sensi nell'arte* (Milan, 1996).

Franz, Marie-Luise von, *Time: Rhythm and Repose* (London, 1978).

Gombrich, E. H., *Symbolic Images* (London, 1972).

Graves, Robert, *The Greek Myths*, 2 vols., repr. ed. (New York, 1993).

Grossato, Alessandro, *Il libro dei simboli* (Milan, 1999).

Hall, James, *Dictionary of Subjects and Symbols in Art*, rev. ed. (London, 1996).

Huizinga, Johan, *The Autumn of the Middle Ages*, Rodney Payton, trans. (Chicago, 1996).

Jung, Carl, *Man and His Symbols* (New York, 1997).

Kerényi, Karl, *Labyrinth-Studien: Labyrinthos als Linienreflex einer mythologischen Idee* (Zurich, 1950).

———, *Miti e misteri* (Turin, 1979).

Kern, Hermann, *Through the Labyrinth: Designs and Meanings over 5,000 Years*, Abigail Clay, trans. (New York, 2000).

Klibansky, Raymond, Erwin Panofsky, and Fritz Saxl, *Saturn and Melancholy: Studies in the History of Natural Philosophy, Religion, and Art* (New York, 1964).

Krauss, Heinrich, and Eva Uthemann, *Was Bilder Erzählen: Die klassischen Geschichten aus*

Antike und Christentum in der abendländischen Malerei (Munich, 1987).

Larsen, Stephen, The Mythic Imagination (New York, 1990).

Le Goff, Jacques, The Birth of Purgatory, Arthur Goldhammer, trans. (London, 1984).

Link, Luther, The Devil: The Archfiend in Art from the Sixth to the Sixteenth Century (New York, 1996).

Mori, Gioia, Arte e astrologia (Florence, 1987).

Panofsky, Erwin, Studies in Iconology: Humanistic Themes in the Art of the Renaissance (New York, 1972).

————, Meaning in the Visual Arts (Chicago, 1982).

Poirion, Daniel, Le Merveilleux dans la literature francaise du Moyen Âge (Paris, 1982).

Ripa, Cesare, Iconology, G. Richardson, ed. (New York, 1979).

Rosenblum, Robert, Transformations in Late Eighteenth Century Art (Princeton, 1970).

Rossi, P. (ed.), La magia naturale nel Rinascimento (Turin, 1989).

Russell, Jeffrey Burton, Lucifer: The Devil in the Middle Ages (Ithaca, 1984).

Santarcangeli, Paolo, Il libro dei labirinti. Storia di un mito e di un simbolo (Milan, 1984).

Saxl, Fritz, The Heritage of Images: A Selection of Lectures, H. Honour and J. Fleming, eds. (New York, 1970).

————, La fede negli astri, S. Settis, ed. (Turin, 1985).

Schwartz-Winklhofer, Inge, and Hans Biedermann, Das Buch der Zeichen und Symbole, 4th ed. (Graz, 1994).

Schwarz, Arturo, Cabbalà e alchimia. Saggio sugli archetipi comuni (Florence, 1999).

————, L'immaginazione alchemica ancora (Bergamo, 2000).

Seznec, Jean, The Survival of the Pagan Gods, Barbara F. Sessions, trans. (Princeton, 1981).

Vercelloni, Virgilio, European Gardens: A Historical Atlas (New York, 1990).

————, Atlante storico dell'idea europea della città ideale (Milan, 1994).

Warburg, Aby, The Renewal of Pagan Antiquity, D. Britt, trans. (Los Angeles, 1999).

Wind, Edgar, Pagan Mysteries in the Renaissance, rev. ed. (Oxford, 1980).

Wittkower, Rudolf, Allegory and the Migration of Symbols (Boulder, CO, 1977).

Wittkower, Rudolf, and Margot Wittkower, Born under Saturn: The Character and Conduct of Artists, A Documentary History from Antiquity to the French Revolution (New York, 1969).

Photograph sources

Sergui Anelli, Electa
Archivi Alinari, Florence
Archivio, Electa, Milan
Archivio fotografico Pinacoteca Capitolinia, Rome
Foto Amoretti, Parma
Fototeca Scala Group, Antella
Foto Saporetti, Milan
The Bridgeman Art Library, London

By kind permission of the Ministero per i Beni e le Attività Culturali we
have here reproduced images provided by:
Soprintendenza per il patrimonio storico, artistico e demoetnoantropo-
logico per le province di Brescia, Cremona e Mantova
Soprintendenza per il patrimonio storico, artistico e demoetnoantropo-
logico per le province di Milano, Bergamo, Como, Lecco, Lodi, Pavia,
Sondrio, Varese
Soprintendenza per il patrimonio storico, artistico e demoetnoantropo-
logico per il Piemonte, Torino
Soprintendenza speciale per il patrimonio storico, artistico e demoet-
noantropologico di Venezia

We also express our thanks to the photographic archives of the museums
and public and private institutions that provided visual material.

The publisher is willing to provide any unidentified iconographical sources
to all entitled.